January 2009

BEFORE PHOTOGRAPHY

Alex

Early Photographers took
inspiration from the
painting Master's inspiration &
perspective!

Enjoy Learning —

love
Kim

BEFORE
PHOTOGRAPHY

Painting and the Invention of Photography

PETER GALASSI

THE MUSEUM OF MODERN ART, NEW YORK

Distributed by New York Graphic Society, Boston

This book and the exhibition it accompanies
have been made possible by a grant from
the National Endowment for the Arts

Schedule of the exhibition:

The Museum of Modern Art, New York
May 9 – July 5, 1981

Joslyn Art Museum, Omaha, Nebraska
September 12 – November 8, 1981

Frederick S. Wight Art Gallery
University of California, Los Angeles
January 4 – February 21, 1982

The Art Institute of Chicago
March 15 – May 9, 1982

Designed by Antony Drobinski
Type set by Concept Typographic Services, New York
Printed by Morgan Press Inc., Dobbs Ferry, New York
Bound by Publishers Book Bindery, Long Island City, New York

The Museum of Modern Art
11 West 53 Street
New York, New York 10019

Printed in the United States of America

CONTENTS

ACKNOWLEDGMENTS

Many individuals and institutions have contributed generously to the preparation of this exhibition and book. The greatest contribution is that of the lenders, who are listed on page 8. Many of the private lenders, and officers of the lending institutions, also have provided indispensable advice, assistance, and information. For this help I owe great thanks to Helmut Börsch-Supan, Verwaltung der Staatlichen Schlösser und Gärten, Berlin; Günter Busch and Gerhard Gerkens, Kunsthalle, Bremen; Hanne Finsen, The Ordrupgaard Collection, Copenhagen; Werner Hofmann and Helmut R. Leppien, Kunsthalle, Hamburg; Martin Butlin, The Tate Gallery, London; C. M. Kauffmann and Mark Haworth-Booth, Victoria and Albert Museum, London; Richard Pare, Canadian Centre for Architecture, Montreal; Knut Berg and Tone Skedsmo, Nasjonalgalleriet, Oslo; Michel Laclotte, Pierre Rosenberg, Jacques Foucart, and Hélène Toussaint, Musée du Louvre, Paris; Daniel Wolf, Daniel Wolf, Inc., New York; Hughes Autexier and François Braunschweig, Texbraun, Paris; Harry H. Lunn, Jr., and Ronald J. Hill, Lunn Gallery, Washington, D.C.; Mrs. Jane Evan-Thomas; Howard Gilman, Pierre Apraxine, and Lee Marks, Gilman Paper Company; André and Marie-Thérèse Jammes; Phyllis Lambert; Samuel J. Wagstaff, Jr.; and Paul F. Walter.

For further aid and counsel I am grateful to J. M. F. Baer, Walter Bareiss, Richard R. Brettell, Richard Brilliant, Geneviève Christy, Jacques Fischer, Shaunagh Fitzgerald, John Gage, Jane Gruenebaum, Françoise Heilbrun, Eugenia Parry Janis, Chantal Kiener, Pierre Lamicq, François Lepage, Gérard Levy, the late Milton J. Lewine, Valerie Lloyd, Pierre Miquel, Weston J. Naef, Theodore Reff, Robert Rosenblum, Conal Shields, William F. Stapp, and Wheelock Whitney III.

Marjorie Munsterberg, Kirk Varnedoe, and Maria Morris Hambourg deserve special thanks for the extraordinary generosity with which they contributed their expertise, their original

observations, and their time at every stage of my work.

I also am particularly grateful for the advice and encouragement of Mr. and Mrs. J. A. Gere and Lawrence Gowing.

In 1979-80 my research toward a doctoral dissertation on the early landscapes of Corot was supported by a fellowship in the Department of European Paintings at The Metropolitan Museum of Art, New York. This research, although conducted independently, inevitably contributed to the present undertaking. I am thankful to the Metropolitan Museum and, for their counsel and encouragement, to Sir John Pope-Hennessy and Charles S. Moffett of European Paintings.

Not a member of the staff of The Museum of Modern Art when I began work on the exhibition, I depended to an unusual degree on that staff. I especially would like to thank Richard E. Oldenburg, Director; Susan Kismaric and Mary E. Fanette, of the Department of Photography; Jane Fluegel, who edited this book; and Antony Drobinski, who designed it.

The idea for *Before Photography* began in 1963, when John Szarkowski was deeply impressed by a lecture by Heinrich Schwarz, entitled "Before 1839: Symptoms and Trends." (Professor Schwarz's seminal contribution is discussed in note 2, p. 30.) Mr. Szarkowski, Director of the Department of Photography at this Museum, developed the idea over a number of years, and in 1979 invited me to prepare the present exhibition. Since then, with great generosity and warmth, Mr. Szarkowski has shared with me his knowledge, his wisdom, his curiosity, and his profoundly original outlook as an art historian. It is also with great warmth that I thank him, not only for his unselfish intellectual guidance but also for the pleasure I have had in working with him.

P. G.

LENDERS TO THE EXHIBITION

The Federal Republic of Germany

Musée Granet, Aix-en-Provence, France
Verwaltung der Staatlichen Schlösser und
 Gärten, Berlin
Massachusetts Historical Society, Boston
Kunsthalle, Bremen
Musée Duplessis, Carpentras, France
Wallraf-Richartz-Museum, Cologne
The Hirschsprung Collection, Copenhagen
The Ordrupgaard Collection, Copenhagen
The Hugh Lane Municipal Gallery of
 Modern Art, Dublin
Kunsthalle, Hamburg
City Art Galleries, Leeds, England
Trustees of the British Museum, London
Royal Academy of Arts, London
Trustees of the Tate Gallery, London
Victoria and Albert Museum, London
The Armand Hammer Foundation,
 Los Angeles
Musée Ingres, Montauban, France
Canadian Centre for Architecture, Montreal
The Notman Photographic Archives, McCord
 Museum, Montreal
Norfolk Museums Service (Norwich Castle
 Museum), England
Musée des Beaux-Arts, Orléans, France
Nasjonalgalleriet, Oslo
Musée du Louvre, Paris
Kunstmuseum, Ribe, Denmark
International Museum of Photography at
 George Eastman House, Rochester

Museum Boymans – van Beuningen,
 Rotterdam
The Library of Congress, Washington, D.C.

Daniel Wolf, Inc., New York
Texbraun, Paris
Lunn Gallery, Washington, D.C.

Arnold H. Crane
Mrs. Jane Evan-Thomas
Mr. and Mrs. J. A. Gere
Gilman Paper Company
André and Marie-Thérèse Jammes
Phyllis Lambert
Samuel J. Wagstaff, Jr.
Paul F. Walter
and three anonymous lenders

BEFORE PHOTOGRAPHY

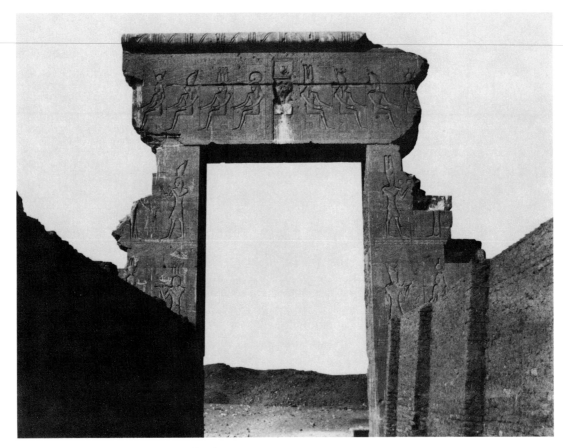

Louis de Clercq
Entrance Portal, Denderah, 1859-60
Albumen-silver print from a paper negative
8⅜ × 11 in.
From *Voyage en Orient*, vol. 5, *Monuments et sites pittoresques
de l'Egypte 1859-1860*
Collection Phyllis Lambert, on loan to the Canadian Centre
for Architecture, Montreal
Not in exhibition

Perhaps the most curious aspect of the race to invent photography is that it was not a race until it was over. With the exception of Daguerre and Niépce (who became partners), none of the four or five serious contestants was aware of the others. Despite this fact, the finish was remarkably close. Indeed, the identity of the winner and the date of the finish depend on which characteristic of the medium is chosen as salient. There are respectable arguments for Thomas Wedgwood in 1802, Nicéphore Niépce in 1826, William Henry Fox Talbot in 1835, and L.-J.-M. Daguerre in 1835 or 1839 (when the invention was publicly announced).

This apparent coincidence is all the more striking because, despite the technical character of the invention, we cannot point to any technical innovation as a catalyst. All of the inventors simply combined two scientific principles that had been known for quite some time. The first of these was optical. Light passing through a small aperture in one wall of a dark room (or "camera obscura") projects an image on the opposite wall. The camera obscura had been a familiar tool of artists and scientists from the sixteenth century. From the eighteenth, it had been common in portable form, designed to project on paper or glass an image that the artist could trace. The second principle was chemical. In 1727, Johann Heinrich Schulze had shown that certain chemicals, especially silver halides, turn dark when exposed to light. The inventors of photography used such chemicals to render permanent the insubstantial image formed in the camera obscura.

"Considering that knowledge of the chemical as well as the optical principles of photography was fairly widespread following Schulze's experiment — which found its way not only into serious scientific treatises but also into popular books of amusing parlour tricks — the circumstance that photography was not invented earlier remains the greatest mystery in its history."[1] For Helmut and Alison Gernsheim, who wrote these words, and for most other historians of photography, the mystery persists because its solution is considered to be primarily scientific. The bulk of writing on photography's prehistory, even in works by art historians, has been technical. The increasing popularity of the camera obscura and the proliferation of other mechanical aids to drawing have been traced in detail. These developments are obviously relevant to the invention of photography. So too is the cumulative search for new methods of pictorial reproduction, which played, for example, a large role in the experiments of Wedgwood and Niépce. But these technical experiments and enthusiasms answer only one side of the question.

No one has proposed that the invention of photography was a mistake or an isolated flash of genius. Most modern studies of the individual inventors treat their careers as representative rather than idiosyncratic, and even the driest technical histories implicitly acknowledge that photography was a product of shared traditions and aspirations. The best writers have recognized that these traditions are social and artistic as well as scientific. Nevertheless, the problem in this form has received less attention than it deserves, perhaps because it cannot be solved by the analysis of a single biography or sequence of scientific or artistic influences.

There is little doubt that reference to the great social and political transformations of the late eighteenth and early nineteenth centuries is an important feature of any adequate solution. However, this aspect of the problem is difficult, since hindsight too readily concludes that the early uses of photography satisfied needs that existed before its invention. Perhaps it is more logical to suggest that the period spawned a great volume of speculative tinkering, whose spirit and products fostered as well as answered such needs.

The social context of the invention of photography is important. Here, however, I propose to concentrate on the narrower (although kindred) issue of photography's relationship to the traditional arts. Previous studies of this issue have yielded many useful facts, but the principles under which the facts have been gathered and organized remain largely unexamined. The principles have changed little since

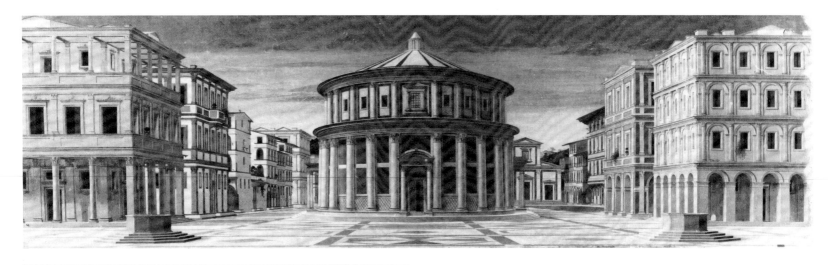

Figure 1. Circle of Piero della Francesca. *An Ideal Townscape*, c. 1470. Panel, 23⅝ × 78¹¹/₁₆ in. Palazzo Ducale, Urbino, Italy

Heinrich Schwarz's representative article of 1949, "Art and Photography: Forerunners and Influences."[2] The article's title reflects its divided conception. The first half traces the history of mechanical aids to post-Renaissance art, especially the camera obscura, whose increasing use, Schwarz argues, led to the invention of photography. Abruptly inverting his argument, Schwarz then lists nineteenth-century paintings derived directly from photographs.

The neat split in Schwarz's method is symptomatic of the prevailing understanding of photography's relationship to painting. Regarded essentially as a child of technical rather than aesthetic traditions, the medium is inevitably considered an outsider, which proceeded to disrupt the course of painting. The extreme corollary of this conception is the notion that photography adopted (or usurped) the representational function of painting, allowing (or forcing) painting to become abstract. This argument, now discredited, seems to have been launched around 1900 by painters, who used it to justify their rejection of nineteenth-century naturalism. The argument has its roots in the conviction — born in 1839 — that photography is the epitome of realism. Few today would accept this notion without qualification, yet it has remained indispensable to most writers who sense a need to supplement the scientific rationale for the invention of photography with an aesthetic one. Devotees of the camera obscura explain the machine's growing popularity as a symptom of a new thirst for accurate description. Others point to the precision

of Biedermeier painting or the spectacular illusion of Daguerre's Diorama. The position is summarized in Beaumont Newhall's words: "The fever for reality was running high."[3]

This formulation is not untrue, but it is vague and ahistorical. So often have Western artists earned the label "realist" and so various are their achievements that the label has meaning only in a historical framework. Such a framework, an admirable one, exists for the Realist movement of the mid-nineteenth century. However, the pre-photographic realism that Newhall and others refer to is a patchwork of disparate expressions, defined not by artistic tradition but by the very invention it is meant to explain. It is, in other words, a tautology, which in effect remands the interpretive burden to the scientific tradition. The object here is to show that photography was not a bastard left by science on the doorstep of art, but a legitimate child of the Western pictorial tradition.

The ultimate origins of photography — both technical and aesthetic — lie in the fifteenth-century invention of linear perspective. The technical side of this statement is simple: photography is nothing more than a means for automatically producing pictures in perfect perspective. The aesthetic side is more complex and is meaningful only in broader historical terms.

Renaissance perspective adopted vision as the sole basis for representation: every perspective picture represents its subject as it would be seen from a particular point of view at a particular

moment. Measured against the accumulated options of prior pictorial art, this is a narrow conception. However, in the four-hundred-odd years of perspective's hegemony over Western painting, artists managed to construe it in an extraordinary variety of ways. Quite apart from the issue of their subjects, the pictures of Paolo Uccello, Jan Vermeer, and Edgar Degas, for example, are very different in appearance. To a great extent these differences may be (and have been) understood in terms of the principle underlying each painter's manipulation of the perspective system or, in other words, the way each conceived the role of vision in art. These conceptions, moreover, did not develop at random, but form a coherent history.

Some familiar features of that history are illustrated in the comparison of the *Ideal Townscape* from the circle of Piero della Francesca (c. 1470, fig. 1) and Emanuel de Witte's *Protestant Gothic Church* (1669, fig. 2). The subject of each picture is a regular, manmade structure, symmetrical along an axis. The earlier painter adopted this as his axis of vision, so that the picture, too, is symmetrical. It presents the ground plan of the architecture almost as clearly as a map. The relative sizes of the buildings are plainly shown and may be checked precisely by reference to the pavement, which is a logical guide to the whole space of the picture.

De Witte, by contrast, chose a point of view well off the axis of symmetry of the church; and his line of sight is not parallel to that axis but oblique, and arbitrary in regard to the structure. The frame also is differently conceived. The Italian view accommodates the entire piazza, but de Witte's picture includes only a portion of the interior of the church. And, just as the point and axis of view are indifferent to the plan of the building, so this portion is a fragment unrelated to the rational form of the church.

To this conception of a narrow slice of space, de Witte added that of a specific slice of time. Unlike the Italian painter, who imposed on his view the clarity of even light, de Witte accepted the momentary play of light and shade, which obscures the architectural logic.

Figure 2. Emanuel de Witte. *Protestant Gothic Church*, 1669. Oil on panel, 16^{15}/$_{16}$ × 13^{3}/$_{8}$ in. Rijksmuseum, Amsterdam

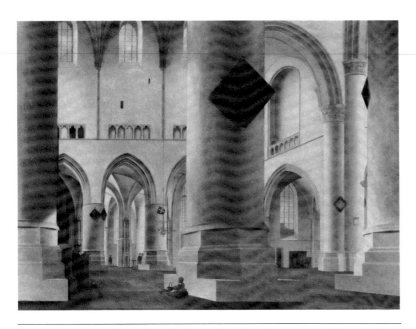

Figure 3. Pieter Jansz Saenredam. *The Grote Kerk, Haarlem*, 1636-37. Oil on panel, 23 7/16 × 32 1/8 in. The Trustees of The National Gallery, London

Both pictures are faithful to the rules of perspective. But the earlier work is formed in the service of its subject's absolute order, while the later submits to the disruptive influence of an ostensibly arbitrary viewpoint and moment in time. We stand outside the Italian view, admirers of the timeless perfection of the imaginary townscape; in de Witte's picture we are participants in the contingent experience of everyday life.

The elaboration of such comparisons leads to a continuous historical analysis of vision in painting. The differences between the fifteenth-century Italian view and de Witte's *Church* are representative of a transformation in the standard of pictorial authenticity. The old standard did not disappear, but it became conservative, marked as a retrospective form. Also divergent from the norm was the vanguard, formed by pictures whose new visual syntax did not enter the mainstream until much later. Such a picture is Pieter Jansz Saenredam's *The Grote Kerk, Haarlem* (1636-37, fig. 3), where the conception of light is less radical than de Witte's but the structure is more so. The frame abruptly truncates the near pillars, which loom enormously in comparison to their counterparts beyond, hiding crucial features of the interior space. The narrow band of pavement is almost powerless to explain the striking juxtaposition of near and far pillars in the middle of the picture. Not until the late nineteenth century was such a willfully fragmentary and internally discontinuous view the common option of every painter.

Such forward glances stand out against the complex but continuous development of the normative visual scheme. The idea of this developing norm as the "history of seeing" in art was conceived within modern art history and has remained one of its major organizing principles. Since the great works of art historians Alois Riegl and Heinrich Wölfflin at the turn of the century, it has been common to explain the difference in formal character between works such as the Italian *Townscape* and de Witte's *Church* in the terms used here — in terms of diverging understandings of the role of vision in art. In other

words, the notion of the "history of seeing" was from the beginning developed not as an independent tool of historical analysis but as a general explanatory principle of style and stylistic change. Meyer Schapiro summarized the principle in his essay "Style": "The history of art is, for Riegl, an endless necessary movement from representation based on vision of the object and its parts as proximate, tangible, discrete, and self-sufficient, to the representation of the whole perceptual field as a directly given, but more distant, continuum with merging parts..."[4] Here is the now familiar sense of art's history as an irreversible trend from tactile to visual intuitions, from knowing to seeing.

As Schapiro demonstrated, this principle is inadequate as a universal explanation of pictorial development, for it fails to account for many important episodes in art. However, the history of the role of vision in art remains a valid tool as long as it is not made to explain more than it can — as long as it is freed from the responsibility of encompassing the entire history of style.

A more limited history of vision as the basis of representation is encouraged by Ernst Gombrich's *Art and Illusion*,[5] which attacks the problem of stylistic change with a refreshingly practical bias. Gombrich proposed that the development from figure 1 to figure 2, for example, need not be explained as an ineluctable drift from tactile to visual intuitions. He showed, rather, that it should be understood in terms of the progressive invention of basic pictorial tools — he called them schemas — each derived from the existing normative analogue of vision and establishing a potential prototype of the next.

Armed with this notion of the artist's pictorial arsenal as a growing toolbox, the historian of perspective may ignore great spans of art, concentrating instead on those periods that developed most intensely new practical applications of the perspective system. The resulting history has a different shape from a value-free chronology of post-Renaissance art. Broadly speaking, it is denser in the fifteenth, seventeenth, and nineteenth centuries, when innovative con-

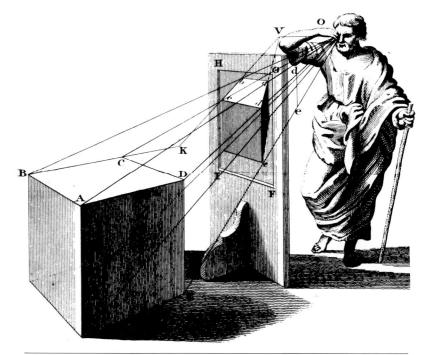

Figure 4. *The Principle of Linear Perspective*. Engraving, 10 × 8 ¾ in. From Brook Taylor, *New Principles of Linear Perspective or, the Art of Designing on a Plane* (London, 1811). Yale University Library, New Haven, Connecticut

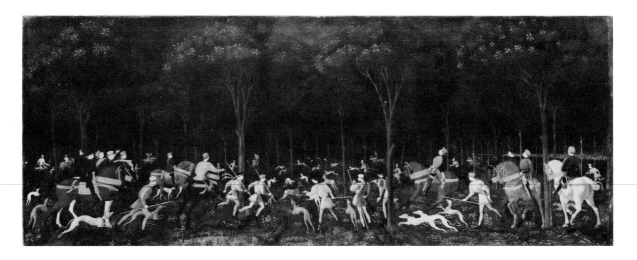

Figure 5. Paolo Uccello. *A Hunt*, c. 1460. Panel, 25 9/16 × 64 15/16 in. Ashmolean Museum, Oxford, England

ceptions of perspective were richer than during the sixteenth and eighteenth centuries. And its emphasis is not guided by absolute value, for Saenredam will claim attention equal to Vermeer, and the young Corot more than David. Similarly, for a given period, it will favor some branches of art over others. The problem of vision was often most directly posed, for example, in the painting of landscapes and views. This tradition thus receives disproportionate attention; around 1800 it is the entire domain of the most radical experiments in the role of vision in art.

Ever since Leon Battista Alberti published *On Painting* in 1435, a perspective picture has been defined as a plane intersecting the pyramid of vision. (See fig. 4.) At the apex of the pyramid is the eye. The pyramid's base is the perimeter of the picture. The picture is the projection upon the intersecting plane of everything that lies within the scope of the pyramid, extending to infinity. The various ingenious objections notwithstanding, Alberti's definition provides that if perfectly produced and viewed with one eye from the apex of the imaginary pyramid, a perspective picture will be like a window through which its subject is seen.

Given this definition, any perspective picture is implicitly the product of three fundamental choices. (1) The artist must choose the arrangement of the subject or (what amounts to the same thing) choose the moment at which to represent an existing subject; (2) he must choose the point of view; (3) he must choose the scope of the view or, in other words, establish the edges of the picture. These three choices determine the basic composition of the picture.

All possible functions of these three interdependent choices lie between two extreme, limiting cases. In one, the point of view and the frame — the visual pyramid — are established first, creating a measured stage. The *Ideal Townscape* of Piero's circle presents just such a stage, on which the buildings are arranged for maximum visibility, and where the position and size of potential figures are easily determined by reference to the preexisting grid. The grid is the key to the reciprocal relationship of two and three dimensions and allows the painter to compose from the former into the latter. Thus Uccello, in his *Hunt* (c. 1460, figs. 5 and 6 [detail]), deployed the men, animals, and trees simultaneously on the surface of the picture and in space, so that there is no gap or obstruction in either.

In the opposite conception of the perspective system, the world is accepted first as an uninterrupted field of potential pictures. From his chosen point of view, the artist scans this field with the pyramid of vision, forming his picture by choosing where and when to stop. De Witte's and Saenredam's pictures are obviously closer to this conception. So too is Degas's *The Racing Field* (c. 1877-80, fig. 7), where point of view and frame rob the figures and animals of their physical integrity, compressing them into an unfamiliar pattern.

Degas of course composed his picture as carefully as Uccello, but his intuitive procedure was different. Uccello conceived of the visual pyramid as a static, neutral container, within which he organized the elements of his picture. In Degas's work the visual pyramid plays an

active, decisive role. We attribute the obstructions to the painter's viewpoint and the asymmetry to the frame, which excludes as well as includes. Where Uccello's painting seems comprehensive, Degas's seems fragmentary, concentrating in a single visual aspect the vital spirit of the entire scene.

Uccello worked from pieces to a whole: he synthesized. Degas worked from a whole to an aspect: he analyzed.

These polar conceptions of perspective have a historical sense. Gradually, over a period of centuries, Uccello's procedure of logical construction gave way to Degas's strategy of selective description. In theory, there must have been a point at which pictorial experiment, diverging from the Renaissance norm, reached a critical stage, a sufficient density, to form a new norm. However, since artistic tradition develops along multiple fronts at different rates, and because the artist's procedure is rarely his subject, this point is difficult to locate. It is not easy to name a date when the world expanded beyond the control of the studio artist, who then unhinged the visual pyramid, wielding it at large in pursuit of his subject.

Nevertheless, the invention of photography poses precisely this historical question. For the photographer, try as he might, could not follow Uccello's procedure. The camera was a tool of perfect perspective, but the photographer was powerless to compose his picture. He could only, in the popular phrase, take it. Even in the studio the photographer began not with the comfortable plane of his picture but with the intractably three-dimensional stuff of the world.

Noting formal characteristics — obstructions and croppings — that readily arise from this unavoidable condition of photography, many art historians tacitly attribute to the invention of the medium the function of a crucial watershed. They explain, for example, some new features of Degas's art in terms of the disruptive influence of photography, ignoring the long tradition from which his artistic procedure is derived. In fact it is not Degas's work that needs explaining but the invention of photography.

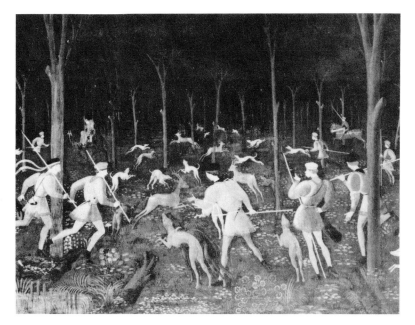

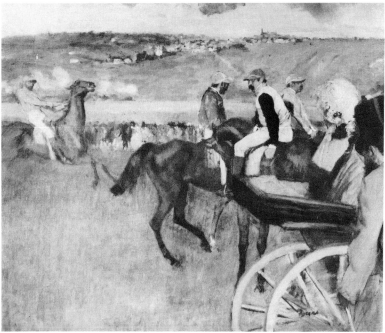

Figure 6. Paolo Uccello. *A Hunt*, c. 1460 (detail)

Figure 7. Edgar Degas. *The Racing Field: Amateur Jockeys near a Carriage*, c. 1877-80. Oil on canvas, 25 15/16 × 31 7/8 in. Musée du Louvre, Paris

Simply on a practical basis, photography would have been unsuited to the Renaissance art of composition. Uccello might have used the camera to make studies of bits and pieces for his pictures; but it is likely that such studies would have displeased him, as they did a much later artist, Edward Hopper: "I once got a little camera to use for details of architecture and so forth but the photo was always so different from the perspective the eye gives, I gave it up."[6]

The Renaissance system of perspective harnessed vision as a rational basis of picture-making. Initially, however, perspective was conceived only as a tool for the construction of three dimensions out of two. Not until much later was this conception replaced — as the common, intuitive standard — by its opposite: the derivation of a frankly flat picture from a given three-dimensional world. Photography, which is capable of serving only the latter artistic sense, was born of this fundamental transformation in pictorial strategy. The invention of photography must then coincide with or succeed the accumulation of pictorial experiment that marks the critical period of transformation from the normative procedure of Uccello's era to that of Degas's.

The present study is designed to explore this proposition. Its paintings and drawings, from the decades before and after 1800, are chosen to mark the emergence of a new norm of pictorial coherence that made photography conceivable. Although these pictures share with the art of their time a spirit of change, and although they were made by artists of many European countries, they do not belong to the mainstream of art. With few exceptions they are landscapes, and most are modest sketches, hardly intended for exhibition. For these very reasons, however, they are perhaps a more reliable guide to the intuitive norm of authentic representation, unburdened by the responsibilities of public art.

These paintings and drawings show that this norm was under drastic revision. They display a new family of pictorial types as yet largely unapplauded and only rarely turned to full artistic advantage, but representative of a significant strain of artistic practice that adopted the analytic function of perspective as its sole tool, discarding the synthetic option as inappropriate to its aims.

The photographs here represent the artistic capital that some early photographers made of this strategy, which painters had long been inventing and which photographers could not avoid.

The preceding argument attempts to abstract from the history of post-Renaissance painting, to isolate for the purpose of clarity, a single thread of development. To this end it employs the rhetorical fiction of the painter's intuitive strategy or procedure. The hypothetical principles of synthesis and analysis are not meant to describe the painter's actual method (for, literally, all paintings are composed) but to call attention to fundamental changes in the conventions of representation.

A comparable sense of these changes may be had by ignoring the artist in favor of the viewer. The latter has no place in Uccello's picture, but he is a virtual participant in Degas's. Erratic, even incoherent, by Uccello's orderly standard, Degas's picture is nevertheless consistent with the conditions of perspective, to which the spectator intuitively responds. From a precise and nearby position, the viewer's knowing eye translates the apparently arbitrary, fragmented forms into the whole space of the picture, and beyond.

A long tradition of pictorial experiment separates Degas's picture from Uccello's. In the seventeenth century, for example, painters often introduced prominent foregrounds that, a century before, would have been considered bizarre and inappropriate, even if accurate in perspective. In Jacob van Ruisdael's *Bentheim Castle* (c. 1670, fig. 8), for instance, the near boulders, insignificant in themselves, are

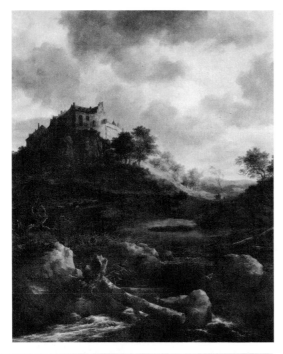

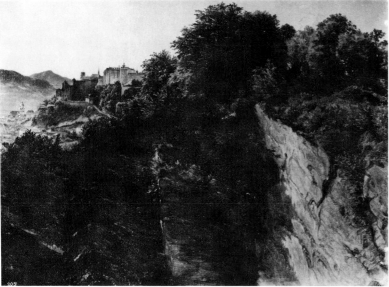

Figure 8. Jacob van Ruisdael. *Bentheim Castle*, c. 1670. Oil on canvas, 26¾ × 21¼ in. Rijksmuseum, Amsterdam

Figure 9. Friedrich Loos. *View of Salzburg from the Mönchsberg*, c. 1829-30. Oil on board, 11 ¹³/₁₆ × 15 ¹⁵/₁₆ in. Österreichische Galerie, Vienna

as large in the picture as the intrinsically more important castle.[7] The viewer intuitively comprehends this discrepancy, acknowledging it as a function of his proximity to the foreground. In judging the picture's space the viewer is also guided by a series of gentle diagonals, which form an unbroken pictorial path between the boulders and the castle. This link is, like Piero's pavement, a two-dimensional measure of a continuous three-dimensional space.

Such an explanatory pictorial path is wholly absent from Friedrich Loos's *View of Salzburg from the Mönchsberg* (c. 1829-30, fig. 9), which presents an even sharper contrast between obstructing foreground and distant subject. It is precisely the lack of an intervening pictorial link — the abrupt discontinuity of the picture's space — that makes the viewer feel his own presence directly before the looming cliff. By stressing the formative role of the vantage point, the artist seems to step aside as the viewer bluntly confronts the world of the picture. Thus in the history of perspective each new norm of pictorial logic, by scuttling an existing convention, appears in its time as an achievement of realism. The result, however, is not an escape from convention but the establishment of a new convention.

This does not mean that the development of pictorial conventions is an abstract, inevitable force. The great periods of innovation in the function of perspective — the mid-fifteenth, mid-seventeenth, and mid-nineteenth centuries — are widely separated in time. Particularly in these periods, it is clear that the pictorial inventions were motivated by changes in artistic value, under historically specific conditions: against the immediately preceding norm the new art indeed had the conviction of a fresh confrontation with reality.

Before Photography concerns the beginnings of the last of these great periods of transformation. In the broad context of the perspective tradition, the paintings and drawings here represent the initial stage of a new standard of pictorial logic. In the specific context of their own time, they are symptomatic of changing artistic values — of an embryonic spirit of realism.

This spirit was related to the Neoclassical principle of artistic renewal, which sought to replace the fantasies of the eighteenth century with a more sober art, based in part on careful visual observation. Neoclassical artists of 1800, led by the French painter Jacques-Louis David, disdained the art of François Boucher's generation as much for its frankly artificial style as for its frivolous content. However, the revival of classical principles also gave new weight to the old, originally Neoplatonic, distinction between a straightforward record of nature and the idealization essential to high art.

Ever since Renaissance artists had reclaimed the appearance of nature as the basis of an ideal art, the theoretical distinction between real and ideal had fostered a loose separation between private sketches and public paintings. Artists and theorists distinguished among several types and two basic categories of sketch: first, the compositional sketch (*ébauche* or *bozzetto*), meant to translate the painter's first idea for a composition into initial and then more elaborate form; second, the study from the model or from nature (*étude*), meant as a record of observation. Unencumbered by public duty, all sketches shared an informal, personal character, which was increasingly prized. But the two kinds of sketch — the *ébauche* and the *étude* — served opposite functions. The former was a record of imagination, the latter of reality. This essay concerns only the latter kind of sketch and its new, important role in art around 1800. By stressing the distinction between imperfect reality and the imagined ideal, Neoclassical theory widened the gap between observational study and finished picture, isolating the sketch as a domain of distinct artistic issues.

The split developed most fully in landscape painting, the class of art that had always held a low place in the academic hierarchy. The highest class was history painting — the representation of the "great deeds of great men, worthy of memory."[8] The landscape, lacking the essential human drama of a great deed, was without intrinsic moral value. As the Abbé Dubos put it in 1719: "The most beautiful land-

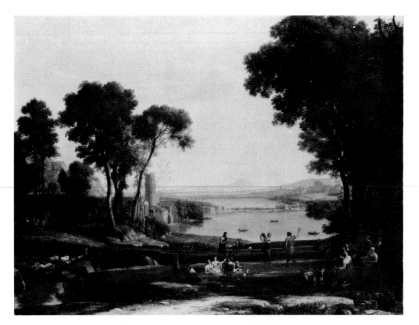

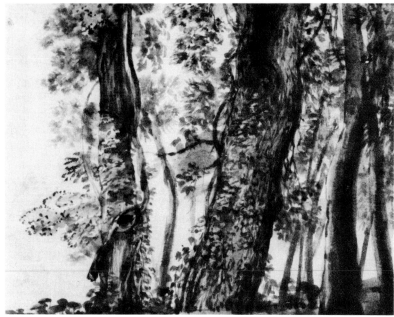

Figure 10. Claude Lorrain. *Landscape with the Marriage of Isaac and Rebekah*, 1648. Oil on canvas, 58⅝ × 77½ in. The Trustees of The National Gallery, London

Figure 11. Claude Lorrain. *Wooded View*, c. 1640. Brown wash on paper, 5¹¹/₁₆ × 7¼ in. Teylers Museum, Haarlem, the Netherlands

scape, even by Titian or Carracci, is of no more interest to us than an actual tract of country, which may be either hideous or pleasant. Such a painting contains nothing which, as it were, speaks to us; and since we are not moved by it we do not find it of particular interest."[9]

This statement, doubtless already conservative at the beginning of the eighteenth century, would have been hopelessly reactionary in 1800. By any standard, landscape painting was rising dramatically in importance. At the heart of this extremely complex phenomenon was the growing conviction that the unembellished landscape possessed intrinsic value: because it was made by God, because it was beautiful, because it was the place where man lived and had lived, or because it was independent of man. The ultimate artistic corollary of this moral conception was the notion that a careful visual record of the landscape was meaningful in itself.

The rise of realistic landscape painting around 1800 contradicted the dominant Neoclassical principle of an ideal art. However, it coincided exactly with the Neoclassical conception of the sketch — devoid of traditional artistic value but devoted to the problem of transcribing the appearance of nature. Academically sanctioned as an aspect of craft, the landscape sketch was a ready vehicle for experiments in realism. The sketch was, in other words, a loophole in the traditional definition of artistic practice, which allowed a generally unacknowledged but formidable shift in artistic values to develop. Thus, although lacking the status of high art and rarely receiving full artistic attention, the landscape sketch — particularly the landscape sketch in oil — became around 1800 the primary vehicle of a tentative but profoundly original sense of pictorial order, based on a heretical concern for the visual aspect of the most humble things.

The traditional, reciprocal relation of sketch and finished picture is evident in the seventeenth-century landscape art of Claude Lorrain. Compared with the grand formulas of Claude's public compositions (fig. 10), his sketches, presumably from nature (fig. 11), are astonishingly informal and immediate. Yet the paintings share with the sketches a delicate sensitivity to light and a subtle response to the variety of nature. Nor are the sketches mere transcriptions from nature; they are so thoroughly informed by the painter's lyrical talent that it is often difficult to judge whether a particular drawing is an invention of the mind or a record of perception. As Lawrence Gowing has written: "... the distinction between the two elements in Claude's art, the artificial pictorial scheme and the actuality of nature, by no means coincided with the division between painting and drawing. ... It seems that the drawings, rather than transmitting particular information, served to indulge and intensify an emotional attitude to nature, an attitude that the paintings dramatized in an ideal, expository order."[10]

For Claude, the theoretical polarities of real and ideal remained in happy solution; by the late eighteenth century, they had begun to precipitate into distinct categories of artistic practice. Consider, for example, J. M. W. Turner's analysis of Claude's method, in a lecture of 1811: "We must consider how [Claude] could have attained such powers but by continual study of parts of nature. Parts, for, had he not so studied, we should have found him sooner pleased with simple subjects of nature, and would not have[,] as we now have, pictures made up of bits, but pictures of bits."[11]

Turner of course preferred "pictures made up of bits" (imaginative compositions) to "pictures of bits" (straightforward visual records). But more important than his preference is his application of the theoretical distinction between imagination and reality to discrete forms of practice. The application suits much better the art of Turner's period than that of Claude's. Although Turner rarely painted pictures of bits, many of his contemporaries did, deriving their clarity of purpose from the growing polarization that all artists felt.

The traditional media of outdoor sketching were monochrome, most often the handy pencil on paper. In the seventeenth century painters also began to sketch outdoors in oil — the dominant medium of studio pictures, distinguished from other media by its range of

color and by its potential subtlety, force, and adaptability. The use of oil was in itself a mark of serious intention; the powerful medium moreover imposed on the painter the artistic burden of its great resources.

A handful of landscape sketches in oil survives from the seventeenth century, and there are records of others. There is also an extraordinary group of sketches made by Alexandre-François Desportes in the early eighteenth century. However, the practice of landscape sketching in oil was neither common nor important in art until the late eighteenth century, when it began to grow rapidly. By the early nineteenth century it already had an autonomous character, so that, for example, a figure painter could make a few landscape sketches in oil, contributing to the widespread trend without fully joining it.

The blossoming of landscape sketching in oil is marked around 1780 by the Italian campaigns of the Frenchman Pierre-Henri de Valenciennes and the Welshman Thomas Jones, both of whom are represented here. Despite many differences in the careers of the two painters, each produced in significant numbers remarkably inventive oil sketches from nature (e.g., fig. 12) that bear no obvious relation to their grandiose, often unimpressive public pictures (e.g., fig. 13). What for Claude had been a fluid commerce between complementary aspects of his art had become for Valenciennes and Jones an unbridgeable gap. No longer able to transfer the conviction of their nature studies to their formulaic public works, they nevertheless found the practice of sketching an admirable vehicle for their talents.

In the next half-century, the landscape sketch in oil enjoyed a rich development. Just as our limited knowledge fails to explain precisely the sudden appearance of the sketches of Valenciennes and Jones around 1780, so it is impossible now to trace, through a series of specific artistic contacts, the virtual explosion of oil sketching in the early nineteenth century. By 1820 the practice was extremely widespread, common among painters from England, France, and

Figure 12. Thomas Jones. *Outskirts of London*, 1784. Oil on paper, 9⅜ × 13 in. The Tate Gallery, London

Figure 13. Thomas Jones. *The Bard*, 1774. Oil on canvas, 45½ × 66 in. National Museum of Wales, Cardiff

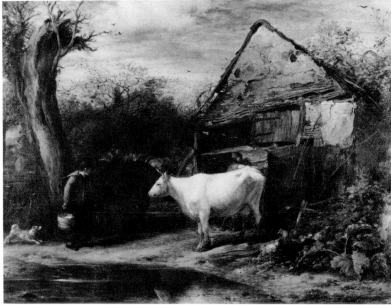

Figure 14. John Linnell. *Study of Buildings*, 1806. Oil on board, 6½ × 10 in. The Tate Gallery, London

Figure 15. John Linnell. *Milking Time*, 1832. Oil on panel, 11¼ × 15¼ in. Victoria and Albert Museum, London. Crown copyright

Germany, as well as from Belgium, Denmark, and Norway.

The melting pot for the various aspects of this Northern phenomenon was nevertheless in the South — in Italy and particularly in Rome. That city had been for several centuries the artistic capital of Europe, and until the mid-nineteenth century most painters of ambition made an early pilgrimage there. The international community of artists, dense with students, provided the landscape sketchers with a sympathetic environment and a lively forum of exchange. Rome and the surrounding landscape, the haunts of Claude and Poussin, were moreover rich in history: here, if anywhere, the landscape itself had intrinsic human significance.

It is a mistake, however, to think of landscape sketching in oil as a definite artistic movement, with its center in Rome. John Constable, perhaps the best of the landscape sketchers, never visited Italy; indeed he made a virtue of his inclination to stay at home. His achievement depends not so much on immediate influence as on the less tangible condition of a tradition under change. Constable's sketches of the 1810s and 1820s and Camille Corot's of the 1820s and 1830s are distinguished from the earlier work of Valenciennes and Jones by their variety of subject and technique and by their formal resolution. The high quality of the works is a product of the artists' talent but no less of the broad artistic transformation that gave form to that talent. The sketch had reached maturity.

It is difficult to maintain the judgment that, as mere studies or documents of nature, the sketches must lack aesthetic intent or value. Although modest in scale and ostensible ambition, they are often vigorous, self-sufficient pictures. This is true even in the rare cases where the sketch (fig. 14) apparently served only to record a motif for a later composition (fig. 15). In general the sketches had no such obvious function. Corot's *View of the Colosseum through the Arches of the Basilica of Constantine* (1825, fig. 16), for example, is practically useless as a document of either building. Nor does the work have any explanatory figures or even a recognizable space in which they might

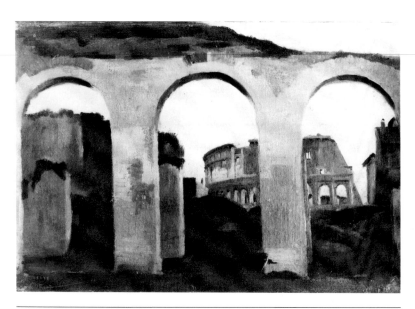

Figure 16. J.-B.-C. Corot. *View of the Colosseum through the Arches of the Basilica of Constantine, Rome*, 1825. Oil on canvas, 9⅛ × 13¹¹⁄₁₆ in. Musée du Louvre, Paris

move. Yet here, directly and powerfully expressed, is the "noble simplicity and calm grandeur" of classical art.

Much has been made of Constable's and Corot's intermittent attempts to bridge the gap between sketch and finished work, to join the virtues of observation and convention. Less attention has been paid to the fact that this gap, as they knew it, was only a few decades old. It is precisely the gap that is distinctive of the period — and significant, for it announces the impending struggle between an inherited rhetorical art and an art devoted to individual perceptions of the world. Still, the struggle was not yet open, nor even yet a struggle. Perhaps paradoxically, the innovations of the landscape sketch in oil were possible because they did not challenge the authority of public art.

Thus the unresolved but bold realism of the sketch was not an attack from without but a symptom of transformation within artistic tradition. It is significant in this respect that none of the painters represented here were amateurs or extreme provincials; all were professional artists who shared a more or less conventional training. Conspicuously absent are the Americans, who lacked the conditioning environment of tradition. The earliest American oil sketches, comparable to those common in Europe from 1780, were made in the late 1840s, when European practice had already begun to change.

For the young Adolf Menzel in the 1840s, the sketch still offered an option of artistic freedom; and the spirit of the sketching tradition is still recognizable in Wassily Kandinsky's small landscapes of 1900-05. But the sketch, as Valenciennes had defined it, is to be found in the later nineteenth century only in the work of conservative artists, such as William Adolphe Bouguereau and Frederic Leighton. It had little place in the art of Gustave Courbet or Claude Monet. Once the artistic problems that first appeared in the landscape sketch began to be broached in the public forum, sketching waned in importance.

In the early nineteenth century, the landscape sketch was a special vehicle of change. John Constable suggested the new values when

he wrote in 1836 that "painting is a science, and should be pursued as an inquiry into the laws of nature. Why, then, should not landscape painting be considered as a branch of natural philosophy, of which pictures are but the experiments."[12] This deeply modern sense of art as exploratory rather than didactic may also be found in the work of many figure painters, most importantly Francisco Goya and Théodore Géricault. A more adventurous historian, faced with the problem posed here, would have included these painters. I have chosen instead to focus on that aspect of landscape painting that is the clearest (if ostensibly the most modest) symptom of the broad artistic transformation that catalyzed the invention of photography. The landscape sketches (and some comparable drawings and finished paintings, also shown here) present a new and fundamentally modern pictorial syntax of immediate, synoptic perceptions and discontinuous, unexpected forms. It is the syntax of an art devoted to the singular and contingent rather than the universal and stable. It is also the syntax of photography.

Of the works presented here, those that most deserve Turner's epithet "pictures of bits" are the ones that take forthrightly as their subject a single, namable thing: the trunk of a tree (p. 41), a cloud (p. 46), a humble gate (pp. 42, 43). The text for these pictures is not to be found in the Bible or in Homer's *Iliad* but in a letter of John Constable: "The sound of water escaping from Mill dams,... willows, Old rotten Banks, slimy posts & brickwork — I love such things.... These scenes made me a painter (& I am grateful)."[13]

There are of course earlier pictures of humble things and bits of nature. Among the most famous are Albrecht Dürer's close nature studies, such as *The Great Piece of Turf* (1503, fig. 17). Obviously, artistic devotion to even the smallest corner of nature was not new, although in numbers alone the landscape studies of 1800 claim a new importance. In addition to their frequency, however, the nineteenth-

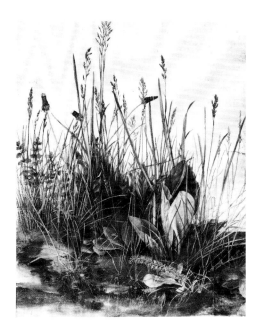

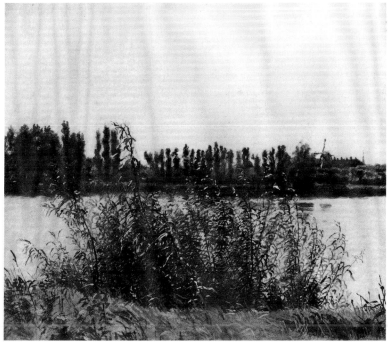

Figure 17. Albrecht Dürer. *The Great Piece of Turf*, 1503. Watercolor and gouache on paper, 16⅛ × 12⅜ in. Albertina, Vienna

Figure 18. Christen Købke. *View at Dosseringen*, c. 1837. (No. 28)

century paintings are distinguished from their precedents by an original pictorial conception.

Dürer's low, close viewpoint monumentalizes the grasses, isolating them pictorially and conceptually against a blank ground. They could be anywhere, almost any size. By contrast, Christen Købke's bush (c. 1837, fig. 18) shares the picture with its environment; the painter evidently sought and enjoyed the delicate confusion of the far bank with the tallest fronds of the plant. Denied the independence it has in our minds, the bush appears in the picture as the chosen feature of a broad scene. In a similar way the cropped treetops of Constable's cloud study (no. 4, p. 46) remind us that, although the noble cumulus is whole and symmetrical in the center of the picture, we see only a section of the sky. These pictures, then, are doubly "bits" — for their nominal subjects and for their frankly narrow pictorial scope.

This sense of the picture as a detail, carved from a greater, more complex whole, is a characteristic, original feature of nineteenth-century art. Perhaps most symptomatic is the phenomenon of close, variant views of the same site. Consider, for example, two sketches made by Constable on July 12 and 15, 1829 (figs. 19, 20). The apparent stimulus for the works was the group of trees at the left in the earlier work, but Constable was mindful also of their surroundings, especially the sky. The frame answers the movement of the clouds and trees, making salient in each picture the drama of earthbound weather that the painter loved.

Valenciennes also made close pairs, directed most often at changes in light (no. 35a and b, p. 33) or changes in weather (figs. 21, 22). These pairs focus our attention on the transient element. Faithful in his public works to the enduring value of ancient truths, Valenciennes devoted his sketches to the contingent and impermanent.

To the comprehensive whole of traditional art, the landscape sketchers of 1800 opposed the precisely determined aspect. Surely one of the most remarkable products of this strategy is the trio of

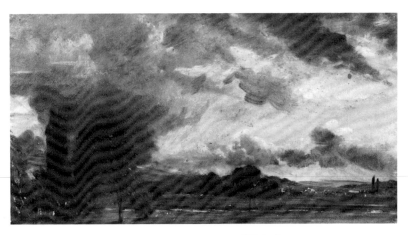

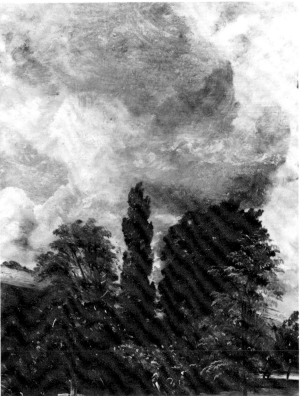

Figure 19. John Constable. *A View of Salisbury, from the Library of Archdeacon Fisher's House, 4:00 p.m., July 12, 1829.* Oil on paper, 6⅜ × 12 in. Victoria and Albert Museum, London. Crown copyright

Figure 20. John Constable. *The Close, Salisbury, 11:00 a.m. – Noon, July 15, 1829.* Oil on paper, 10⅜ × 8 in. Victoria and Albert Museum, London. Crown copyright

watercolors painted by John Linnell at Kensington in 1812 (no. 30 a-c, pp. 56, 57). Here again the parallel text is by Constable, who wrote that "it is the business of a painter not to contend with nature, and put this scene (a valley filled with imagery 50 miles long) on a canvas of a few inches, but to make something out of nothing, in attempting which he must almost of necessity become poetical."[14]

Like Valenciennes's choice of a laundry-draped Roman rooftop (instead of the Colosseum), Linnell's choice of a barren Kensington brickfield (instead of Tintern Abbey) almost seems to explain the pictorial variations. It is as if the very ordinariness of the subject were a challenge to the painter's aesthetic imagination — a challenge to make something out of nothing. Constable of course did not believe that his subjects were nothing; he meant only that earlier artists would have considered them so. He also meant that artistic concern for humble things required a new pictorial language. By showing, in their variations, that even the most humble scene offered a variety of pictorial aspect, the painters claimed an active, potentially poetic, role in their works.

What made a pictorial "something" out of an actual "nothing" was — literally and metaphorically — the painter's point of view. If slimy posts mattered to Constable, what convinces us of the fact is the way he looked at them. It is precisely the mediating conditions of perception — the cropping frame, the accidents of light, the relative point of view — that make the pictures here seem real. Separated from the ideal drama of older art by the triviality of their subjects, the pictures are also divergent in form. It is as if the expository order of traditional compositions were an obstacle to the spirit of immediacy the artists sought. The works appear to be formed by the eye instead of the mind.

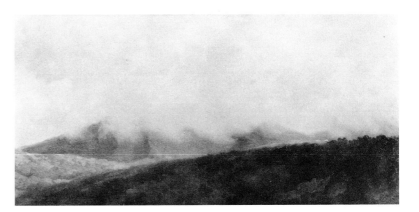

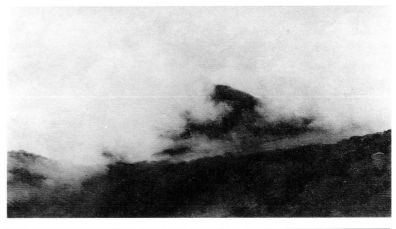

Figure 21. Pierre-Henri de Valenciennes. *Monte Cavo in the Clouds,* 1782-84. Oil on board, 5 11/16 × 11 11/16 in. Musée du Louvre, Paris

Figure 22. Pierre-Henri de Valenciennes. *Monte Cavo in the Clouds,* 1782-84. Oil on board, 5 15/16 × 11 3/16 in. Musée du Louvre, Paris

Criticizing the landscape painters who exhibited at the Salon of 1859, Charles Baudelaire wrote: "They take the dictionary of art for art

itself; they copy a word from the dictionary, believing that they are copying a poem. But a poem can never be copied; it has to be composed. Thus, they open a window, and the whole space contained in the rectangle of that window — trees, sky and house — assumes for them the value of a ready-made poem."[15]

For Baudelaire, imagination was a synthetic faculty, "the queen of the faculties," the mark of artists. "[Our public] are not artists, not naturally artists... They feel, or rather they judge, in stages, analytically. Other more fortunate peoples feel immediately, all at once, synthetically."[16] Art must serve imagination: a picture must be composed.

It was on the same grounds, in another part of his review of the same Salon (the first to include photographs), that Baudelaire claimed that photography could not be an art. A medium that allowed the artist no right to compose — to meddle in the internal affairs of the picture — could never be a vehicle of the imagination. Like Baudelaire, many critics of the day saw a causal connection between photography and the new strain of painting — "this silly cult of nature, not refined, not explained by imagination."[17] Their suggestion that photography might be responsible for this "cult" is still voiced today.

However, the new attitude (and its pictorial expressions) had begun to develop before photography was invented. What better illustration is there for Baudelaire's argument than Friedrich Wasmann's *View from a Window* (c. 1833, fig. 23)? If photography had an impact on painting (and it certainly did), it is because the new medium was born to an artistic environment that increasingly valued the mundane, the fragmentary, the seemingly uncomposed — that found in the contingent qualities of perception a standard of artistic, and moral, authenticity.

Of course many early photographers sought to emulate the look and meaning of traditional compositions, but the medium often defeated them. The photographs obstinately described with equal

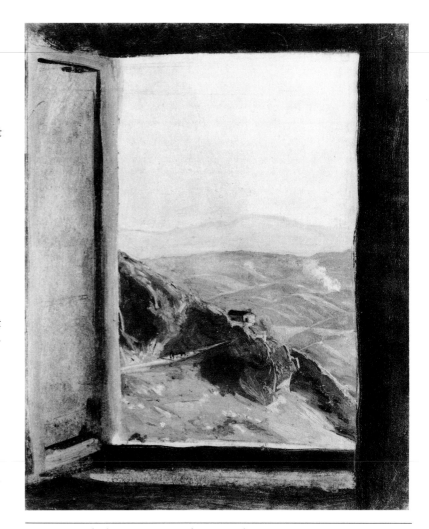

Figure 23. Friedrich Wasmann. *View from a Window,* c. 1833. (No. 40)

precision (or imprecision) the major and minor features of a scene, or showed it from the wrong point of view, or included too little or too much. Even photographers who aimed only at a clear record were sometimes sorely rewarded with a disturbingly unfamiliar picture. Lady Elizabeth Eastlake, for example, observed that when photographed in bright sunlight, "hollies, laurels, ivy, and other smooth-leaved evergreens…instead of presenting a sunny effect look rather as if strewn with shining bits of tin, or studded with patches of snow."[18] Many other critics noticed comparable problems and complained that if photography could only record, it often did not record well enough.

In a sense the critics were right on both counts. Photography recorded not the physical reality before the lens but its visible aspect, determined by a specific point and scope of view, at a particular moment, in a particular light. The description was seamless, but only in two dimensions. The photographer ignored this fact at his peril, risking obstructions and discontinuities, fortuitous juxtapositions, and unexpected densities and gaps in spatial logic.

Even the most attentive photographer must soon have compiled his own catalogue of the now familiar photographic mistakes. But the best early photographers evidently profited from their errors and learned, with surprising rapidity, to control (or at least to collaborate with) the refractory new medium. They also discovered a positive value in pictures that many would have called, and did call, mistakes.

The photographs presented here, like the paintings and drawings, are pictures of bits: telling details and vivid, singular perceptions. And, like the paintings, the photographs show a fierce independence from traditional standards of artistic value and coherence. There is, however, a difference. In painting, the new standards had been won through long experiment and only gradually acquired a dominant role. In photography, the camera's inability to compose rendered the old standards nearly obsolete from the outset.

The originality thus imposed on the photographer was compounded by the nature of the task he generally faced. Most early photographs — records of people, places, and things — were made in a spirit of documentation and investigation. Like the landscape sketchers but on a much broader scale, the photographers had a mandate to seek the specific and provisional in place of the general and didactic.

The photographs here were made in the first three decades of photography. They were made, in other words, before photographers could work without a tripod, or with exposures capable of stopping rapid action — and before photographers possessed a coherent tradition or a well-developed consensus of purpose. In these decades, and for some time thereafter, the painters, nourished by a rapidly changing tradition, led the way in applying the new vocabulary they now shared with photographers. What nineteenth-century photographer matched the achievement of Degas or Monet? But the very uncertainty of photography's status, its increasing technical versatility, and the variety of its worldly functions, combined to make it from the beginning a powerful force of change. That we now deeply value photography's disruptive character is perhaps the best measure of the degree to which the medium has shaped our conception of modern art.

NOTES

The notes are confined to the minimum. The other literature on which I have drawn is cited in the bibliography.

1. Helmut and Alison Gernsheim, *The History of Photography from the Camera Obscura to the Beginning of the Modern Era* (New York: McGraw-Hill, 1969), p. 13.

2. Heinrich Schwarz, "Art and Photography: Forerunners and Influences," *Magazine of Art,* vol. 42, no. 7 (Nov. 1949), pp. 252-57. The late Professor Schwarz was a pioneer in the critical evaluation of this issue. Although his later publications do not depart from the spirit of the 1949 article, Schwarz apparently modified his views as he pursued the subject. Of particular importance is an unpublished lecture, "Before 1839: Symptoms and Trends," first delivered at the 1963 meeting of the College Art Association, in Baltimore. John Szarkowski, Director of the Department of Photography at The Museum of Modern Art, was deeply impressed by the lecture and its illustrative materials. His interest in the issue, prompted by Schwarz's lecture, eventually led to plans for the present exhibition. However, his efforts to obtain a transcript of the lecture were unsuccessful, despite the kind assistance of Professor Schwarz's widow.

The only record of the lecture is to be found in the *Year Book of the American Philosophical Society* (1963), p. 600: The lecture "deals particularly with observations on pre-photographic paintings of the 1820s and 1830s; that is to say, with paintings of the last two pre-photographic decades in which already strong 'photographic' features can be observed even if these paintings were done without the aid of any mechanical device. The introduction of the paper concerned with pre-photographic mechanical aids and devices used by artists from the fifteenth-century onwards pointed to the interdependence of science and art."

Another clue to Schwarz's position appears in his book *Salzburg und das Salzkammergut: Die künstlerische Entdeckung der Stadt und der Landschaft im 19. Jahrhundert,* 3d ed. (Vienna: Anton Schroll, 1957). Of the sharp, bright landscapes painted by Ferdinand Georg Waldmüller in the 1830s (no. 38), Schwarz wrote (pp. 54, 55; my translation): "They are exemplary of a positivist-realist outlook, which would find its most extreme, namely mechanical, expression in photography, 'the evil spirit of the century.' Already in his landscapes of the Salzkammergut, Waldmüller (as Graf Athanasius Raczynski reports) had made use of the dark-mirror or Claude-glass, so loved by English painters and amateurs. One can clearly recognize in the croppings and light-dark contrasts of Waldmüller's early Salzkammergut landscapes, the effect of this optical aid, which had been in use for centuries. In 1833, while Waldmüller painted in the Salzkammergut, Fox Talbot, the future inventor of photography, was drawing at Lake Como with the help of a camera lucida. And a few years later, in 1839, Talbot succeeded in preserving and reproducing the image he caught in the camera obscura."

I am thankful to John Maass of Philadelphia, who heard Schwarz's 1963 lecture and confirms its significance for the present investigation.

3. Beaumont Newhall, *The History of Photography from 1839 to the Present Day,* 4th ed. rev. (New York: The Museum of Modern Art, 1964), p. 12.

4. Meyer Schapiro, "Style" (1953), reprinted in Morris Philipson and Paul J. Gudel, eds.,

Aesthetics Today (New York: New American Library, 1980), p. 157.

5. E. H. Gombrich, *Art and Illusion: A Study in the Psychology of Pictorial Representation,* 2d ed. rev. (Princeton, New Jersey: Princeton University Press, 1961). Gombrich, moreover, provides a brief review of the development of the notion of "the history of seeing," pp. 9-30.

6. Quoted in Brian O'Doherty, "Portrait: Edward Hopper," *Art in America,* vol. 52, no. 6 (Dec. 1964), p. 77.

7. Thus Heinrich Wölfflin described the picture in *Principles of Art History: The Problem of the Development of Style in Later Art* (1922), trans. M. D. Hottinger (1932; reprint, New York: Dover, 1950), p. 85.

8. The phrase is that of Leon Battista Alberti in *Ten Books on Architecture* (1486), quoted in E. H. Gombrich, "The Renaissance Theory of Art and the Rise of Landscape," *Norm and Form: Studies in the Art of the Renaissance* (London: Phaidon, 1966), p. 111.

9. Quoted in London: British Museum, *French Landscape Drawings and Sketches of the Eighteenth Century* (exh. cat., 1977), p. 9.

10. Lawrence Gowing, review of Marcel Roethlisberger, *Claude Lorrain: The Drawings* (Berkeley: University of California Press, 1968), in *The Art Quarterly,* vol. 37, no. 1 (Spring 1974), pp. 92-93. For further discussion of Claude's sketches, see Roethlisberger and J. A. Gere, introduction to Paris: Musée du Louvre, *Claude Lorrain: Dessins du British Museum* (exh. cat., 1978).

11. See Jerrold Ziff, "'Backgrounds, Introduction of Architecture and Landscape': A Lecture by J. M. W. Turner," *Journal of the Warburg and Courtauld Institutes,* vol. 26 (1963), pp. 124-47. This passage is also quoted in Lawrence Gowing, *Turner: Imagination and Reality* (New York: The Museum of Modern Art, 1966), p. 13. I have borrowed in the next paragraph Gowing's observation that "Turner rarely painted pictures of bits."

12. From Constable's fourth lecture on the history of landscape painting, delivered at the Royal Institution, London, on June 16, 1836. Quoted in C. R. Leslie, *Memoirs of the Life of John Constable Composed Chiefly of His Letters* (1845); reprint, Jonathan Mayne, ed. (London: Phaidon, 1951), p. 323.

13. Letter from Constable to John Fisher, Oct. 23, 1821. R. B. Beckett, ed., *John Constable's Correspondence,* 6 vols. (Ipswich, England: Suffolk Records Society, 1962-68), vol. 6, pp. 77-78.

14. Letter from Constable to John Fisher, Aug. 1824. *Ibid.,* p. 172.

15. Charles Baudelaire, *Art in Paris 1845-1862: Salons and Other Exhibitions,* trans. and ed. Jonathan Mayne (London: Phaidon, 1965), pp. 194-95.

16. *Ibid.,* p. 152. The entire passage in the original is "...notre public ne cherche que le Vrai. Il n'est pas artiste, naturellement artiste; philosophe peut-être, moraliste, ingénieur, amateur d'anecdotes instructives, tout ce qu'on voudra, mais jamais spontanément artiste. Il sent ou plutôt il juge successivement, analytiquement. D'autres peuples, plus favorisés, sentent tout de suite, tout à la fois, synthétiquement." Baudelaire, *Oeuvres complètes* (Paris: Gallimard, 1961), p. 1033.

17. Baudelaire, trans. Mayne, p. 194. I have made minor corrections in the translation. The original: "...ce culte niais de la nature, non épurée, non expliquée par l'imagination...." *Oeuvres complètes,* p. 1077.

18. Lady Elizabeth Eastlake, "Photography" (1857), reprinted in Beaumont Newhall, ed., *Photography: Essays and Images. Illustrated Readings in the History of Photography* (New York: The Museum of Modern Art, 1980), p. 93.

PLATES
PAINTINGS AND DRAWINGS

Pierre-Henri de Valenciennes
Rooftop in Sunlight, Rome, c. 1782-84
Oil on paper, mounted on board
7 1/8 × 14 3/8 in.
Musée du Louvre, Paris
No. 35a

Pierre-Henri de Valenciennes
Rooftop in Shadow, Rome, c. 1782-84
Oil on paper, mounted on board
7 1/8 × 13 1/4 in.
Musée du Louvre, Paris
No. 35b

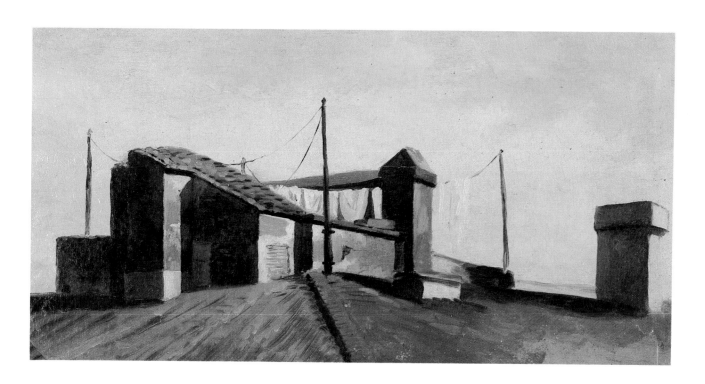

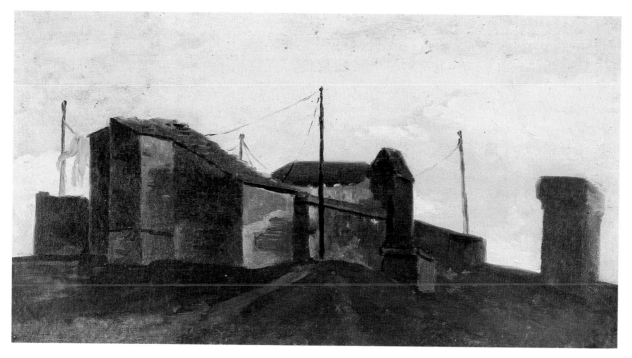

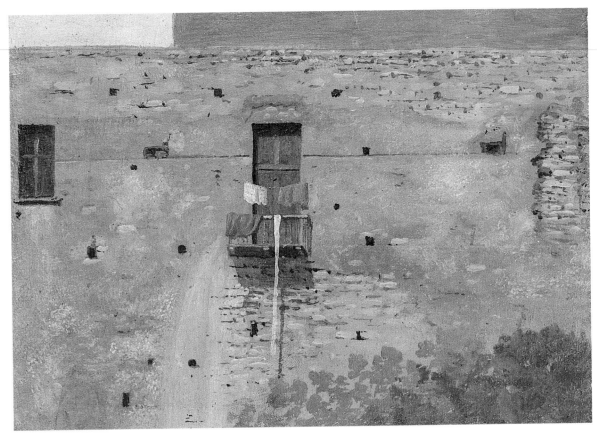

Thomas Jones
A Wall in Naples, c. 1782
Oil on paper
4⅜ × 6¼ in.
Collection Mrs. Jane Evan-Thomas, England
No. 27

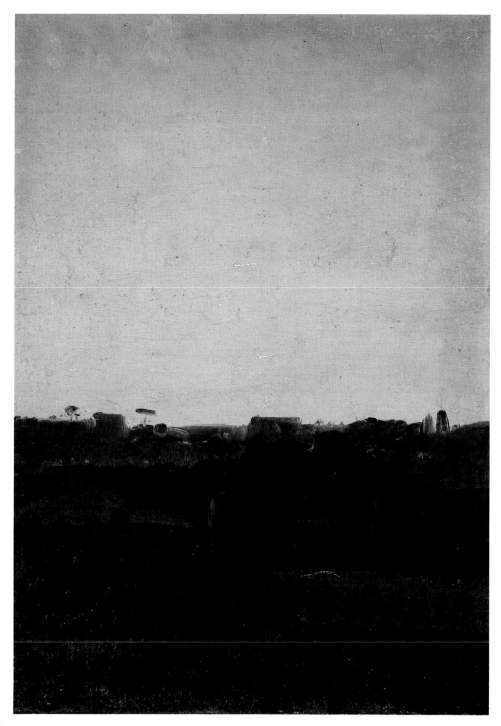

François-Marius Granet
The Roman Campagna at Sunset, 1802-19
Oil on paper, mounted on canvas
9⅜ × 6¹¹/₁₆ in.
Musée Granet, Aix-en-Provence, France
No. 21

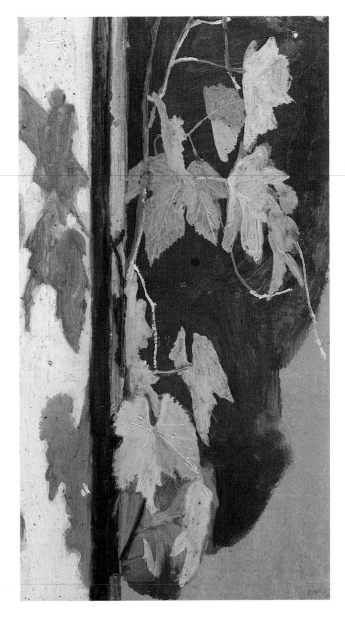

Friedrich Wasmann
Study of a Grapevine, c. 1830-35
Oil on paper
6³⁄₈ × 3⁹⁄₁₆ in.
Kunsthalle, Hamburg
No. 41

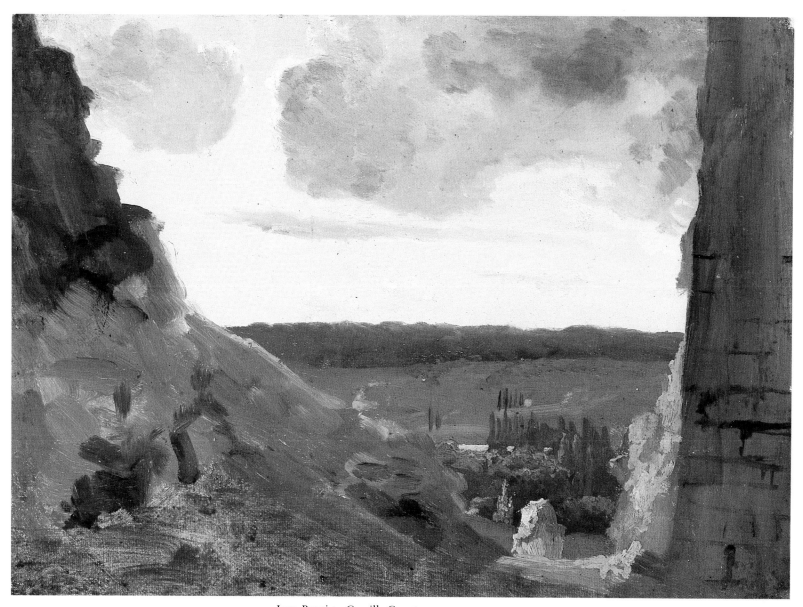

Jean-Baptiste-Camille Corot
Medieval Ruins, c. 1828-30
Oil on canvas, mounted on board
9 × 12 in.
The Armand Hammer Foundation, Los Angeles
No. 8

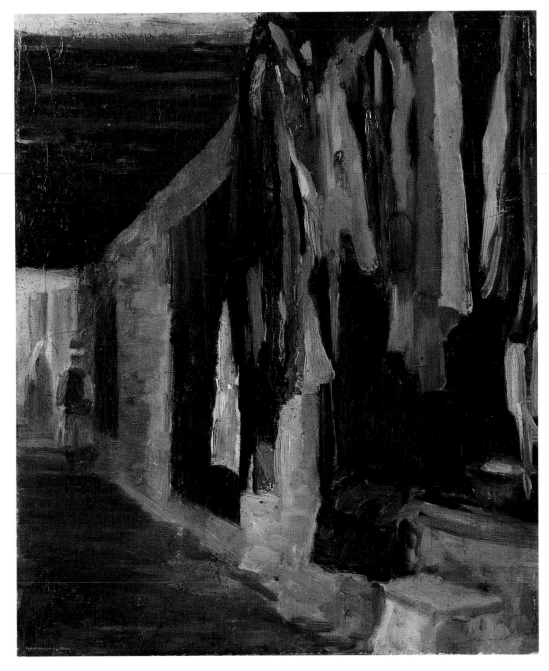

Louis-Gabriel-Eugène Isabey
The Stall of a Cloth-Dyer, Algiers, 1830
Oil on paper
11 5/16 × 9 11/16 in.
Private collection, France
No. 26

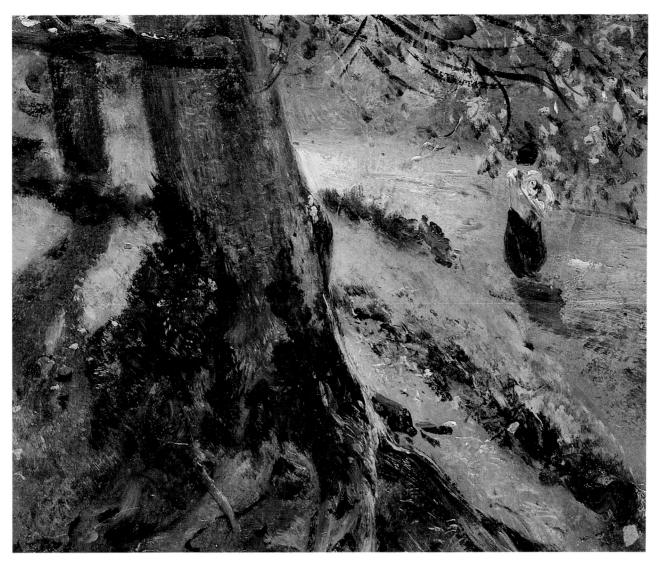

John Constable
Study of Tree Trunks, c. 1821 (?)
Oil on paper
9¾ × 11½ in.
Victoria and Albert Museum, London
No. 5

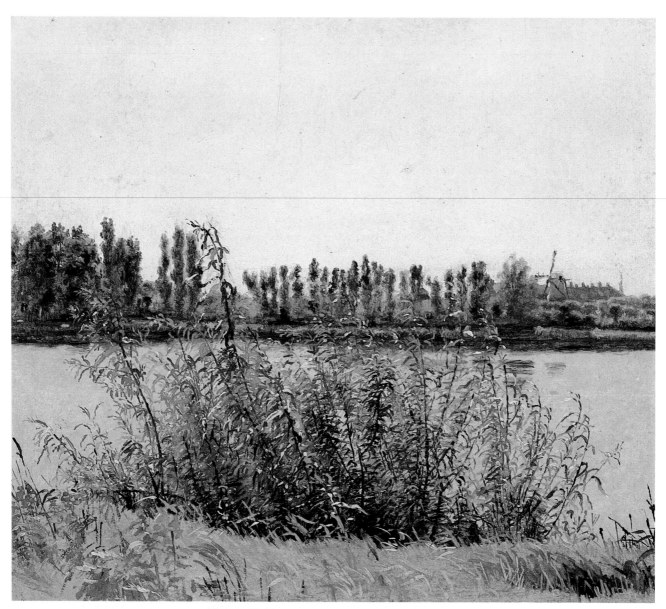

Christen Købke
View at Dosseringen, c. 1837
Oil on paper
10 × 11⅜ in.
The Ordrupgaard Collection, Copenhagen
No. 28

John Constable
Study of the Trunk of an Elm Tree, c. 1821 (?)
Oil on paper
12 × 9¾ in.
Victoria and Albert Museum, London
No. 6

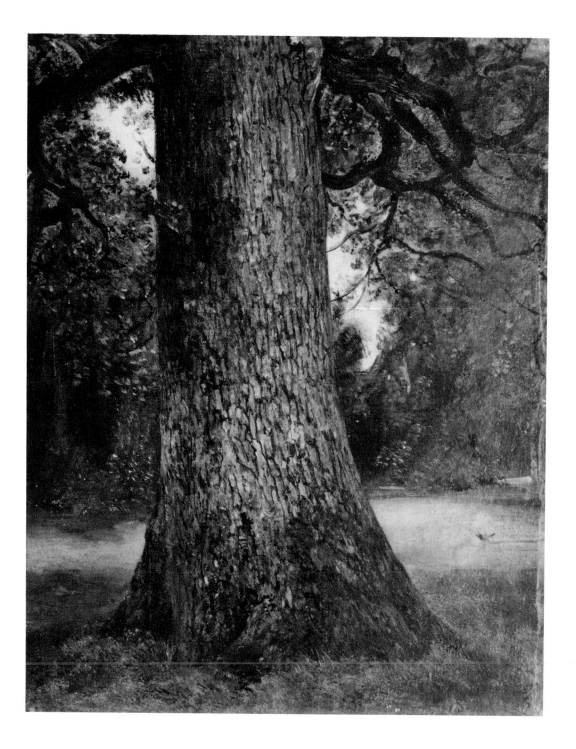

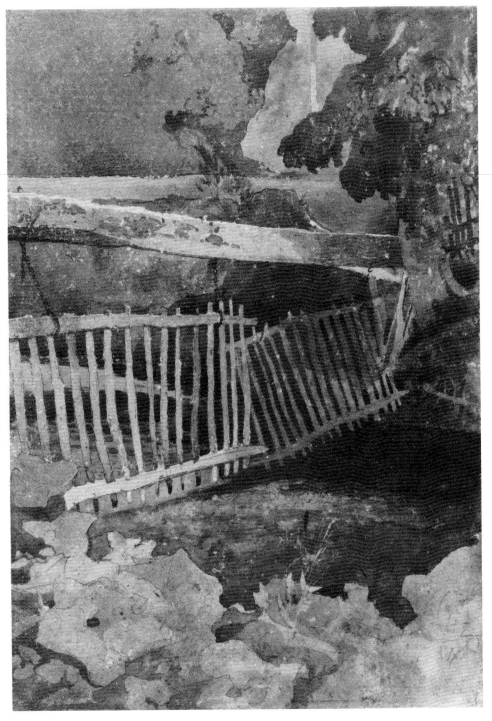

John Sell Cotman
The Drop-Gate, Duncombe Park, 1805
Watercolor and pencil on paper
13 × 9¹/₁₆ in.
Trustees of the British Museum, London
No. 9

42

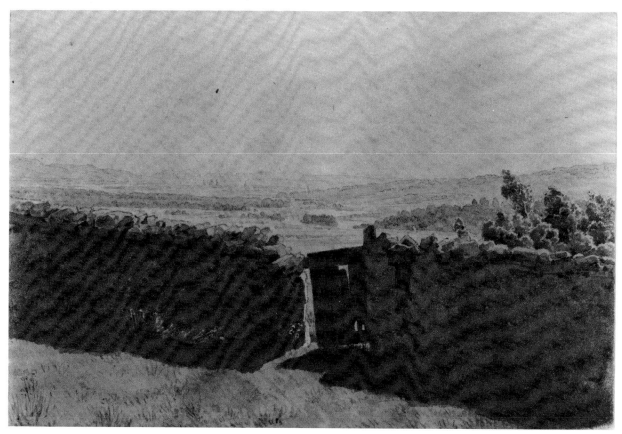

Caspar David Friedrich
Gate in the Garden Wall, c. 1828 (?)
Watercolor and pencil on paper
4¾ × 7¼ in.
Kunsthalle, Hamburg
No. 17

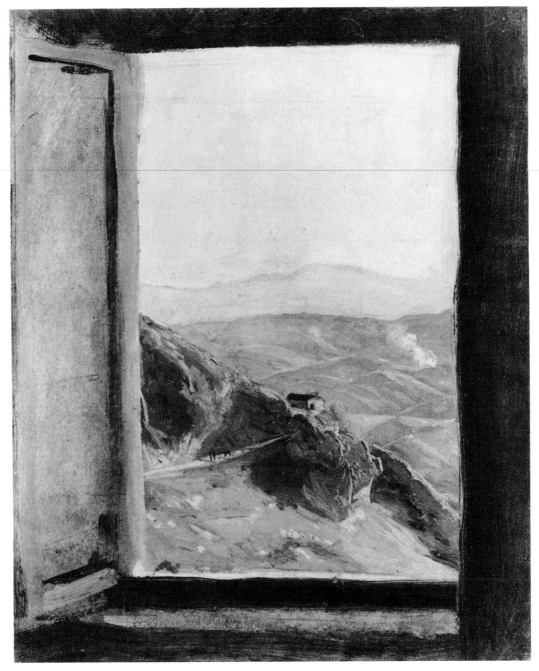

Friedrich Wasmann
View from a Window, c. 1833
Oil on paper
9½ × 7⁹/₁₆ in.
Kunsthalle, Hamburg
No. 40

Christoffer Wilhelm Eckersberg
A Courtyard in Rome, 1813-16
Oil on canvas
13³/₁₆ × 10¹³/₁₆ in.
Kunstmuseum, Ribe, Denmark
No. 15

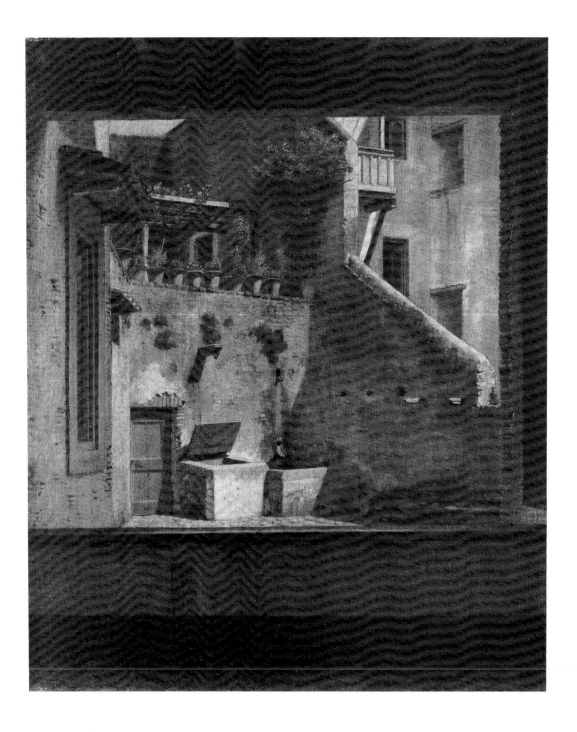

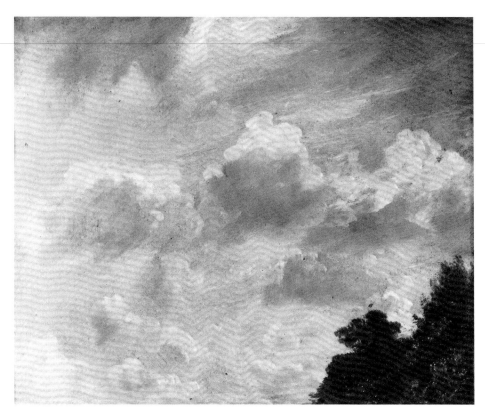

John Constable
Study of Clouds and Trees, 1821
Oil on paper, mounted on board
9½ × 11¾ in.
Royal Academy of Arts, London
No. 4

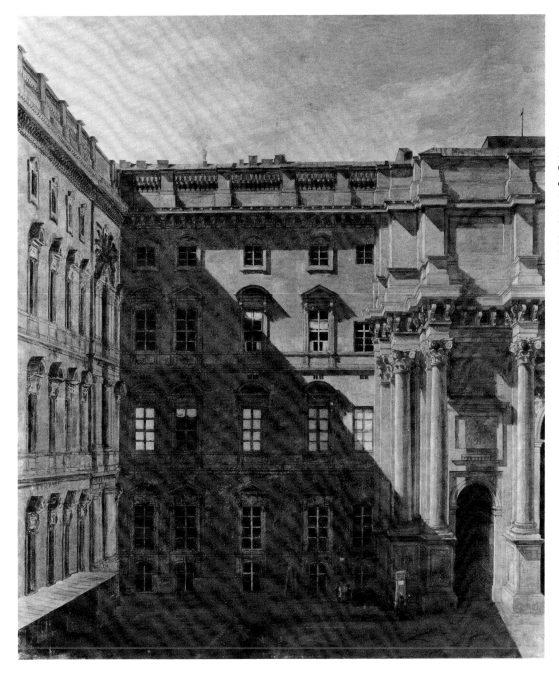

Eduard Gaertner
Corner of the Eosander-Hof, or Outer Courtyard,
of the Royal Palace, Berlin, c. 1831
Oil on canvas
$22^{13}/_{16} \times 18^{11}/_{16}$ in.
Verwaltung der Staatlichen Schlösser und Gärten,
Berlin
No. 18

Jean-Auguste-Dominique Ingres
Tivoli, the Peristyle of the So-called Temple of Vesta, 1806-20
Pencil on paper
11½ × 7 in.
Musée Ingres, Montauban, France
No. 25

Ernst Meyer
The Theater of Marcellus, Rome, 1830s (?)
Oil on paper, mounted on canvas
13 3/8 × 10 1/16 in.
The Hirschsprung Collection, Copenhagen
No. 32

Adolf Henning
Choir of the Cistercian Church, Altenberg, 1833
Oil on paper
14 × 10⅛ in.
Verwaltung der Staatlichen Schlösser und Gärten, Berlin
No. 24

François-Marius Granet
Gothic Interior, 1802-19
Oil on paper, mounted on panel
8⅝ × 11⅝ in.
Musée Granet, Aix-en-Provence, France
No. 20

Thomas Fearnley
Finger Logs at the Water's Edge, 1836 or 1839 (?)
Oil and pencil on paper
$12^9/_{16} \times 7^1/_4$ in.
Nasjonalgalleriet, Oslo
No. 16

Friedrich Nerly
Hillside, Italy, 1828-35
Oil on paper, mounted on board
12 × 17^{11}/$_{16}$ in.
Kunsthalle, Bremen
No. 33

François-Marius Granet
Fragment of Roman Architectural Sculpture,
1802-19
Oil on paper, mounted on board
8¼ × 10¹/₁₆ in.
Musée Granet, Aix-en-Provence, France
No. 22

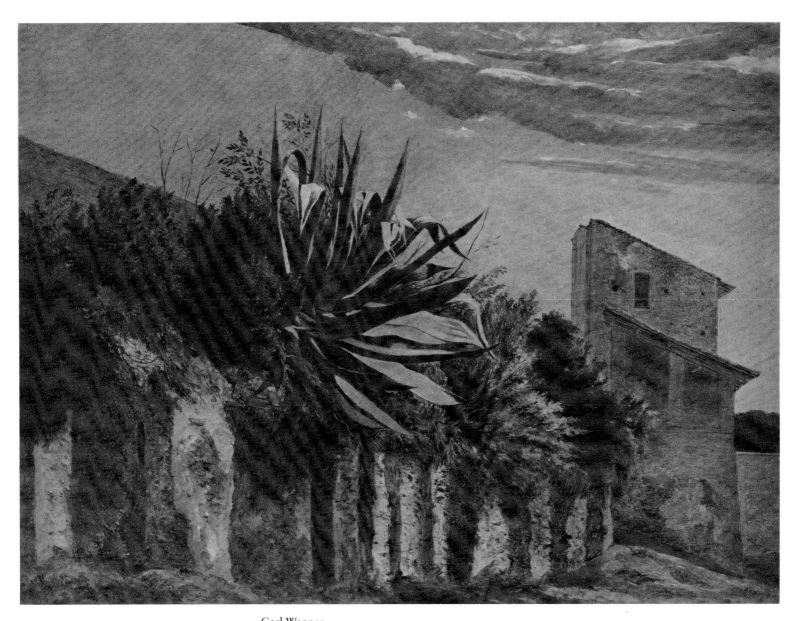

Carl Wagner
At the City Wall of Rome, 1823
Oil on paper, mounted on board
12½ × 17⅛ in.
Kunsthalle, Bremen
No. 37

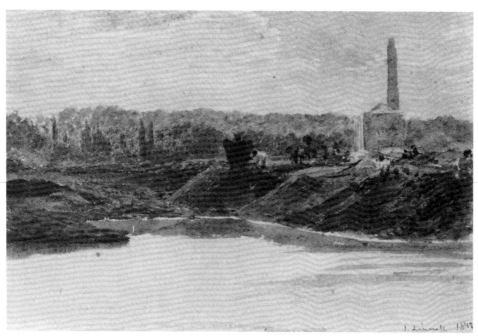

John Linnell
The Brick Kiln, Kensington, 1812
Three works, watercolor and pencil on paper
Each, 4 × 5⅝ in.
Private collection
No. 30 a-c

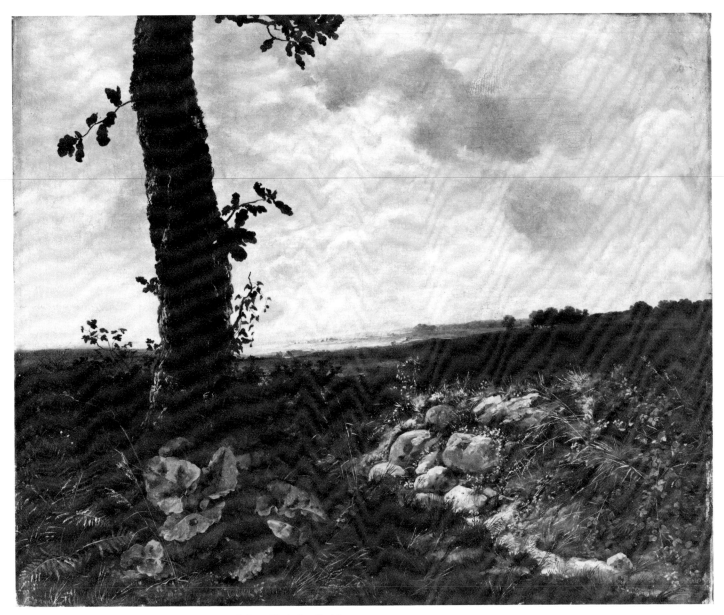

Johan Christian Dahl
View from Praestø, c. 1814
Oil on canvas
22 $^{13}/_{16}$ × 28 $^{3}/_{8}$ in.
Nasjonalgalleriet, Oslo
No. 11

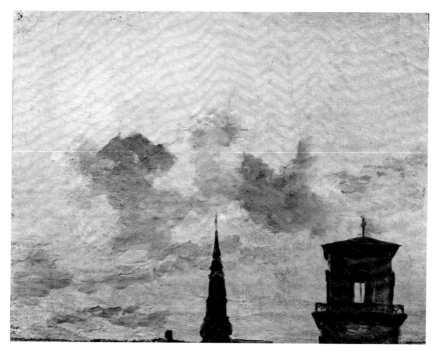

Johan Christian Dahl
Copenhagen Churchtowers against an Evening Sky,
c. 1830
Oil on canvas, mounted on board
4½ × 6 in.
Kunsthalle, Hamburg
No. 13

Léon Cogniet
At Lake Nemi, near Rome, 1817-24
Oil on paper, mounted on panel
8¾ × 6⅞ in.
Musée des Beaux-Arts, Orléans, France
No. 3

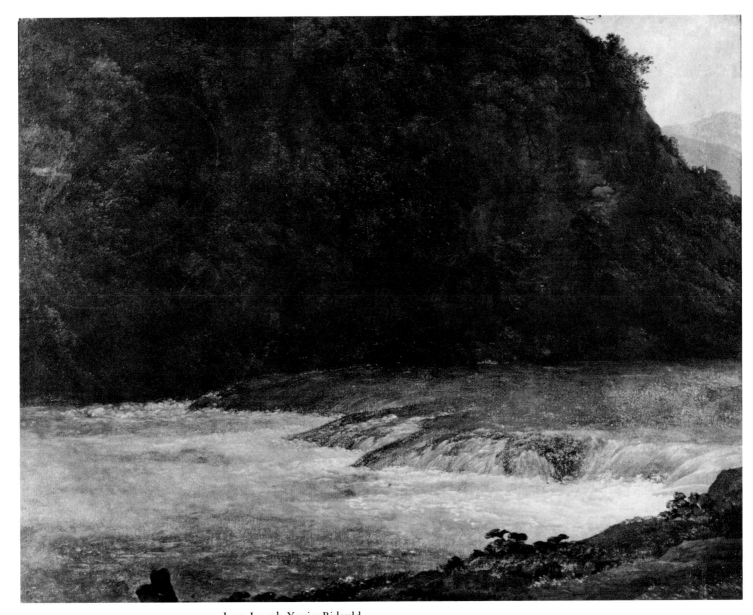

Jean-Joseph-Xavier Bidauld
A Cascade, c. 1790
Oil on canvas
14^{15}/$_{16}$ × 19^{11}/$_{16}$ in.
Musée Duplessis, Carpentras, France
No. 2

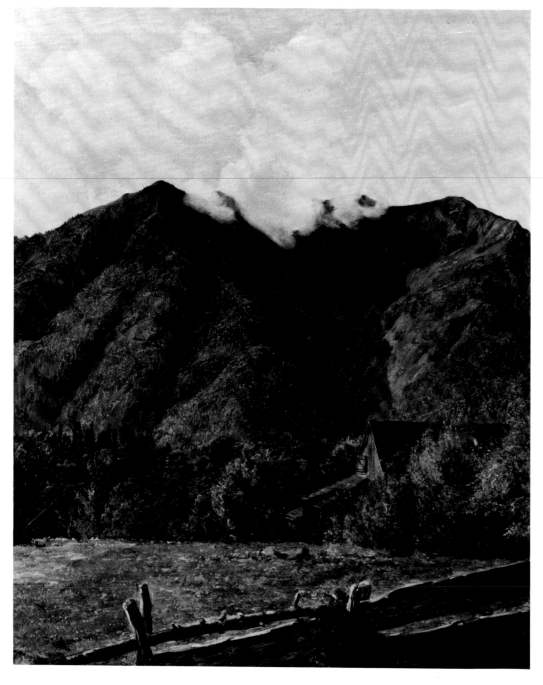

Ferdinand Georg Waldmüller
The Ziemitzberg, near Ischl, 1831
Oil on panel
12⅜ × 10¼ in.
The Federal Republic of Germany, on loan to the
Wallraf-Richartz-Museum, Cologne
No. 38

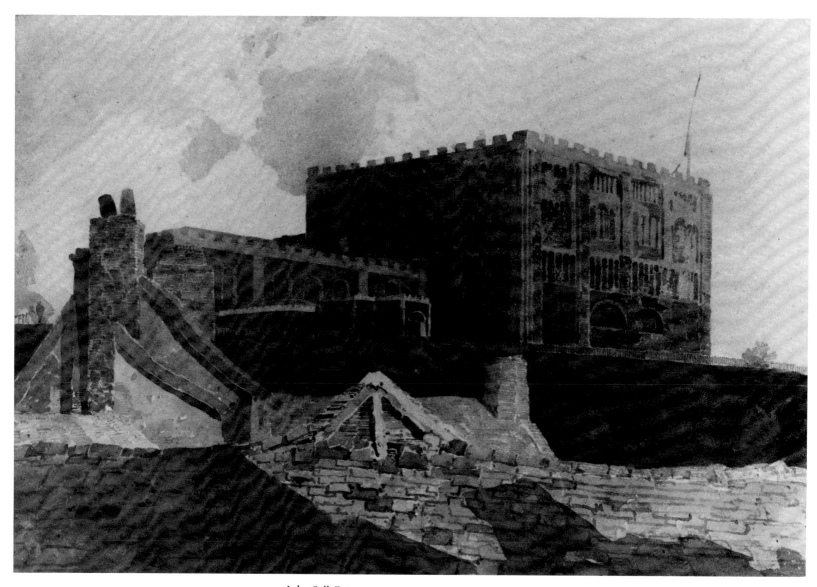

John Sell Cotman
Norwich Castle, c. 1808-09
Watercolor and pencil on paper
12 3/4 × 18 9/16 in.
Norfolk Museums Service (Norwich Castle
Museum), England
No. 10

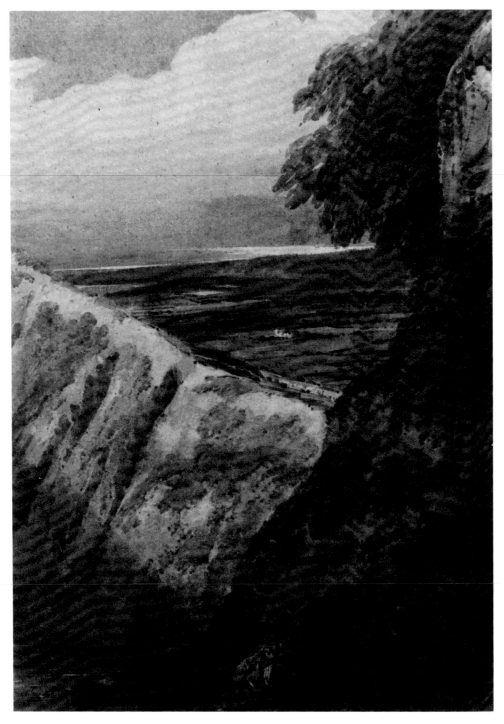

Thomas Girtin
Coast of Dorset, near Lulworth Cove, c. 1797
Watercolor and pencil on paper
14¼ × 10¼ in.
City Art Galleries, Leeds, England
No. 19

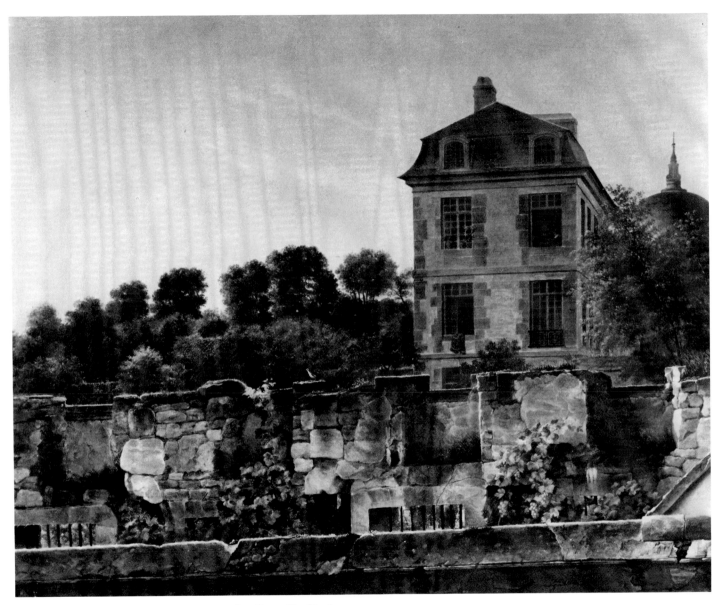

Jan-Frans Van Dael
Landscape: The Painter's House, 1828
Oil on canvas
19^{11}/$_{16}$ × 24 in.
Museum Boymans–van Beuningen, Rotterdam
No. 36

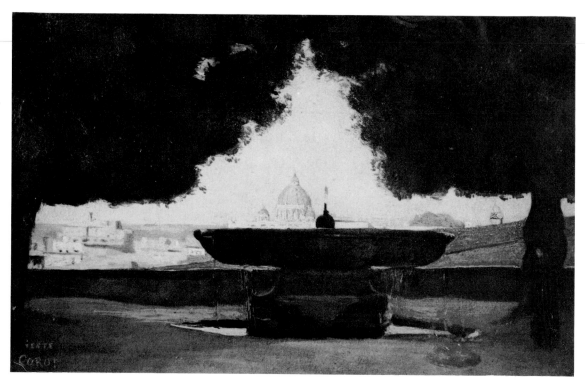

Jean-Baptiste-Camille Corot
Rome, the Fountain of the French Academy,
1826-27
Oil on canvas
7 × 11½ in.
The Hugh Lane Municipal Gallery of Modern Art,
Dublin
No. 7

Pierre-Henri de Valenciennes
Porta del Popolo, Rome, c. 1782-84
Oil on paper, mounted on board
$6^1/_{16} \times 16^5/_{16}$ in.
Musée du Louvre, Paris
No. 34

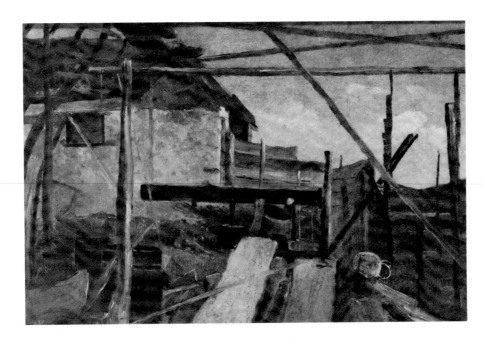

Francis Danby
Boatbuilder's Yard, 1838 (?)
Oil on paper
4¾ × 7¼ in.
Collection Mr. and Mrs. J. A. Gere, London
No. 14

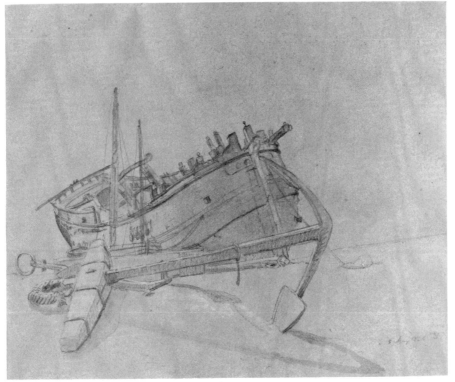

Johan Christian Dahl
Shipwreck and Anchor, 1826
Pencil and wash on paper
9 × 10⁷/₁₆ in.
Nasjonalgalleriet, Oslo
No. 12

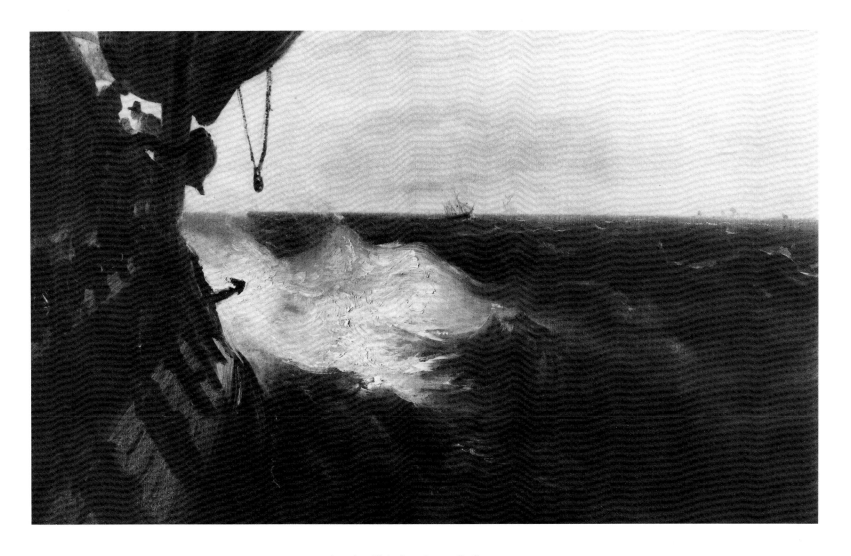

Jean-Antoine-Théodore Baron Gudin
Sailing Ship on the Sea, 1837-39
Oil on paper, mounted on panel
15 1/8 × 25 1/2 in.
Kunsthalle, Bremen
No. 23

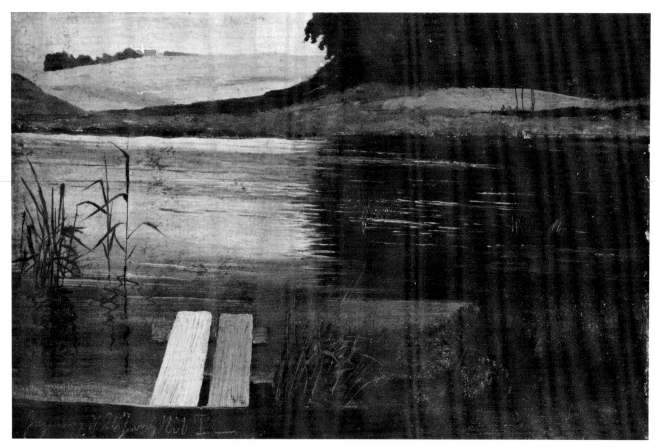

Johan Thomas Lundbye
Study at a Lake, 1838
Oil on paper
5½ × 8⁷/₁₆ in.
The Hirschsprung Collection, Copenhagen
No. 31

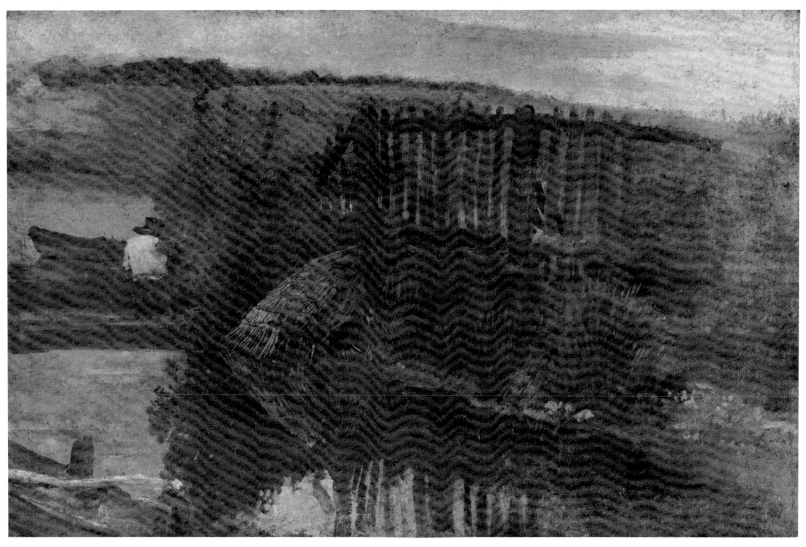

John Linnell
At Twickenham, 1806
Oil on board
6½ × 10 in.
Trustees of the Tate Gallery, London
No. 29

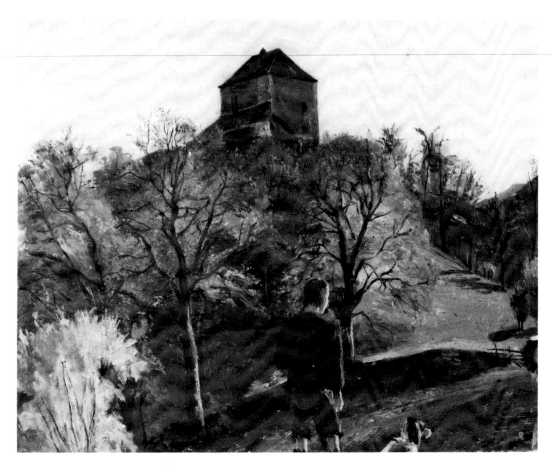

Friedrich Wasmann
Castle in the Tyrol, c. 1831
Oil on paper
8½ × 10¼ in.
Kunsthalle, Hamburg
No. 39

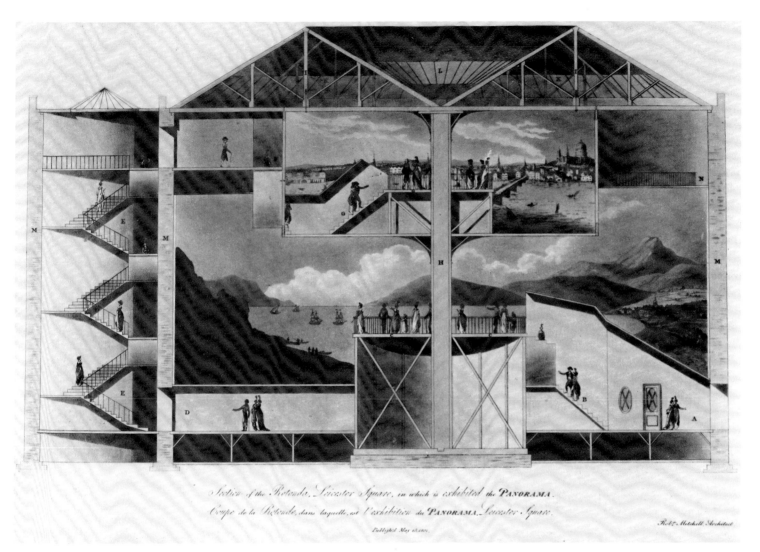

Figure 24. *Section of the Rotunda, Leicester Square, in Which Is Exhibited the Panorama*, 1801. Colored aquatint, 12½ × 18 in. From Robert Mitchell, *Plans and Views in Perspective of Buildings Erected in England and Scotland* (1801). Greater London Council, Print Collection

Robert Barker first exhibited his *Panorama of London* (no. 1) in 1792 at 28 Castle Street, London. The public response was so enthusiastic that in 1793 Barker moved the panorama to a new building in Leicester Square, where he could display two panoramas, one above the other. This section of the building, in which *London* is exhibited on the upper level, shows how the spectators entered the central viewing platform from below so that the circular picture would not be interrupted by a doorway.

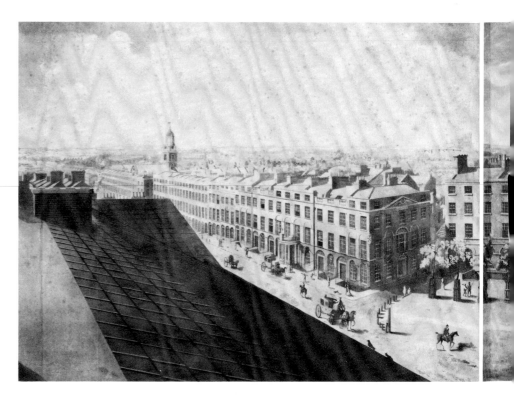

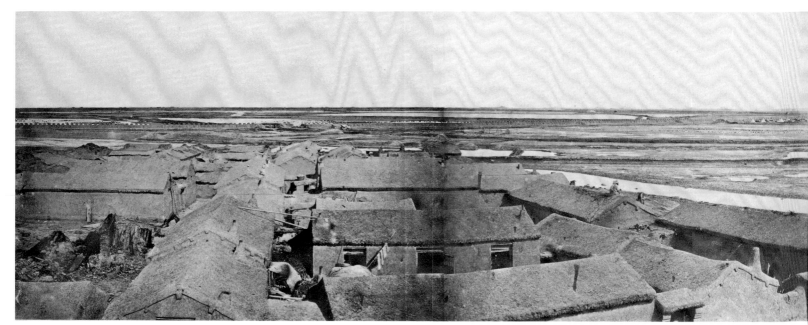

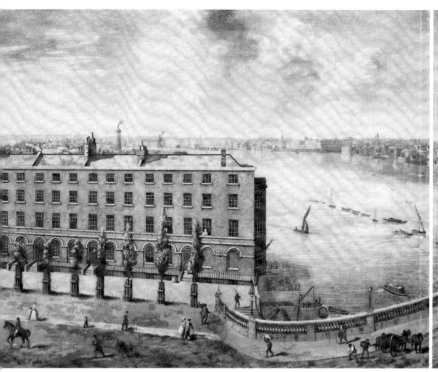

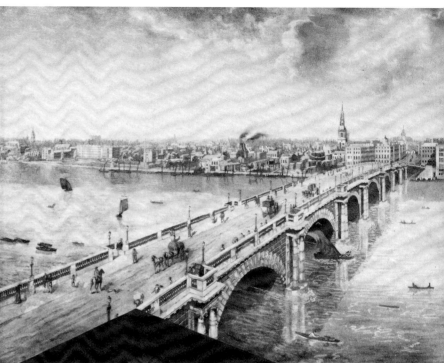

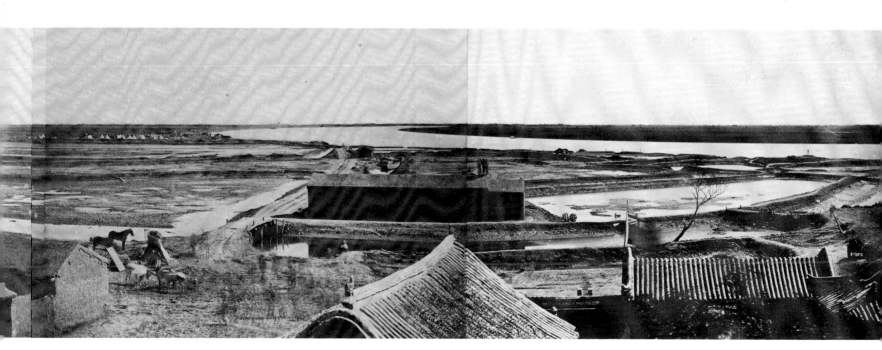

PANORAMAS

PHOTOGRAPHS

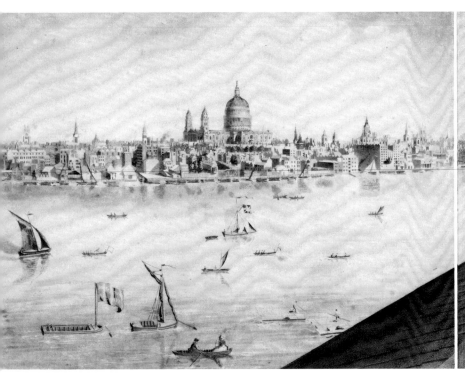
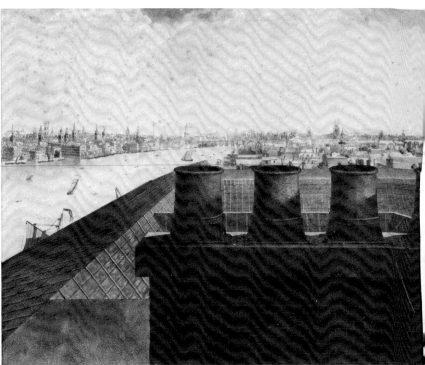
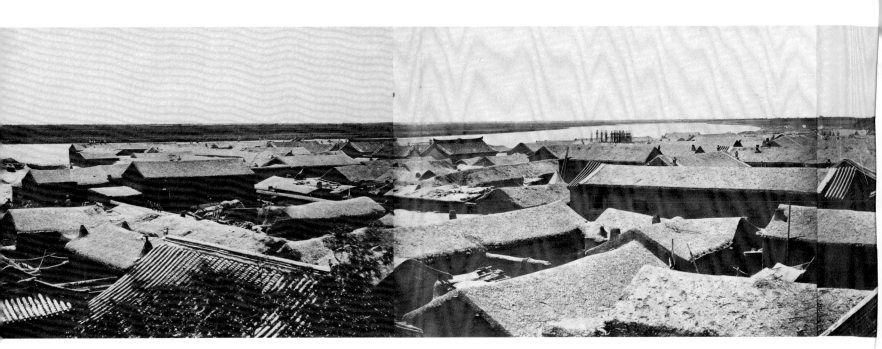

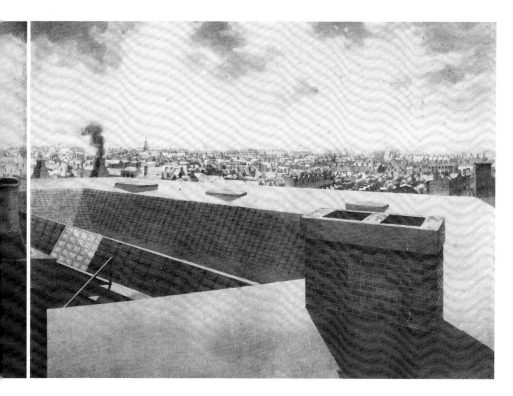

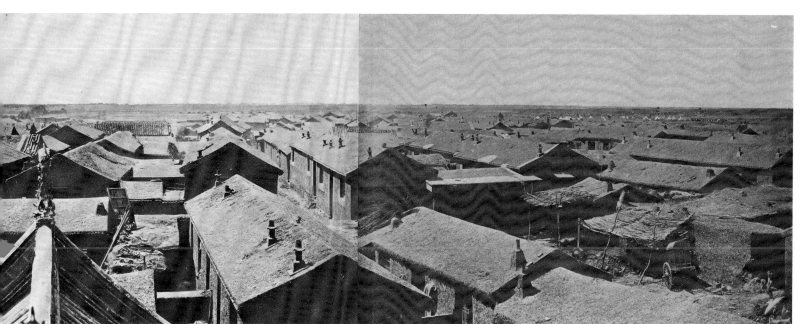

Robert Barker
A Panorama of London, 1791-92
Aquatint by Frederick Birnie after preparatory
drawings for Barker's painting
Six sheets, overall 17 × 132 in.
Trustees of the British Museum, London
No. 1

Felice Beato
Panorama at Tangku, 1860
Albumen-silver prints from glass negatives
Eight sheets, overall 8⅝ × 88⅞ in.
The Museum of Modern Art, New York
Purchased as the Gift of Shirley C. Burden and the
Estate of Vera Louise Fraser
No. 49

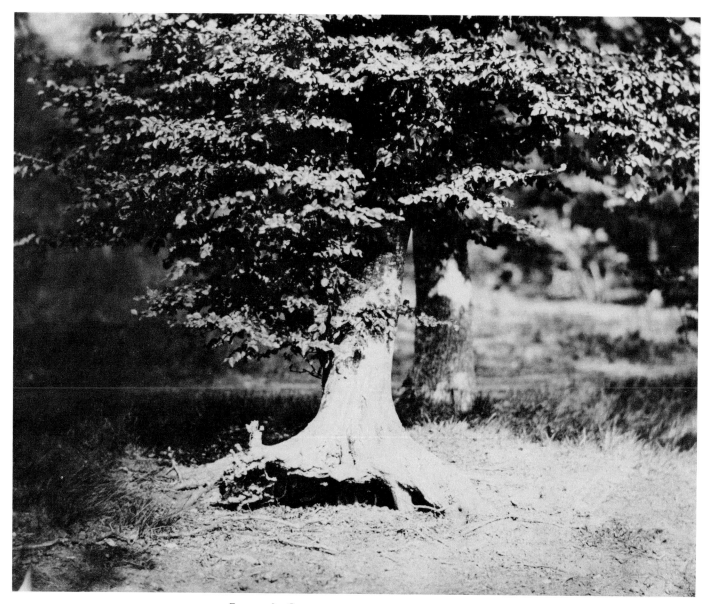

Gustave Le Gray
Beech Tree, c. 1855-57
Albumen-silver print from a glass negative
12⁹/₁₆ × 15⁹/₁₆ in.
Private collection
No. 61

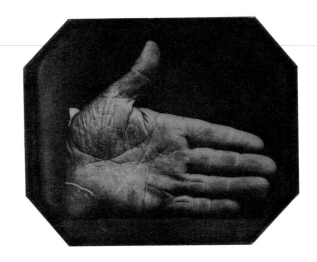

Albert Sands Southworth and
Josiah Johnson Hawes
Captain Jonathan W. Walker's Branded Hand,
c. 1845
Daguerreotype
2¼ × 2⅝ in.
Massachusetts Historical Society, Boston
No. 73

Roger Fenton
Dead Stag, 1852
Albumen-coated salt print from a paper negative
6⅞ × 8½ in.
Daniel Wolf, Inc., New York
No. 55

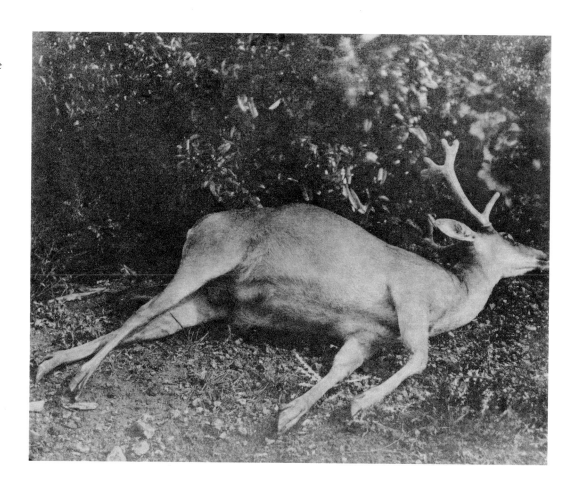

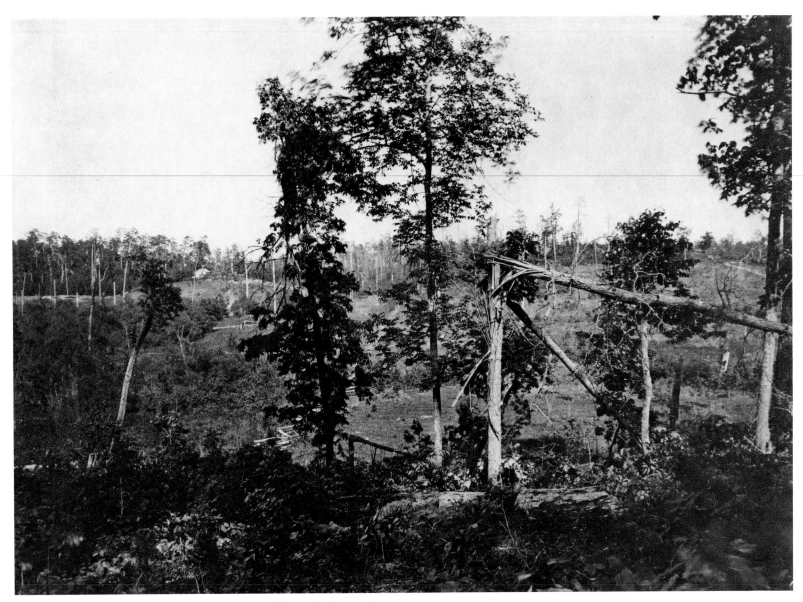

George N. Barnard
The Battleground of Resaca, 1864-65
Albumen-silver print from a glass negative
10¼ × 14³⁄₁₆ in.
The Museum of Modern Art, New York
Acquired by Exchange with the
Library of Congress
No. 48

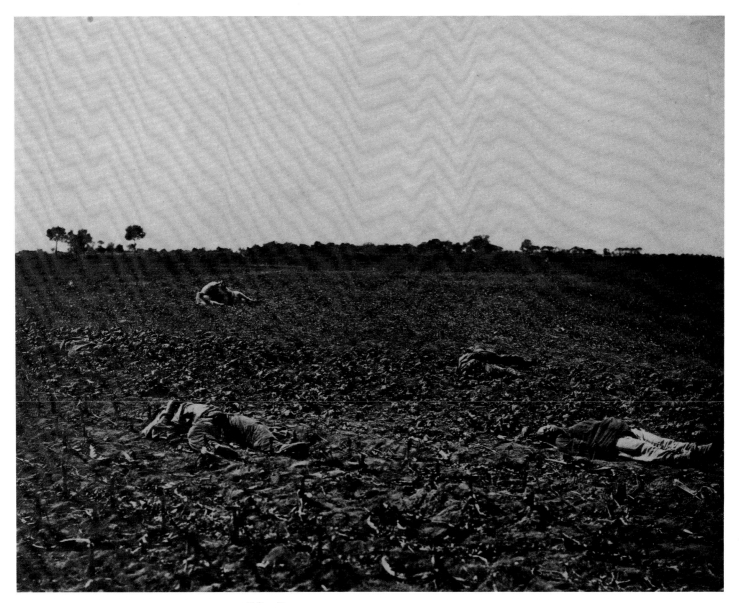

Felice Beato
Charge of the Dragoon's Guard at Palichian, 1860
Albumen-silver print from a glass negative
9¹⁄₁₆ × 11⅞ in.
The Museum of Modern Art, New York
Purchased as the Gift of Shirley C. Burden and the
Estate of Vera Louise Fraser
No. 50

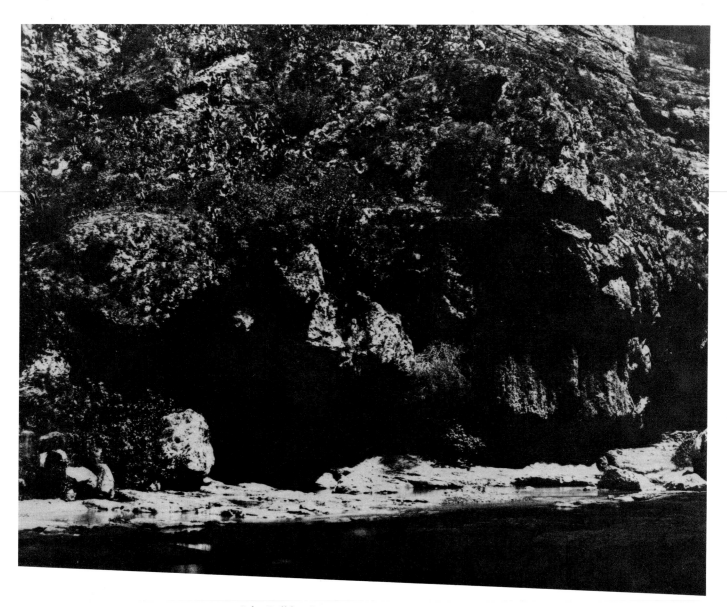

John Bulkley Greene
River Bank, North Africa, 1855-56
Salt print from a paper negative
9¼ × 11¾ in.
Lunn Gallery, Washington, D.C.
No. 57

Photographer unknown
Study of the Sky, c. 1865
Albumen-silver print from a glass negative
8⅛ × 6¾ in.
Collection André and Marie-Thérèse Jammes, Paris
No. 46

William Henry Fox Talbot
The Open Door, 1843
Salt print from a paper negative
5⁷/₁₆ × 7³/₈ in.
Arnold H. Crane Collection, Chicago
No. 76

Photographer unknown
The Silver Hook, 1860s (?)
Albumen-silver print from a glass negative
$2^{15}/_{16} \times 2^{15}/_{16}$ in.
The Museum of Modern Art, New York
Purchased as the Gift of
Mrs. John D. Rockefeller 3rd
No. 44

Timothy H. O'Sullivan
Steam Rising from a Fissure near Virginia City,
Nevada, 1867-69
Albumen-silver print from a glass negative
$7^{15}/_{16} \times 10^{13}/_{16}$ in.
Gilman Paper Company Collection
No. 68

Albert Sands Southworth and
Josiah Johnson Hawes
Marion Augusta Hawes or *Alice Mary Hawes*
c. 1855-60
Daguerreotype
4 × 3 in.
International Museum of Photography at
George Eastman House, Rochester
No. 74

Humphrey Lloyd Hime
The Prairie on the Bank of the Red River,
Looking South, 1858
Albumen-silver print from a glass negative
5¼ × 6¾ in.
The Notman Photographic Archives,
McCord Museum, Montreal
No. 59

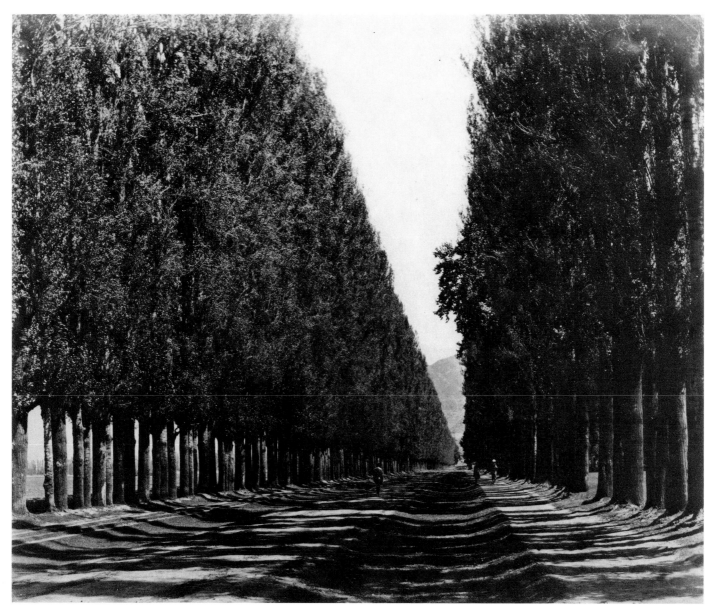

Samuel Bourne
A Road Lined with Poplars, Kashmir, 1863-70
Albumen-silver print from a glass negative
8¹⁵/₁₆ × 11 in.
Collection Paul F. Walter, New York
No. 52

Linnaeus Tripe
Ava, Upper Burma, 1855-56
Salt print from a paper negative
10⅝ × 13½ in.
Collection Phyllis Lambert, on loan to the
Canadian Centre for Architecture, Montreal
No. 77

Louis-Auguste Bisson and Auguste-Rosalie Bisson
Cathedral of Notre Dame, Paris, the Saint Marcel Portal, Called the Sainte Anne Portal, c. 1853
Albumen-silver print from a glass negative
$14^5/_{16} \times 9^9/_{16}$ in.
Collection Phyllis Lambert, on loan to the
Canadian Centre for Architecture, Montreal
No. 51

Pierre-Charles Simart (?)
Shrub, c. 1856
Salt print enlarged from a glass negative
$12^5/_8 \times 17^1/_{16}$ in.
Collection André and Marie-Thérèse Jammes, Paris
No. 72

Jean-Charles Langlois
Detail of the Fortification at Malakhov, 1855
Albumen-silver print from a paper negative
$10^7/_{16} \times 12^9/_{16}$ in.
Collection Texbraun, Paris
No. 60

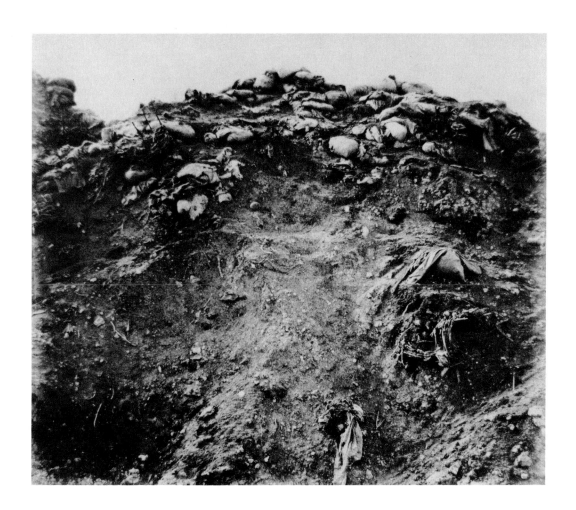

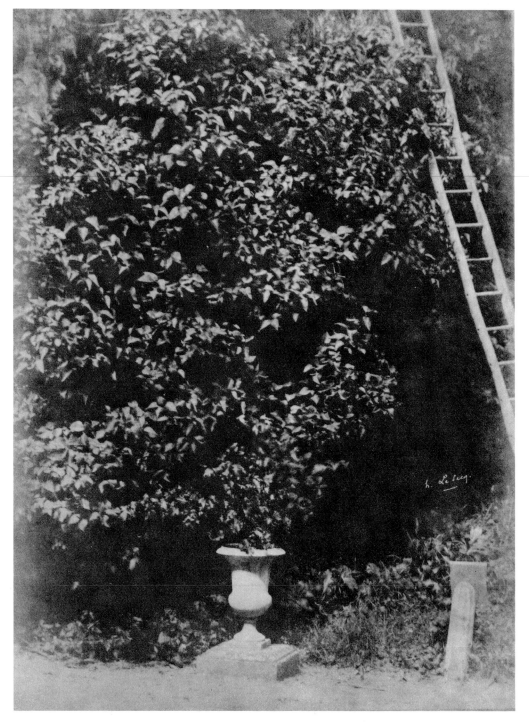

Henri Le Secq
Garden Scene, c. 1852
Salt print from a paper negative
12¹³/₁₆ × 9¹¹/₁₆ in.
International Museum of Photography at
George Eastman House, Rochester
No. 63

Henri Le Secq
Chartres Cathedral, South Transept Porch,
Central Portal, 1851-52
Photolithograph
13 1/8 × 9 5/16 in.
Collection Phyllis Lambert, on loan to the
Canadian Centre for Architecture, Montreal
No. 62

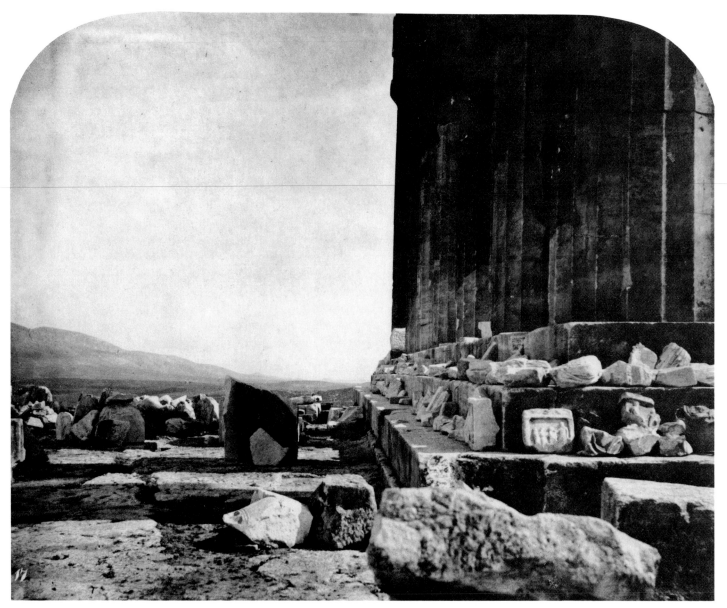

William James Stillman
*The Parthenon, Athens, Profile of the Eastern
Facade*, 1868-69
Carbon print from a glass negative
7⅜ × 9⅜ in.
The Museum of Modern Art, New York
Gift of Miss Frances Stillman
No. 75

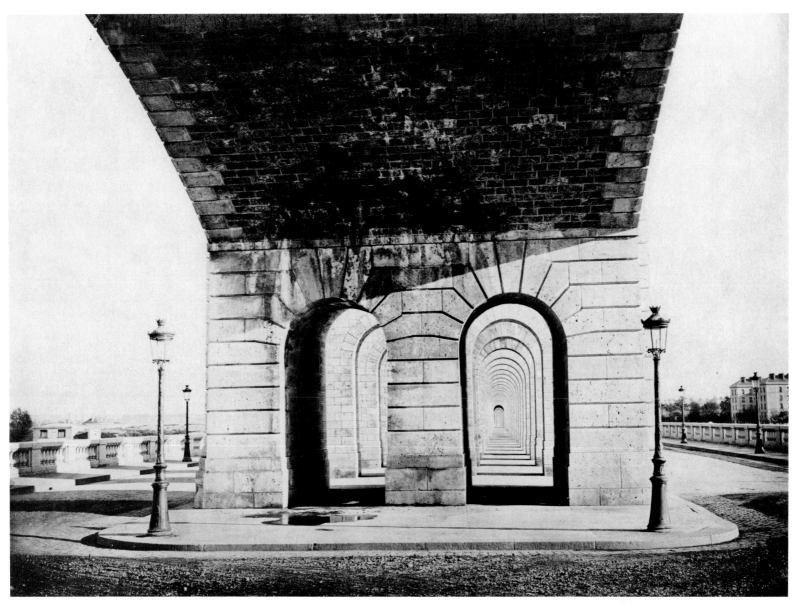

A. Collard
Bridge, 1860s (?)
Albumen-silver print from a glass negative
$9^{15}/_{16} \times 13^{7}/_{8}$ in.
Collection Samuel J. Wagstaff, Jr., New York
No. 53

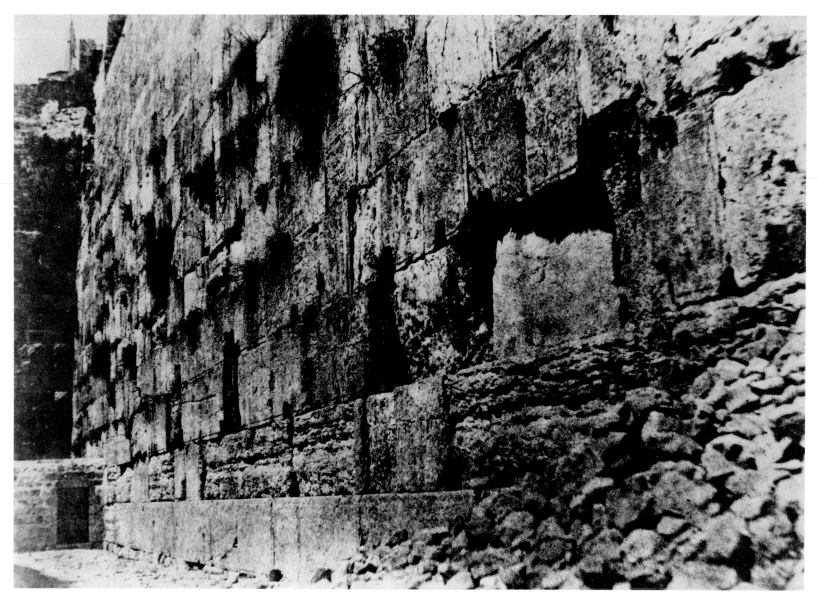

Auguste Salzmann
Jerusalem, the Temple Wall, West Side, 1853-54
Salt print from a paper negative
9³/₁₆ × 13 ⅛ in.
The Museum of Modern Art, New York
Purchase
No. 71

Robert MacPherson
*The Theater of Marcellus, from the Piazza
Montanara, Rome*, c. 1855
Albumen-silver print from a glass negative
$16^{1}/_{16} \times 11^{1}/_{4}$ in.
Collection Samuel J. Wagstaff, Jr., New York
No. 64

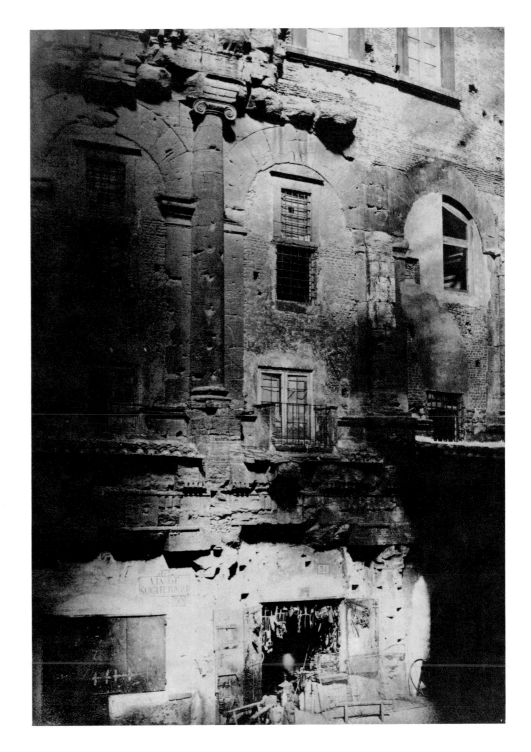

Charles Marville
*Spire of the Chapel of the Collège Saint Dizier
(Haute Marne)*, 1860s (?)
Albumen-silver print from a glass negative
14¼ × 9⅞ in.
Gilman Paper Company Collection
No. 65

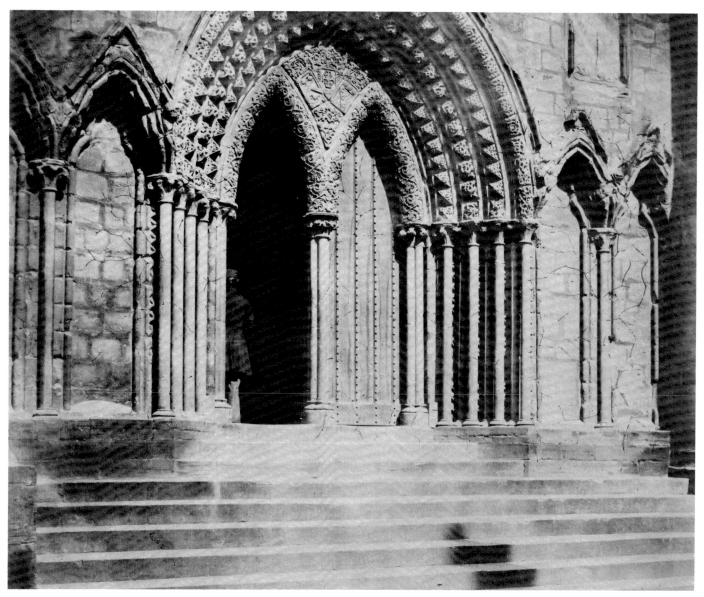

Roger Fenton
Lichfield Cathedral, Porch of the South Transept,
c. 1855
Albumen-silver print from a glass negative
13 7/16 × 16 1/4 in.
The Museum of Modern Art, New York
John Parkinson III Fund
No. 56

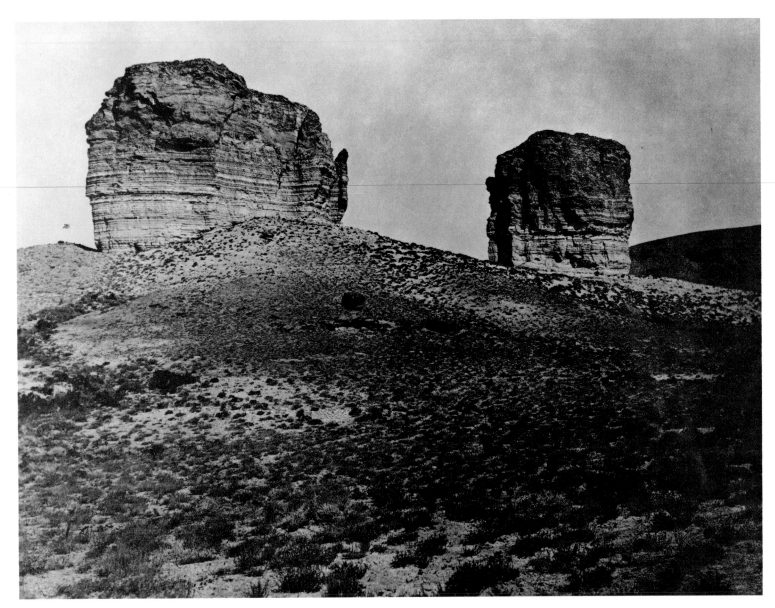

Timothy H. O'Sullivan
Buttes near Green River City, Wyoming, 1867-69
Albumen-silver print from a glass negative
7⅞ × 10½ in.
The Library of Congress, Washington, D.C.
No. 69a

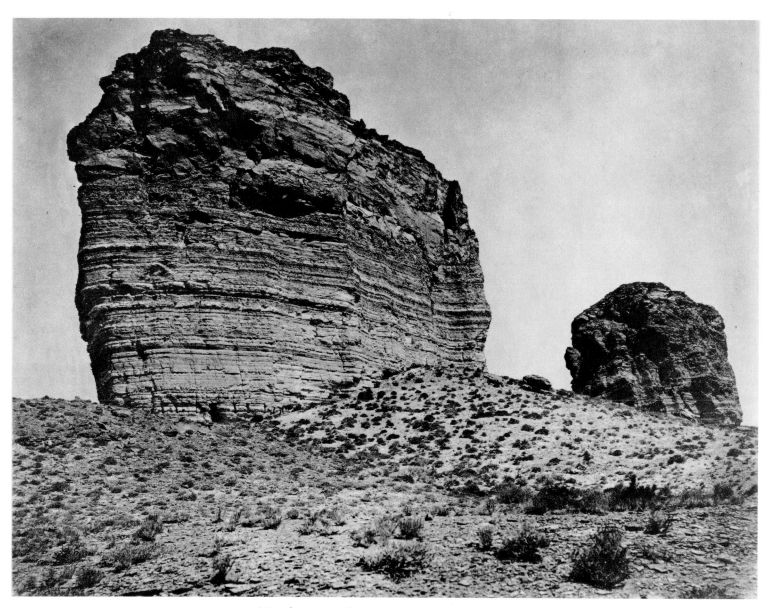

Timothy H. O'Sullivan
Buttes near Green River City, Wyoming, 1867-69
Albumen-silver print from a glass negative
7⅞ × 10½ in.
The Library of Congress, Washington, D.C.
No. 69b

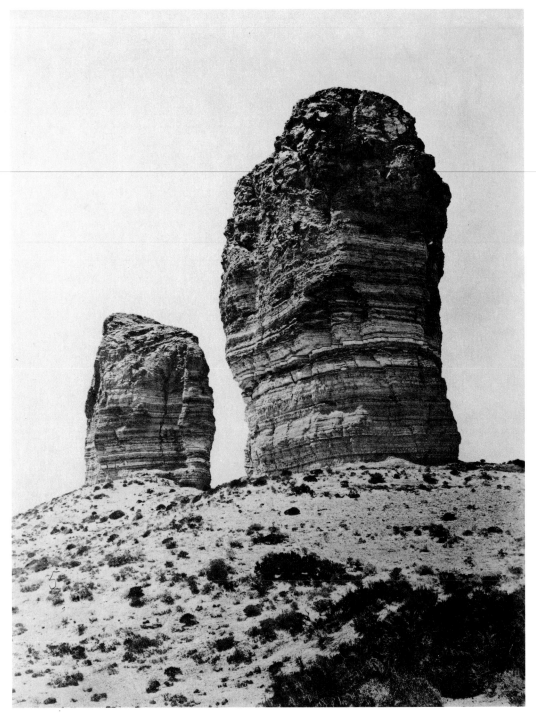

Timothy H. O'Sullivan
Buttes near Green River City, Wyoming, 1867-69
Albumen-silver print from a glass negative
10½ × 7⅞ in.
The Library of Congress, Washington, D.C.
No. 69c

Maxime Du Camp
Profile of the Great Sphinx, from the South,
1849-51
Salt print from a paper negative
6¼ × 8⁹/₁₆ in.
Gilman Paper Company Collection
No. 54

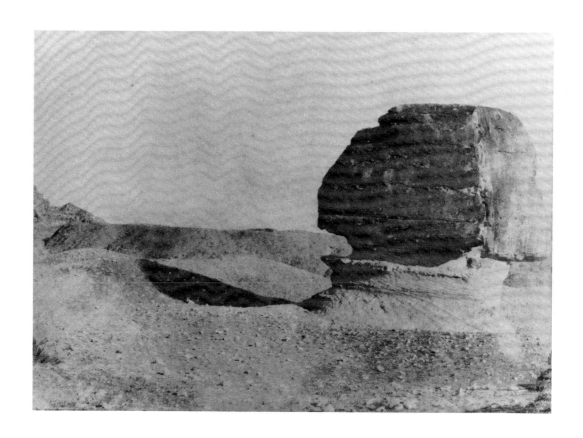

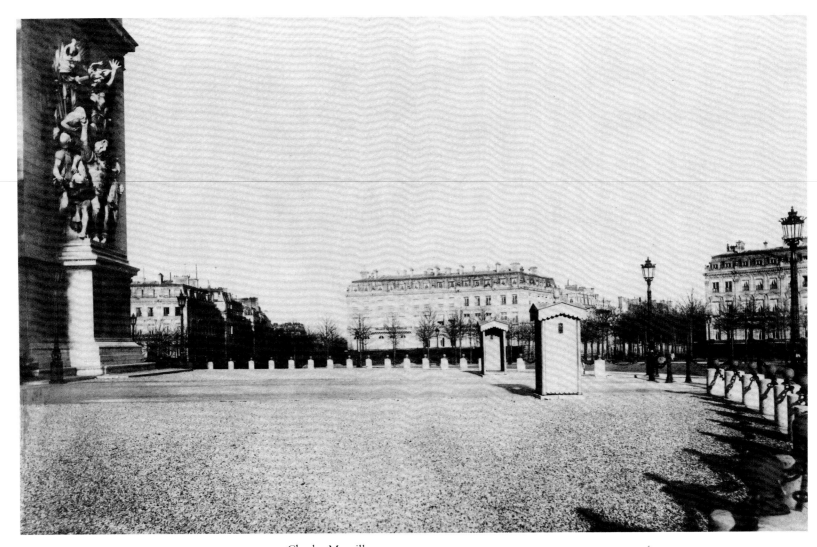

Charles Marville
Place de l'Etoile, Paris, 1860s (?)
Albumen-silver print from a glass negative
$8^9/_{16} \times 14^7/_{16}$ in.
Collection Samuel J. Wagstaff, Jr., New York
No. 66

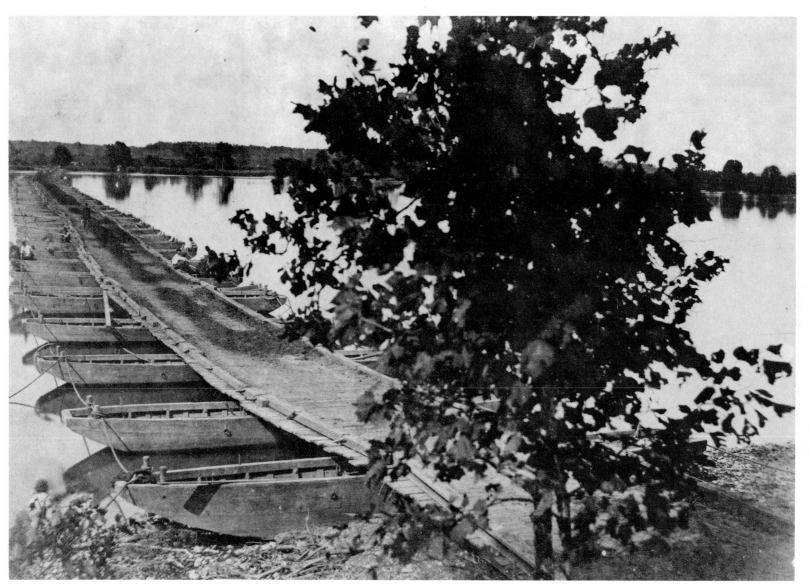

Andrew Joseph Russell
Pontoon Bridge Crossed by General Ord,
at Akin's Landing, 1864
Albumen-silver print from a glass negative
8 × 11 $^{13}/_{16}$ in.
Collection Samuel J. Wagstaff, Jr., New York
No. 70

Photographer unknown
New York (?), 1850s (?)
Salt print from a paper negative
9⅜ × 6⅞ in.
Collection Paul F. Walter, New York
No. 42

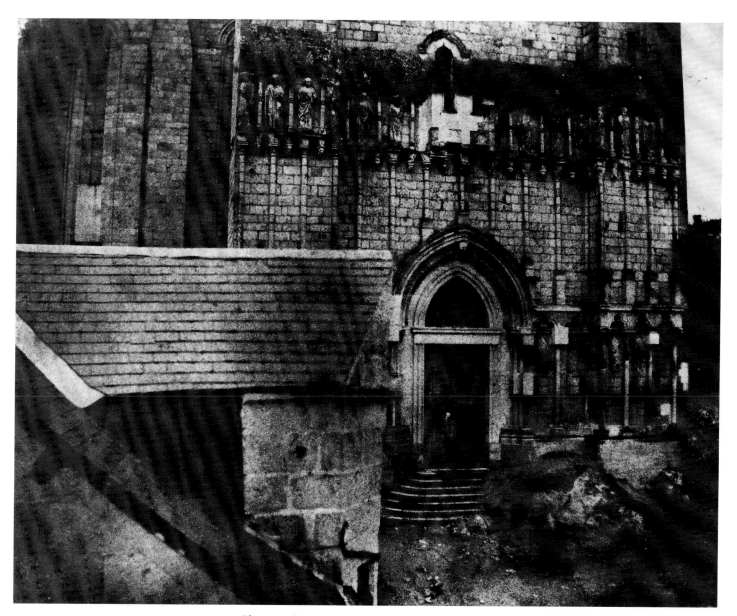

Photographer unknown
Church of Saint Martin, Candes, 1851-55
Salt print from a paper negative
$8^{1}/_{16} \times 10^{1}/_{16}$ in.
International Museum of Photography at
George Eastman House, Rochester
No. 43

Photographer unknown
*Triumphal Entry of the Bavarian Army into
Munich*, 1871
Albumen-silver print from a glass negative
8½ × 7³/₁₆ in.
Lunn Gallery, Washington, D.C.
No. 47

Alfred A. Hart
Rounding Cape Horn, c. 1869
Stereograph, albumen-silver prints from
glass negatives
Two prints, overall 3 × 6⅛ in.
The Museum of Modern Art, New York
Purchase
No. 58

Photographer unknown
Through the Window, 1860s (?)
Albumen-silver print from a glass negative
2⅝ × 2¹³/₁₆ in.
The Museum of Modern Art, New York
Purchased as the Gift of
Mrs. John D. Rockefeller 3rd
No. 45

Charles Nègre
Miller at Work, Grasse, 1852-53
Salt print from a paper negative
$8^{1}/_{16} \times 6^{5}/_{16}$ in.
Collection André and Marie-Thérèse Jammes, Paris
No. 67

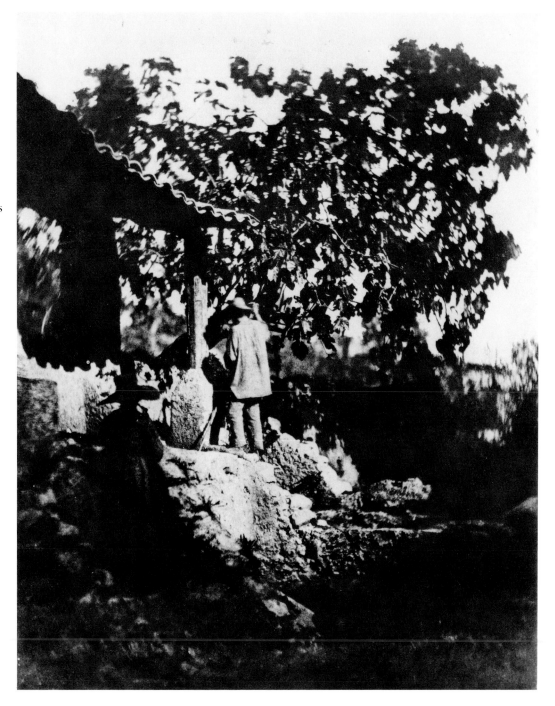

CATALOGUE

In the dimensions, height precedes width. The citations of relevant literature are intended to be helpful rather than comprehensive. The sources noted often contain much more extensive references. The following works are cited in abbreviation:

Bramsen et al. 1972
Henrik Bramsen et al., *Dansk Kunst Historie,* vol. 3. *Akademiet og Guldalderen 1750-1850* (Copenhagen: Politiken, 1972).

Bremen 1973
Gerhard Gerkens and Ursula Heiderich, eds., *Katalog der Gemälde des 19. und 20. Jahrhunderts in der Kunsthalle Bremen* (Bremen: Kunsthalle, 1973).

Bremen 1977-78
Bremen: Kunsthalle, *Zurück zur Natur: Die Künstlerkolonie von Barbizon, Ihre Vorgeschichte und ihre Auswirkung* (exh. cat., 1977-78).

Detroit 1968
Detroit Institute of Arts, *Romantic Art in Britain: Paintings and Drawings 1760-1860* (exh. cat., 1968).

Hamburg 1976
Hamburg: Kunsthalle, *William Turner und die Landschaft seiner Zeit* (exh. cat., 1976).

Jammes, *Egypte*
Marie-Thérèse and André Jammes, *En Egypte au temps de Flaubert: Les Premiers Photographes 1839-1860* (exh. cat., Paris: Kodak-Pathé, 1977).

London 1980-81
London: The Arts Council of Great Britain, *Painting from Nature: The Tradition of Open-Air Oil Sketching from the 17th to 19th Centuries* (exh. cat., 1980-81).

New York 1975
New York: The Metropolitan Museum of Art, *French Painting 1774–1830: The Age of Revolution* (exh. cat., 1975).

New York 1980
New York: The Metropolitan Museum of Art, *After Daguerre: Masterworks of French Photography (1848–1900) from the Bibliothèque Nationale* (exh. cat., 1980).

New York and Buffalo 1975
New York: The Metropolitan Museum of Art, and Buffalo: Albright-Knox Art Gallery, *Era of Exploration: The Rise of Landscape Photography in the American West, 1860-65* (exh. cat., 1975).

Paris 1976-77
Paris: Orangerie des Tuileries, *La Peinture allemande à l'époque du Romantisme* (exh. cat., 1976-77).

Paris 1976
Paris: Bibliothèque Nationale, *Une Invention du XIXe siècle: La Photographie. Collections de la Société Française de Photographie* (exh. cat., 1976).

Philadelphia 1978
Philadelphia Museum of Art, *The Second Empire: Art in France under Napoleon III* (exh. cat., 1978).

Thieme-Becker
U. Thieme and F. Becker, eds., *Allgemeines Lexikon der bildenden Künstler,* 36 vols. (Leipzig: Seeman, 1907-47).

Robert Barker
British, 1739-1806

1. *A Panorama of London,* 1791-92
Aquatint by Frederick Birnie after preparatory drawings for Barker's painting
Six sheets, overall 17 × 132 in. (43 × 334 cm)
Trustees of the British Museum, London
Illustrated pp. 75-78

This work is an aquatint representing a much larger painting by Barker, first exhibited in 1792. The original, nearly 1500 square feet in area, was exhibited in a complete circle and viewed from within (see fig. 24, p. 74). It was the first full-circle panorama, a type of picture that enjoyed considerable popularity in the early nineteenth century.

The panoramas were popular spectacles, noticed but generally scorned by the serious art world. Their ostensible aim was a comprehensive illusion of the depicted scene — most frequently a city or a battle or a great public event. This illusion was achieved, to a striking degree, by surrounding the viewer with the picture, whose upper and lower edges were concealed by elements of the platform on which the viewer stood. The popularity of the panoramas is often cited as a symptom of the thirst for realism that is thought to have prompted the invention of photography. However, the particular character of this realism rarely has been carefully considered.

Barker's panorama marks a new stage in the tradition of broad city views. Such views, of which Jacopo de' Barbari's woodcut of Venice in 1500 is exemplary, compromised between the principles of perspective and of map-making. By adopting a high, humanly impossible, bird's-eye vantage point, the artists conveyed a maximum of reliable topographical information in the form of a single view. The standard comprehensive view of London,

Figure 25. Claes Jansz Visscher, the Younger. *View of London*, 1616. Engraving, four sheets, overall 16½ × 85 in. The Folger Shakespeare Library, Washington, D.C.

developed in the late sixteenth century, was closer to an elevation than a plan, and emphasized the skyline, dominated by St. Paul's Cathedral (fig. 25). Consistent with the principle of comprehensive display, the view straightened the winding Thames, aligning the buildings on the riverbank with the picture plane.

The characteristic view of London, which changed little before 1800, showed the more important north bank of the river from the South. Barker followed this tradition, but in other respects departed radically from the standard he inherited. He constructed the panorama from a series of careful perspective studies, all made from his chosen viewpoint on the roof of the Albion Mills, at the foot of Blackfriars Bridge. This fidelity to a single viewpoint accounts for the drastically unconventional appearance of the work. The most prominent feature — occupying a third of the picture — is no longer St. Paul's but the roof on which the artist

stood. The heart of the city has become only one of many features of the view, and the river, winding as in reality, no longer offers its bank in a rigid line of display.

By cheating only a little, Barker could have banished the looming rooftop to show more of the city. Instead, he included it with enthusiasm, decisively marking the viewer's standpoint, which determines the entire organization of the picture. The panorama is rich in precisely observed detail, but clearly Barker was less concerned with presenting a thorough record of the city than with making the viewer feel he was there. Evidently these two aims — both in a sense realistic — are not only distinct but potentially contradictory.

Barker's panorama and others like it (see fig. 28, p. 126), were of course designed as much to thrill as to inform the paying public. However, contemporary topographical prints of London (presumably intended to inform) show a similar shift away from the principle of comprehensive display. Most astonishing are those made from the pinnacle of St. Paul's — formerly the most important feature *in* the picture. Nothing could illustrate better the trans-

feral of value from the represented scene to the experience of looking at it. (An example of such a print is J. Henshall's *Panoramic View of London… taken from the Upper Gallery of St. Paul's Cathedral*, 1836; British Museum, London, Dept. of Prints and Drawings, Crace Collection, Portfolio III, no. 105.)

This sense of the view as an aspect, determined by the position of the viewer and implying his participation, is directly relevant to the other works in this exhibition. The topographical prints, and panoramas such as Barker's, help to show that the innovative spirit of these paintings and drawings is symptomatic rather than eccentric.

Literature: Germain Bapst, *Essai sur l'histoire des panoramas et des dioramas* (Paris: Imprimerie National, 1889). Hubert J. Pragnell, *The London Panoramas of Robert Barker and Thomas Girtin circa 1800* (London Topographical Society, 1968). Heinz Buddemeier, *Panorama Diorama Photographie* (Munich: Wilhelm Fink, 1970). J. A. Schmoll gen. Eisenwerth, "Die Stadt im Bild," in Ludwig Grote, ed., *Die Deutsche Stadt im 19. Jahrhundert* (Munich: Prestel, 1974), pp. 295-314. Richard D. Altick, *The Shows of London* (Cambridge,

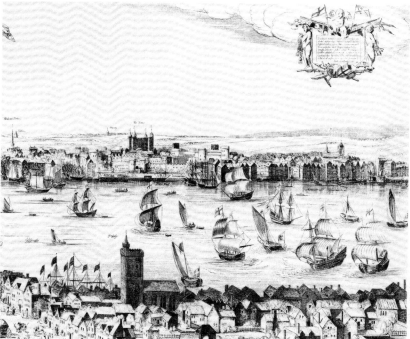

Massachusetts: Harvard University Press, 1978), chapters 10-15. Gustav Solar, *Das Panorama und seine Vorentwicklung bis zu Hans Conrad Escher von der Linth* (Zurich: Orell Füssli, 1979). Helmut Börsch-Supan, "Die Anfange des Panoramas in Deutschland"; I am thankful to the author for permission to read this paper, soon to be published.

Jean-Joseph-Xavier Bidauld
French, 1758-1846

2. *A Cascade*, c. 1790
Oil on canvas
14 15/16 × 19 11/16 in. (38 × 50 cm)
Musée Duplessis, Carpentras, France
Illustrated p. 61

Bidauld was one of the minor masters of French Neoclassical landscape painting. On his first trip to Italy, in 1785-90, he made a number of fine oil studies from nature. This picture was probably made on that trip, but it is not a sketch. The deep, old-fashioned tones and the frankly artificial details in the foreground mark the painting as a studio work. All the more striking, therefore, are the mod-

esty of the subject and the large area given over to the inarticulate mass of the opposite bank of the stream.

The function of the work is not clear. It may have been intended for the trade in finished paintings of modest scale and subject. This class of pictures was an important one, for it invited thematic and stylistic freedom and undermined academic authority. Nevertheless, such pictures usually depicted a more likely spot than this one, and often included figures.

Literature: New York 1975, p. 316. Suzanne Gutwirth, "The Sabine Mountains: An Early Italian Landscape by Jean-Joseph-Xavier Bidauld," *Bulletin of the Detroit Institute of Arts*, vol. 55, no. 3 (1977), pp. 147-52. Carpentras: Musée Duplessis, *Jean-Joseph-Xavier Bidauld: Peintures et dessins* (exh. cat., 1978), no. 19; reviewed by Philip Conisbee, *Burlington Magazine*, vol. 120 (Dec. 1978), p. 880. London 1980-81, pp. 28-29.

Léon Cogniet
French, 1794-1880

3. *At Lake Nemi, near Rome*, 1817-24
Oil on paper, mounted on panel
8 3/4 × 6 7/8 in. (22.2 × 17.4 cm)
Musée des Beaux-Arts, Orléans, France
Illustrated p. 60

Cogniet, a portrait and history painter, won the Prix de Rome in 1817. During his stay in Italy, which ended by 1824, he painted a number of small landscape studies in oil, as did many figure painters. The widespread habit of keeping such studies as tokens of the student sojourn at Rome is documented by Amélie Cogniet's painting, *Interior of the Studio of Léon Cogniet in 1831* (Musée des Beaux-Arts, Orléans), in which the little sketches are displayed on the wall of the studio.

Literature: Hans Vollmer in Thieme-Becker, vol. 7 (1912), pp. 176-77. Albert Boime, *The Academy and French Painting in the Nineteenth Century* (London: Phaidon, 1971), p. 158 and fig. 135.

Figure 26. J.-B.-C. Corot. *Rome, the Fountain of the French Academy,* 1826-27. Pencil on oil on paper 5 ⅜ × 9 ⅞ in. Cabinet des Dessins, Musée du Louvre, Paris

John Constable
British, 1776-1837

4. *Study of Clouds and Trees,* 1821
Oil on paper, mounted on board
9½ × 11¾ in. (24.2 × 29.9 cm)
Inscribed, verso: *Hampstead,/Sept. 11, 1821./10 to 11 Morning under the sun/Clouds silvery grey on warm ground/sultry. Light wind to the S.W. fine all day – but rain the night following.*
Royal Academy of Arts, London
Illustrated p. 46

5. *Study of Tree Trunks,* c. 1821 (?)
Oil on paper
9¾ × 11½ in. (24.8 × 29 cm)
Victoria and Albert Museum, London
Illustrated in color p. 39

6. *Study of the Trunk of an Elm Tree,* c. 1821 (?)
Oil on paper
12 × 9¾ in. (30.6 × 24.8 cm)
Inscribed, verso: *JC*
Victoria and Albert Museum, London
Illustrated p. 41

The terms of inherited convention and direct observation are crucial to any discussion of early nineteenth-century landscape painting. For Constable, however, these terms describe a relationship richer and more complex than is to be found in the work of his contemporaries. Constable applied his deep familiarity with older art to his work as a sketcher, and more than any contemporary painter brought a fresh view of nature to his finished works. These parallel ambitions nearly met in 1815 when, for the only time, he painted an exhibition picture out of doors (*Boat Building,* Victoria and Albert Museum, London).

In 1819, Constable began work on the great series of six-foot exhibition pictures of which *The Hay*

Wain (1821, National Gallery, London) is the most famous. This project recast the shape of his art. As John Gage has pointed out, the distinction between outdoor sketch and finished work broadened again in the 1820s from its near closure the decade before. One might expect that as the finished works became grander, the sketches, once again only studies, became trivial. The opposite is the case, as these three works show. They, as much as the six-footers, are accomplishments of maturity.

Literature: Norwich: Castle Museum, *A Decade of English Naturalism 1810-1820,* ed. and intro. John Gage (exh. cat., 1969-70). London: The Tate Gallery, *Constable: Paintings, Watercolors & Drawings* (exh. cat., 1976). London 1980-81, pp. 36-39.
No. 4: Detroit 1968, no. 126.
Nos. 5 and 6: Graham Reynolds, *Victoria and Albert Museum: Catalogue of the Constable Collection* (London: HMSO, 1973), nos. 234 and 235, respectively.

Jean-Baptiste-Camille Corot
French, 1796-1875

7. *Rome, the Fountain of the French Academy,* 1826-27
Oil on canvas
7 × 11½ in. (18 × 29 cm)
Stamped, l.l.: *VENTE COROT*
The Hugh Lane Municipal Gallery of Modern Art, Dublin
Illustrated p. 65

8. *Medieval Ruins,* c. 1828-30
Oil on canvas, mounted on board
9 × 12 in. (23 × 30.5 cm)
Stamped, l.r.: *VENTE COROT*
The Armand Hammer Foundation, Los Angeles
Illustrated in color p. 37

Before he left Paris for Rome in 1825, Corot already understood the sketching tradition he would find in full bloom there. Both of his teachers had studied with Pierre-Henri de Valenciennes (nos. 34, 35), and since 1822 Corot himself had been sketching in oil. His very first Roman studies (such as fig. 16, p. 24), dated December 1825, are already mature works. Corot returned to France in 1828 not as a promising student but as a seasoned painter. His powers are well represented in *Medieval Ruins* (no. 8), a view from the ruined fortress at Pierrefonds or at Arques, painted after his return. Corot continued to sketch near Paris and on trips throughout France; but he worked most intensely and developed most rapidly in Italy, which he visited again in 1834 and 1843. It is in the Italian sketches, for instance, that Corot first came to the elegiac, hazy image of his later landscapes (as in *Nemi, the Lake Seen through the Trees,* 1843, Kunsthistorisches Museum, Vienna).

Some of Corot's best Roman studies, including *Rome, the Fountain of the French Academy* (no. 7), borrowed from the venerable topographical tradition. The familiarity of the topographical views like the celebrity of the monuments lent the authority of tradition to the little painted studies. Number 7 represents, in the foreground, the fountain of the Villa Medici (the home of the French Academy in Rome) and, in the distance, St. Peter's Basilica.

Corot's method in Italy is nowhere more evident than in this work and a related drawing (fig. 26). Following standard practice, Corot painted his Italian studies on paper prepared with an oil ground in tan or beige (or, less frequently, on canvas). Unlike

Figure 27. Caspar David Friedrich. *The Churchyard,* c. 1825-30. Oil on canvas, 12⅛ × 9⅞ in. Kunsthalle, Bremen

some of his contemporaries, he did not proceed immediately to paint but first drew his scene carefully in pencil on the prepared ground. Figure 26 documents this method, for it is not an independent drawing but an abandoned painting.

Corot's constructive sense is already evident in the abandoned work. He has understood the framing trees as an echo of St. Peter's great dome, and has found other analogies of form in the structure of the fountain. Presumably, in the course of making figure 26, Corot made a discovery and began again on canvas, producing number 7. The discovery requires some explanation. From Corot's viewpoint on the Pincian Hill, the impressive symmetry of St. Peter's silhouette — a large dome flanked by smaller domes — is destroyed. The smaller dome on the right is subsumed in the mass of the larger dome. Corot discovered that he could restore the beloved symmetry by substituting for the missing small dome the spout of the foreground fountain.

The significance of this discovery is illustrated by

the presence of the same device in a nearly contemporary painting by Caspar David Friedrich, *The Churchyard* (c. 1825-30, fig. 27). As in many of Friedrich's works, the pictorial structure may be read as a command: You will pass from the crumbling wall of life through the graveyard of death, to the redemption of heaven, revealed on earth in the spire of the church. Here, as so often, the formulaic piety of the command is rendered convincing by the earthly beauty of the picture. Relevant to Corot's picture is the astonishing identity between Friedrich's spire and the narrow, triangular gap in the gate.

The visual pun, so similar to Corot's, is not like the approximate rhyming of shapes found in many older pictures. It is an exact pictorial identity, wrought from disparate worldly things by the painter's precise point of view. It announces the painter's authority over the two-dimensional image, even when the latter is nominally no more than an accurate view of a given scene. The fact that Corot's picture shares none of Friedrich's symbolic message would seem to make the comparison more rather than less interesting.

Literature: Alfred Robaut and Etienne Moreau-Nélaton, *L'Oeuvre de Corot* (Paris: H. Floury, 1905). Germain Bazin, *Corot,* 3d ed. (Paris: Hachette, 1973). Paris: Orangerie des Tuileries, *Hommage à Corot: Peintures et dessins des collections françaises* (exh. cat., 1975). London 1980-81, pp. 43-44.
No. 7: Robaut, no. 79. London: The Arts Council of Great Britain, *Berlioz and the Romantic Imagination* (exh. cat., 1969), no. 176, ill. in color. Paris, *Hommage à Corot,* 1975, no. 13, for later versions of the picture.
No. 8: Robaut, no. 212. Los Angeles County Museum of Art, *The Armand Hammer Collection* (exh. cat., 1972), no. 8.

John Sell Cotman
British, 1782-1842

9. *The Drop-Gate, Duncombe Park,* 1805
Watercolor and pencil on paper
13 × 9¹/₁₆ in. (33 × 23.1 cm)
Trustees of the British Museum, London
Illustrated p. 42

10. *Norwich Castle,* c. 1808-09
Watercolor and pencil on paper
12¾ × 18⁹/₁₆ in. (32.4 × 47.2 cm)
Inscribed, verso of mount: *Castle Norwich*
Norfolk Museums Service (Norwich Castle Museum), England
Illustrated p. 64

In 1798 Cotman left his native Norwich for London. There, primarily through the patronage of Dr. Thomas Monro, he absorbed the lessons of the advanced school of young watercolor painters. He learned most from Thomas Girtin (no. 19). Within several years, Cotman had developed an original style — a pattern of discrete and interlocking areas of flat color, laid on in an even wash. This style has been called artificial, unrelated to observation, and so it occasionally became. But it emerged, most strongly in the Greta landscapes of 1805, from an inventive compromise between the conditions of watercolor and the demands of observation. Like the flat patterns of Japanese prints, the forms of Cotman's best works are not arbitrary but refer precisely to vivid perceptions of external things.

Literature: *No. 9:* Adele M. Holcomb, *John Sell Cotman* (London: British Museum, 1978), no. 20.
No. 10: Miklos Rajnai and Marjorie Allthorpe-Guyton, *John Sell Cotman: Early Drawings (1798-1842) in Norwich Castle Museum* (Norwich: Norfolk Museums Service, 1979), no. 69.

Johan Christian Dahl
Norwegian, 1788-1857

11. *View from Praestø*, c. 1814
Oil on canvas
22¹³/₁₆ × 28⅜ in. (58 × 72 cm)
Nasjonalgalleriet, Oslo
Illustrated p. 58

12. *Shipwreck and Anchor*, 1826
Pencil and wash on paper
9 × 10⁷/₁₆ in. (22.9 × 26.6 cm)
Inscribed, l.r.: *d. 5 May 1826 JD*
Nasjonalgalleriet, Oslo
Illustrated p. 68

13. *Copenhagen Churchtowers against an Evening Sky*, c. 1830
Oil on canvas, mounted on board
4½ × 6 in. (11.5 × 15.2 cm)
Kunsthalle, Hamburg
Illustrated p. 59

In 1811 Dahl left his native Bergen for the Copenhagen Academy, where he made a thorough study of the great seventeenth-century Dutch landscape painters. In 1816 he became a pupil of C. W. Eckersberg (no. 15) upon the latter's return from Italy. In 1818 Dahl moved to Dresden where, except for several important trips, he stayed until his death. From 1823, he shared a house with Caspar David Friedrich (no. 17).

In 1820-21 Dahl traveled to Naples and then to Rome, where he joined the circle of the Danish sculptor Bertel Thorvaldsen. The trip was critical, for Dahl rapidly absorbed the lessons of the open-air landscape painters who congregated in Naples and Rome. In 1826 Dahl made the first of five summer sketching trips to his native Norway, whose grand landscape remained his favored subject.

View from Praestø (no. 11) reflects Dahl's early admiration for the Dutch landscape masters, especially Jacob van Ruisdael. It is perhaps a student exercise—a foreground study raised to the level of a full-scale painting. Yet this does not explain how Dahl could have abbreviated so severely the older compositional schemes that the picture recalls.

Dahl made *Shipwreck and Anchor* (no. 12) on his first and most important return visit to Norway, in 1826. Ostensibly it is a study for one of a series of slightly later paintings of shipwrecks, such as *After the Storm* (1829, Nasjonalgalleriet, Oslo). But instead of drawing the ship alone or placing the anchor to one side, Dahl chose a point of view that collapsed the two objects (and a smaller boat between them) into a confusing tangle of forms.

The cloud study (no. 13) is one of dozens that Dahl made after his return from Italy in 1821. In addition to its place in the international vogue of cloud sketching, the work invites comparison with two other nearly unrelated threads of contemporary painting. First, the picture recalls a theme of Dahl's mentor Friedrich, in which church spires reach toward the vault of heaven. Second, the picture is a synoptic but precise topographical representation. It shows the steeple of St. Peter's Church and the belfry of the Church of Our Lady (built 1811-29) from the fourth or fifth story of a building on the east side of Copenhagen's Nytorv (or New-market) Square. Together these two towers were (after 1829) the identifying feature of the Copenhagen skyline. Thus to the nineteenth-century viewer, the picture denoted Copenhagen as surely as today a view of the Eiffel Tower denotes Paris.

Literature: Karl Roy Lunde, "Johan Christian Dahl" (Ph.D. dissertation, Columbia University, New York, 1970), the only extended study of Dahl in English, with bibliography. Oslo: Nasjonalgalleriet, *Dahls Dresden* (exh. cat., 1980).
No. 11: Oslo: Nasjonalgalleriet, *J. C. Dahl og Danmark* (exh. cat., 1973), no. 16. Leif Østby, "J. C. Dahls Dansk Laereår," *Kunstmuseets Årsskrift*, vol. 61 (1974), pp. 3-42, with English summary, pp. 127-28.
No. 12: Leif Østby, *Johan Christian Dahl: Tegninger og Akvareller* (Oslo: Nasjonalgalleriet, 1957).
No. 13: Hamburg 1976, no. 254. Paris 1976-77, no. 36.

Francis Danby
British, 1793-1861

14. *Boatbuilder's Yard*, 1838 (?)
Oil on paper
4¾ × 7¼ in. (12.2 × 18.5 cm)
Inscribed on the mount: *Francis Danby, ARA*
Collection Mr. and Mrs. J. A. Gere, London
Illustrated p. 68

Literature: Eric Adams, *Francis Danby: Varieties of Poetic Landscape* (New Haven, Connecticut: Yale University Press, 1973), no. 46; reviewed by Allen Staley, *Burlington Magazine*, vol. 117 (Nov. 1975), pp. 732-35. London 1980-81, no. 75.

Christoffer Wilhelm Eckersberg
Danish, 1783-1853

15. *A Courtyard in Rome*, 1813-16
Oil on canvas
13³/₁₆ × 10¹³/₁₆ in. (33.5 × 27.5 cm)
Kunstmuseum, Ribe, Denmark
Illustrated p. 45

Eckersberg is the key figure in the splendid unfolding of early nineteenth-century Danish painting. Around 1800 the Copenhagen Academy was an important artistic center; among others, Caspar David Friedrich (no. 17) and Johan Christian Dahl

(nos. 11-13) studied there. Yet in the art of the leading Academy teachers — Jens Juel and Nicolai Abildgaard — it is difficult to find the sources of the bright, unself-conscious art that would follow in Denmark.

For this puzzle, Eckersberg's years in Paris (1811-13) and in Rome (1813-16) have a special importance. In Paris, where he studied under Jacques-Louis David, Eckersberg painted several serious history pictures, but he rapidly began to adapt the formal clarity of Neoclassicism to his taste for simple, unheroic views. The transformation is complete in the crisp Roman paintings of the following three years.

Eckersberg returned to Copenhagen in 1816, applied his new style to Danish subjects, became a professor at the Academy in 1818, and taught nearly all of the talented landscape painters of the next generation. His development in Paris and Rome was decisive for the new Danish art. It is also symptomatic of a broad European trend in which the Neoclassical principle of careful observation was unburdened of its rhetorical function.

Literature: Leo Swane in Thieme-Becker, vol. 10 (1914), pp. 320-22. Bramsen et al. 1972, pp. 281-310. Copenhagen: Statens Museum for Kunst, *Dansk Malere i Rom i det 19. århundrede* (exh. cat., 1977-78), no. 14.

Thomas Fearnley
Norwegian, 1802-1842

16. *Finger Logs at the Water's Edge*,
1836 or 1839 (?)
Oil and pencil on paper
12⁹/₁₆ × 7¼ in. (32 × 18.5 cm)
Inscribed: *Furuspirer – de 5 til høire var maarkne* (roughly translated: "Logs for masts — the 5 on the right are decayed")
Nasjonalgalleriet, Oslo
Illustrated p. 52

After early training in Oslo, Copenhagen, and Stockholm, Fearnley became a student of J. C. Dahl (nos. 11-13) in 1829. He had copied a picture by Dahl as early as 1822 and made a special trip to Norway to meet him in 1826. Fearnley adopted the themes and practice of his master, often sketching in oil.

By the 1830s, the oil sketch had become a popular vogue, produced as much for its superficial qualities as for its sensitivity to natural appearance. Fearnley's work of the 1830s, often marked by lurid colors and arbitrary handling, is exemplary of this trend. Fearnley, who lived abroad most of his life, probably made *Finger Logs at the Water's Edge* (no. 16) on one of his later sketching trips to Norway, in 1836 or 1839. Some of the painter's unwonted facility is evident here. However, the exceptional absence of the horizon and the nearly vertical presentation of the floating logs suggest the continuing vigor of the sketching tradition, even as the force of its realist impulse passed into public painting.

Literature: Sigurd Willoch, *Maleren Thomas Fearnley* (Oslo, 1932). Karl Roy Lunde, "Johan Christian Dahl" (Ph.D. dissertation, Columbia University, New York, 1970), pp. 182 ff.

Caspar David Friedrich
German, 1774-1840

17. *Gate in the Garden Wall*, c. 1828 (?)
Watercolor and pencil on paper
4¾ × 7¼ in. (12.2 × 18.5 cm)
Kunsthalle, Hamburg
Illustrated p. 43

The content of Friedrich's art is abstract and symbolic, but its material is insistently physical; the spiritual meaning of the pictures is grounded in explicit visual fact. It should not be surprising, then,

that some of Friedrich's bolder inventions share a family resemblance with some contemporary landscapes whose naturalism is anything but spiritual.

Thus Friedrich's *On the Sailboat* (1818-19, Hermitage, Leningrad) may be compared to a sketch by J.-A.-T. Gudin (no. 23); or his *Churchyard* (c. 1825-30, fig. 27) to a Roman view by Corot (no. 7). So, too, the unbroken horizon and near emptiness of Friedrich's *Monk by the Sea* (1809, Schloss Charlottenburg, Berlin) is to be found in a sunset by F.-M. Granet (no. 21), a photograph by H. L. Hime (no. 59), and many other nineteenth-century landscapes of widely different mood and intent.

These comparisons do not do justice to the differences in meaning among the works. But the formal similarities, echoing across national, stylistic, and thematic borders, force us to acknowledge common syntactical features of nineteenth-century art, their origins in perception and their divergence from traditional pictorial structures. Even the criticisms of some of Friedrich's pictures might easily apply to some works of the Impressionists, who employed and enriched but did not invent the new structures. Friedrich's *Tetschen Altar* (1807-08, Gemäldegalerie, Neue Meister, Dresden), for instance, was faulted for its lack of a conventional, introductory foreground. And of the *Monk by the Sea* one critic wrote that "because of its monotony and boundlessness, with nothing but the frame as a foreground, one feels as if one's eyelids had been cut off." (Heinrich von Kleist, quoted in the London exhibition catalogue cited below, p. 107.)

Literature: London: The Tate Gallery, *Caspar David Friedrich 1774-1840: Romantic Landscape Painting in Dresden* (exh. cat., 1972), no. 111, dated c. 1837-40. Hamburg: Kunsthalle, *Caspar David Friedrich* (exh. cat., 1974), no. 200. Hamburg 1976, no. 241.

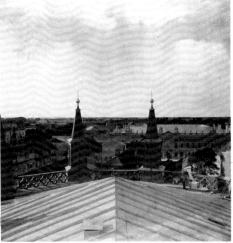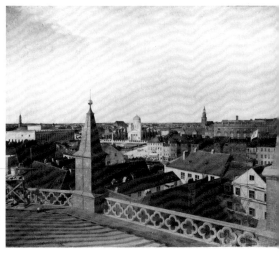

Eduard Gaertner
German, 1801-1877

18. *Corner of the Eosander-Hof, or Outer Courtyard, of the Royal Palace, Berlin*, c. 1831
Oil on canvas
22¹³⁄₁₆ × 18¹¹⁄₁₆ in. (58 × 47.5 cm)
Verwaltung der Staatlichen Schlösser und Gärten, Berlin
Illustrated p. 47

Gaertner was the best architectural view painter of mid-nineteenth century Germany. He served a long apprenticeship — at the Berlin porcelain factory (1814-21) and under the theater-scene painter Karl Gropius (1821-25). Gaertner then spent three years in Paris, where he is thought to have studied under Jean-Victor Bertin, who had been a student of Pierre-Henri de Valenciennes (nos. 34, 35) and a teacher of J.-B.-C. Corot (nos. 7, 8). Returning to Berlin in 1828, Gaertner rapidly established a high reputation for his specialty. In the next decade he worked frequently for King Friedrich Wilhelm III, who commissioned Gaertner's masterpiece — a six-part panorama of Berlin from the roof of the recently built Friedrichwerdersche Kirche (fig. 28).
 In 1830 and 1831, Gaertner painted two large views of the inner and outer courtyards of the Royal Palace, named respectively for their architects the Schlüter-Hof and the Eosander-Hof (both paintings are now at the Staatliche Schlösser

und Gärten, Potsdam-Sanssouci; see Wirth, figs. 27 and 28). Number 18 is a study related to the second of these works, which shows three sides of the courtyard from another point of view but includes the same diagonal shadow. This shadow, the decisive feature of the sketch, loses most of its formal power in the full, three-dimensional space of the finished work.

Literature: Berlin: Berlin Museum, *Eduard Gaertner* (exh. cat., 1968). Irmgard Wirth, *Eduard Gaertner: Der Berliner Architekturmaler* (Berlin: Propyläen, 1979), no. 21, ill. in color on the jacket; Wirth dates the sketch c. 1832, after the finished work.

Thomas Girtin
British, 1775-1802

19. *Coast of Dorset, near Lulworth Cove*, c. 1797
Watercolor and pencil on paper
14¼ × 10¼ in. (38 × 28 cm)
City Art Galleries, Leeds, England
Illustrated p. 63

The precise subject of number 19 is uncertain, but the work surely belongs to the series of watercolors Girtin worked up from sketches on a tour of Southwest England and Wales in 1797.

Figure 28. Eduard Gaertner. *Panorama of Berlin from the Roof of the Friedrichwerdersche Kirche*, 1834. Oil on canvas; two three-part paintings, 35⅞ × 123 in. and 35⅞ × 125 in. Verwaltung der Staatlichen Schlösser und Gärten, Berlin

Literature: Manchester: Whitworth Art Gallery, *Watercolours by Thomas Girtin* (exh. cat., 1975), no. 38. New Haven, Connecticut: Yale Center for British Art, *English Landscape 1630-1850* (exh. cat., 1977), no. 115, a related work.

François-Marius Granet
French, 1775-1849

20. *Gothic Interior*, 1802-19
Oil on paper, mounted on panel
8⅝ × 11⅝ in. (22 × 29.5 cm)
Musée Granet, Aix-en-Provence, France
Illustrated p. 51

21. *The Roman Campagna at Sunset*, 1802-19
Oil on paper, mounted on canvas
9⅜ × 6¹¹⁄₁₆ in. (23.8 × 17 cm)
Musée Granet, Aix-en-Provence, France
Illustrated in color p. 35

22. *Fragment of Roman Architectural Sculpture*, 1802-19
Oil on paper, mounted on board
8¼ × 10¹⁄₁₆ in. (21 × 25.6 cm)
Musée Granet, Aix-en-Provence, France
Illustrated p. 54

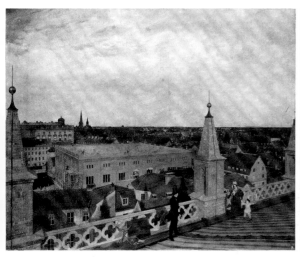 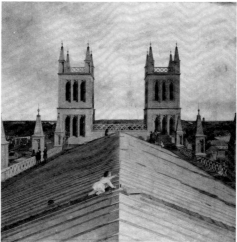 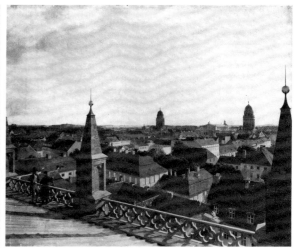

A native of Aix-en-Provence, Granet first studied with the local master of landscape painting and later (1799-1801) in Paris under Jacques-Louis David. In 1802, with his friend Auguste de Forbin, he traveled to Rome, where he remained for seventeen years. In 1826 Forbin (then director of the national museums) appointed Granet to a curatorship at the Louvre.

Granet was celebrated in his own day for his interior views of religious ceremonies, dimly lit by a few windows and peopled by monks in the trance of ritual. The works express perfectly the Romantic view of religion as foreign, mysterious, vaguely threatening, and fascinating. All of this is present in *Gothic Interior* (no. 20), which in size and technique must be classed with another aspect of Granet's work, little known in his own day.

Following the example of Pierre-Henri de Valenciennes (nos. 34, 35) and anticipating that of J.-B.-C. Corot (no. 7), Granet painted in Italy a large number of small landscape studies in oil. *The Roman Campagna at Sunset* (no. 21) is exemplary of the originality of these works. With a thorough disregard for conventional pictorial space, Granet has concentrated on the delicate tones of the sunset, making a picture that we read vertically, as if to follow the descent of the sun. It is one of the characteristic images of modern art—of Whistler and Rothko for example—a work whose very emptiness calls attention to its subtlety.

Literature: New York 1975, pp. 458-60. London 1980-81, pp. 30-31.

Jean-Antoine-Théodore Baron Gudin
French, 1802-1880

23. *Sailing Ship on the Sea*, 1837-39
Oil on paper, mounted on panel
15⅛ × 25½ in. (38.5 × 65 cm)
Kunsthalle, Bremen
Illustrated p. 69

Gudin won early success in the Salons of the 1820s and was soon acclaimed as one of the leading marine painters of France. He enjoyed numerous official commissions, among them an order for ninety-seven paintings illustrating the glories of French naval history. The Baron Gudin was, in other words, a thoroughly acceptable artist, and like many other acceptable artists of the day, he made oil sketches from nature that bear no obvious relation to his finished works and are very different in spirit. This work, unusually large for an oil sketch, was made from a gun portal of the ship *La Véloce*, or perhaps from one of its lifeboats.

The sense of the picture is illustrated by the apocryphal story in which the landscape painter J. M. W. Turner is said to have leaned out of the window of a speeding train to study a storm. The

episode is supposed to have provided the raw material for Turner's famous painting *Rain, Steam, and Speed—The Great Western Railway* (1844, National Gallery, London), which indeed presents an impressively stormy confusion of the elements. The story, nevertheless, seems irrelevant: instead of the view from the train, the painting shows the train itself, seen from the traditional, imaginary bird's eye.

The spirit of Turner's story is better suited to Gudin's picture, whose subject is neither the ship nor the sea but the experience of looking out at the sea from the ship.

Literature: Bremen 1973, pp. 129-30. New York 1975, p. 475. Hamburg 1976, no. 318. Bremen 1977-78, no. 392.

Adolf Henning
German, 1809-1900

24. *Choir of the Cistercian Church, Altenberg,* 1833
Oil on paper
14 × 10⅛ in. (35.5 × 25.7 cm)
Inscribed l.r.: *Altenberg/Juli 33*
Verwaltung der Staatlichen Schlösser und Gärten, Berlin
Illustrated p. 50

Born in Berlin, Henning began to study painting at the age of twelve, in 1821. Number 24 was made in the interval between the close of his formal studies

in 1832 and his departure for Italy in October 1833. Henning returned to Berlin in 1838 and became a member of the Academy the following year. He painted biblical and mythological themes, landscapes, and genre scenes, but was best known for his portraits. This picture, like Corot's *Medieval Ruins* (no. 8), reflects widespread artistic enthusiasm for the medieval past, also a prominent theme of early photographers.

Literature: H. Vollmer in Thieme-Becker, vol. 16 (1923), pp. 405-06. Helmut Börsch-Supan, *Deutsche Romantiker: Deutsche Maler zwischen 1800 und 1860* (Munich: C. Bertelsmann, 1972), ill. in color, fig. 61.

Jean-Auguste-Dominique Ingres
French, 1780-1867

25. *Tivoli, the Peristyle of the So-called Temple of Vesta*, 1806-20
Pencil on paper
11½ × 7 in. (29.2 × 17.9 cm)
Musée Ingres, Montauban, France
Illustrated p. 48

Ingres won the Prix de Rome in 1806. He overstayed his official four-year visit by ten years, leaving only in 1820. In this period Ingres made scores of drawings of Rome and its environs. Some of these are related to the backgrounds of his portraits, but it is clear that Ingres made the drawings for their own sake.

The linear purity and graphic clarity of the drawings is in tune with Ingres's Neoclassical training. But in their approach to their subjects, the drawings are highly original, sometimes eccentric, and often radical. This is perhaps most obvious in Ingres's views of the Roman Forum, where he repeatedly chose a vantage point that obscured rather than described the salient monuments and general plan. In figure 29, for example, he gave prominence to a

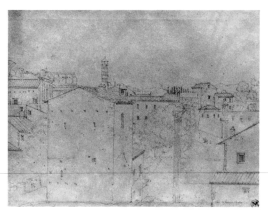

Figure 29. J.-A.-D. Ingres. *View of the Roman Forum*, 1806-11. Pencil on paper, 16¹³⁄₁₆ × 9⁵⁄₁₆ in. Musée Ingres, Montauban, France

building of no consequence, reduced the grand alley of trees to a nearly illegible mass, and relegated the Temple of Antoninus and Faustina, the Basilica of Constantine, and the Colosseum to fragmentary appearances at the upper left. A topographer no more would have valued this view than Pierre-Henri de Valenciennes's view of the Piazza del Popolo (no. 34). The clarity of the picture, as in many of Ingres's Roman drawings, is formal and pictorial rather than descriptive.

The Tivoli drawing (no. 25) also represents an original point of view. The so-called Temple of Vesta, a Roman Republican monument, is perched on a cliff overlooking a magnificent cascade. Since Claude Lorrain, the view of this little round temple, with Rome in the distance, had been a standard image—an imaginary classical landscape found in reality. Ingres also drew this standard view; his drawing of the temple's interior is much less familiar.

Literature: Robert Rosenblum, *Jean-Auguste-Dominique Ingres* (New York: Abrams, [1968]). Hans Naef, *Ingres in Rome* (exh. cat., Washington, D.C.: International Exhibitions Foundation, 1971), no. 134.

Louis-Gabriel-Eugène Isabey
French, 1803-1886

26. *The Stall of a Cloth-Dyer, Algiers*, 1830
Oil on paper
11⁵⁄₁₆ × 9¹¹⁄₁₆ in. (28.8 × 24.7 cm)
Private collection, France
Illustrated in color p. 38

Eugène Isabey first exhibited at the Salon in 1824 and rapidly established a reputation as a marine painter. With Colonel Jean-Charles Langlois (no. 60) and Baron Gudin (no. 23), he accompanied the French naval expedition to Algiers in 1830 as an official artist. In addition to his official work, Isabey painted several oil sketches in the city, including this one. For Isabey as for other French painters — Eugène Delacroix and Henri Matisse are the great examples — the light and color of North Africa acted as a liberating force.

Literature: Pierre Miquel, *Eugène Isabey 1803-1886* (Maurs-la-Jolie: Editions de la Martinelle, 1980), pp. 53-61.

Thomas Jones
British, 1742-1803

27. *A Wall in Naples*, c. 1782
Oil on paper
4³⁄₈ × 6¼ in. (11.2 × 15.9 cm)
Collection Mrs. Jane Evan-Thomas, England
Illustrated in color p. 34

After two years of study at Oxford and two more of initial instruction in drawing, Jones was apprenticed to Richard Wilson in 1763-65. This apprenticeship to the leading British landscape painter of the day was decisive for the young Welsh gentleman. Through Wilson, Jones learned to emulate the seventeenth-century masters of landscape and must also have acquired the notion of sketching outdoors

in oil. Wilson, like Pierre-Henri de Valenciennes (nos. 34, 35) had probably received the notion from the French landscapist Claude-Joseph Vernet, who had advocated oil sketching in a short treatise published in 1817 but written much earlier. There is no evidence that Vernet or Wilson made much of the practice, but Jones was already sketching in oil before his important trip to Italy in 1776-83. He stayed first in Rome for two years and then traveled to Naples, where he did much of his best work, including a series of remarkable studies of buildings and rooftops.

Number 27 is one of the best of this series. From an evidently humble Neapolitan building, of whose overall form and dimensions there is no clue, Jones has abstracted a striking symmetry. The focus is the door and little balcony, marked by a decisive white stroke of laundry. Repeated in this strong center is the simple color scheme of the whole: the blue of the sky, the green of the foliage, the brown and black of the wall. The resolute balance of classical art is here, and its theme of harmony between nature and man; yet it is as if these were not created but discovered.

Literature: A. P. Oppé, ed., "Memoirs of Thomas Jones," *The Walpole Society Annual Volume*, vol. 32 (1946-48), pp. 1-162. Detroit 1968, pp. 128-29. London: Greater London Council, *Thomas Jones (1742-1803)* (exh. cat., 1970), no. 65; reviewed by J. A. Gere, *Apollo*, vol. 9 (June 1970), pp. 469-70. London 1980-81, pp. 20-22.

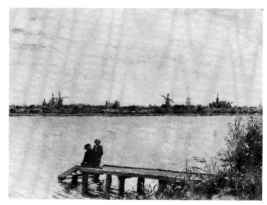

Figure 30. Christen Købke. *View at Dosseringen*, c. 1837. Oil on paper, 9¼ × 12¼ in. The Ordrupgaard Collection, Copenhagen

Christen Købke
Danish, 1810-1848

28. *View at Dosseringen*, c. 1837
Oil on paper
10 × 11⅜ in. (25.5 × 29 cm)
The Ordrupgaard Collection, Copenhagen
Illustrated in color p. 40

Christen Købke possessed considerable natural talent and an unerring instinct for the bright, homey values of what is called the Golden Age of Danish painting. Through his teacher C. W. Eckersberg (no. 15), his own trip to Italy (1838-40), and the legacy of the Danish sculptor Bertel Thorvaldsen, Købke was exposed to the ambitions of Europe at large. He left them almost entirely alone.

Købke painted portraits and landscapes. The latter, excepting the Italian views, described places he knew. One of Købke's favorite subjects was a spot called Dosseringen, which is separated from Copenhagen proper by a small lake. He painted a dozen or more pictures of the lakeshore, often with Copenhagen in the distance (as in fig. 30). Together the pictures seem to describe a casual walk along the shore, with glances forward and back or across the lake, and brief pauses to look more closely. The bush singled out for attention in number 28 appears in the corner of another view at Dosseringen (Krohn, no. 106, ill. p. 72).

Literature: Mario Krohn, *Maleren Christen Købkes arbejder: Illustreret Fortegnelse* (Copenhagen: Kunst-

foreningen, 1915), no. 111. I. Buhl in Thieme-Becker, vol. 21 (1927), pp. 103-05. Bramsen et al. 1972, pp. 331-53.

John Linnell
British, 1792-1882

29. *At Twickenham*, 1806
Oil on board
6½ × 10 in. (16.5 × 25.5 cm)
Inscribed, verso: *J. Linnell 1806 Twickenham*
Trustees of the Tate Gallery, London
Illustrated p. 71

30a-c. *The Brick Kiln, Kensington*, 1812
Three works, watercolor and pencil on paper
Each, 4 × 5⅝ in. (10.2 × 14.3 cm)
a. Inscribed, l.r.: *J. Linnell 1812*
b. Inscribed, l.r.: *J. Linnell 1812*
c. Inscribed, l.l.: *J. L.*; l.r.: *1812*
Private collection
Illustrated pp. 56,57

Linnell is best known for his friendship with William Blake, whom he met in 1818, and with Samuel Palmer, whom he introduced to Blake. A great deal of his most interesting work, however, was done before he knew Blake. In 1805 Linnell became a student of John Varley. He must also have learned from his work as a copyist for Dr. Thomas Monro, who earlier had employed Thomas Girtin (no. 19), J. M. W. Turner, and John Sell Cotman (nos. 9, 10).

Between 1805 and 1815 Linnell, along with several other students of Varley, painted a number of studies (in oil or in watercolor) whose subjects in the environs of London are often almost aggressively mundane. Writing of the three views of the brick kiln (no. 30a-c), John Gage has suggested that the stimulus for these works may lie more in the tastes of Dr. Monro than in the tame work of Varley. In a letter of 1828, Samuel Palmer commented

thus on a sketching trip of Dr. Monro and Welby Sherman: "The Doctor led the way to that selected scene which he intended to commend first of all to his visitor's attention. It did not consist wholly of nature nor wholly of art. Had *we* had the happiness of beholding it, how must it have rais'd our esteem and admiration of *his* taste who first discover'd & explored it! Rara Avis! It consisted, I say, not of mere sylvan simplicity or unadorned grandeur, but presented that most rare, fortunate concurrence & due admixture of nature and of art in which great critics assert perfection to consist. Here was landscape in its flattest and most inoffensive simplicity; & uncorrupted architecture in its purest elements & *most primitive order!* At last the picturesque tourists arrived at the Arcadia of their destination; —and Behold!—it was a BRICK FIELD!!!!!" (In G. Grigson, *Samuel Palmer: The Visionary Years*, London, 1947, pp. 80-81; quoted by Gage, in *The Art Quarterly*, vol. 37, no. 1 [Spring 1974], p. 89.)

Literature: Detroit 1968, pp. 237-39. London: The Tate Gallery, *Landscape in Britain c. 1750-1850* (exh. cat., 1973), pp. 102-03. London: P. & D. Colnaghi & Co., *A Loan Exhibition of Drawings, Watercolours and Paintings by John Linnell and his Circle* (exh. cat., 1973). Hamburg 1976, p. 300. London 1980-81, no. 72.

Johan Thomas Lundbye
Danish, 1818-1848

31. *Study at a Lake*, 1838
Oil on paper
5¹⁄₂ × 8⁷⁄₁₆ in. (14 × 21.5 cm)
Inscribed, l.l.: *Jaegersborg. d 26 Juny 1838 TL*
The Hirschsprung Collection, Copenhagen
Illustrated p. 70

In the 1820s and 1830s Christen Købke (no. 28) and his contemporaries in Denmark had made a high virtue of artistic modesty. In the 1840s several

younger landscape painters, including Lundbye, began to seek a prouder view of their native land in larger, grander pictures. Lundbye often succeeded, sometimes at the expense of the liveliness of his early studies, like this one.

Literature: I. Buhl in Thieme-Becker, vol. 24 (1930), p. 470. Bramsen et al. 1972, pp. 430-42.

Ernst Meyer
Danish, 1797-1861

32. *The Theater of Marcellus, Rome*, 1830s (?)
Oil on paper, mounted on canvas
13³⁄₈ × 10¹⁄₁₆ in. (34 × 25.5 cm)
Inscribed, l.r.: *E MEYER*
The Hirschsprung Collection, Copenhagen
Illustrated p. 49

Meyer, who spent most of his life in Italy, made a career of painting affectionate, nostalgic pictures of Italian peasants and tradesmen. He worked in a tradition, founded in the seventeenth century, that exploited the contrast between the lost grandeur of the great Roman monuments and their humble modern occupants. The pictures also frequently implied that the tradesmen, loafers, itinerant musicians, bandits, and washerwomen were the authentic inheritors of the noble Roman character. Meyer himself summarized the tradition when he wrote: "Let other artists rush into the Vatican and study the ancients, I shall remain here [in the street]: this is my Vatican." (Quoted in Copenhagen, 1967, no. 46.)

Number 32 is an exceptionally blunt expression of the theme, a work nearly devoid of traditional pictorial structure. It represents the Theater of Marcellus, which was completed by the Emperor Augustus in 13-11 B.C. In the Middle Ages the Theater served as the private fortress of the Pierleoni family; since the sixteenth century its upper floors

have been a palace, based on designs by Baldassarre Peruzzi; and until 1927 it housed the ground-floor shops seen here.

Meyer's painting seems to endorse the observation of Oswald in Mme de Staël's novel *Corinne* of 1807: "The reading of history, the reflections it inspires, touches our soul much less than these stones in disorder, these ruins amid new houses. The eyes are all-powerful over the soul…" (Mme la Baronne de Staël-Holstein, *Corinne, ou l'Italie* [1807], 8th ed. Paris: Nicolle, 1818, vol. 1, p. 128.)

Meyer was in Italy in 1824-41, 1844-48, and 1852-61. This work, for its quality and style, is traditionally assigned to the first of these periods. In the 1911 catalogue of The Hirschsprung Collection, for instance, E. Hannover places the picture among the works of the 1830s.

Literature: Emil Hannover, *Fortegnelse over Den Hirschsprungske Samling af danske Kunstneres Arbejder* (Copenhagen, 1911), no. 322. I. Buhl in Thieme-Becker, vol. 24 (1930), p. 470. Copenhagen: Thorvaldsens Museum, *Danske Kunstnere i Italia* (exh. cat., 1967), with English translation. Knud Voss, *Guldalderens Malerkunst: Dansk Arkitekturmaleri 1800-1850* (Copenhagen: Arnold Busck, 1968), fig. 126. Copenhagen: Statens Museum for Kunst, *Danske Malere i Rom i det 19. århundrede* (exh. cat., 1978), no. 61.

Friedrich Nerly
German, 1807-1878

33. *Hillside, Italy,* 1828-35
Oil on paper, mounted on board
12 × 17¹¹/₁₆ in. (30.5 × 45 cm)
Kunsthalle, Bremen
Illustrated p. 53

Literature: Bremen: Kunsthalle, *Friedrich Nerly: Ein deutscher Romantiker in Italien* (exh. cat., 1957), no. 26. Bremen 1973, p. 247. Martina Rudloff, "Rumohr und die Folgen: Zu den Bremer Ölskizzen Friedrich Nerlys," *Niederdeutsch Beiträge zur Kunstgeschichte,* vol. 16 (1977), pp. 93-106.

Pierre-Henri de Valenciennes
French, 1750-1819

34. *Porta del Popolo, Rome,* c. 1782-84
Oil on paper, mounted on board
6¹/₁₆ × 16⁵/₁₆ in. (15.5 × 41.5 cm)
Inscribed, above: *porta del popolo in Roma no 5*
Musée du Louvre, Paris
Illustrated p. 67

35a. *Rooftop in Sunlight, Rome,* c. 1782-84
Oil on paper, mounted on board
7⅛ × 14⅜ in. (18.2 × 36.5 cm)
Inscribed, verso: *loggia a Roma*
Musée du Louvre, Paris
Illustrated in color p. 33

35b. *Rooftop in Shadow, Rome,* c. 1782-84
Oil on paper, mounted on board
7⅛ × 13¼ in. (18.2 × 33.7 cm)
Inscribed, verso: *loggia a Roma*
Musée du Louvre, Paris
Illustrated in color p. 33

Born in Toulouse, Valenciennes settled in Paris on return from his first trip to Italy in 1771. In 1773 he

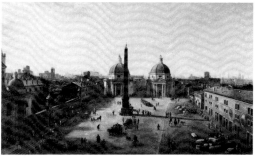

Figure 31. Gaspar van Wittel. *Piazza del Popolo, Rome,* c. 1683. Oil on canvas, 25½ × 48 in. Brooks Memorial Art Gallery, Memphis, Tennessee, Gift of Mr. and Mrs. Hugo Dixon

entered the studio of Gabriel-François Doyen and in 1777 left again for Italy. On a visit to Paris in 1781 he met the great landscape painter Claude-Joseph Vernet. It is now generally believed that Valenciennes's Italian oil sketches were painted during his last stay in Rome, c. 1782-84, and were prompted by the counsel of Vernet. Valenciennes made his début at the Paris Salon in 1787 and soon his work was hailed as the equivalent in landscape to the Neoclassical history painting of Jacques-Louis David and his school. Valenciennes assumed the mantle of leadership of the school of Neoclassical landscape, taught at the academy, and in 1800 published a widely read and influential treatise on perspective and landscape painting.

In 1864 Henri Delaborde, who did not know Valenciennes's sketches, criticized the painter's public work as rigid and *retardataire,* a detour from the path that had led to the naturalism of the mid-nineteenth century. Since 1930, when the sketches came to light, Valenciennes frequently has been called a proto-Impressionist, an artist well ahead of his time. He was in fact neither a conservative nor a radical. Recent art historians, especially Robert Rosenblum, have shown repeatedly that Neoclassicism was a complex, compound phenomenon in which many aspects of later art were hinted. The two sides of Valenciennes's work are part of that complexity: the freedom of the sketches could not have existed without the dogma of the finished works.

Valenciennes's treatise and the sketches themselves show that he did not think of the studies nar-

rowly, as documents of motifs to be incorporated in later finished works. In painting the studies the artist intended to acquaint himself with natural appearance in the general sense and above all with conditions of light and atmosphere. One corollary of this conception was that, especially in and around Rome, nearly any subject matter would do. Thus some of Valenciennes's studies are comparable to the work of other artists, particularly the English, for whom low subjects had a positive value. Even when painting in the city of Rome, Valenciennes was often indifferent to the celebrity of her monuments. Who could recognize easily the nominal subject of number 34, the proper view of which is made from the opposite direction (fig. 31).

Literature: P. H. de Valenciennes, *Elémens de perspective pratique à l'usage des artistes suivis de réflexions et conseils à un élève sur la peinture et particulièrerment sur le genre de paysage* (1800; enlarged ed. Paris: Aimé Payen, 1820). Henri Delaborde, *Etudes sur les beaux-arts en France et en Italie* (Paris: Renouard, 1864), pp. 138-76. Lionello Venturi, "P. H. de Valenciennes," *The Art Quarterly,* vol. 4, no. 2 (Winter 1941), pp. 88-109. Toulouse: Musée Paul-Dupuy, *P. H. de Valenciennes* (exh. cat., 1956-57). Germain Bazin, "P. H. de Valenciennes," *Gazette des Beaux-Arts,* ser. 6, 59 (May-June 1962), pp. 353-62. Wheelock Whitney III, "P. H. de Valenciennes" (M.A. thesis, Courtauld Institute, London, 1975). Paris: Louvre, *Les Paysages de P. H. de Valenciennes 1750-1819* (Le petit journal des grandes expositions, N.S., no. 30; exh. cat., 1976); reviewed by Philip Conisbee, *Burlington Magazine,* vol. 118 (1976), p. 336. London: British Museum, *French Landscape Drawings and Sketches of the Eighteenth Century* (exh. cat., 1977), pp. 99-102. London 1980-81, pp. 23-26.

Jan-Frans Van Dael
Flemish, 1764-1840

36. *Landscape: The Painter's House,* 1828
Oil on canvas
19¹¹/₁₆ × 24 in. (50 × 61 cm)
Inscribed, l.l.: *Vandael 1828*
Museum Boymans– van Beuningen, Rotterdam
Illustrated p. 66

Van Dael was a Flemish flower painter who worked
in Paris. He painted other landscapes, but this is
apparently the only one known today. It has been
proposed that the picture shows the artist's own
house in or near Paris and that the painter next to
the easel in the window is Van Dael himself.
Whether or not this is true, the painting is a splen-
did pendant to any number of nineteenth-century
views made from behind a window looking out.

Literature: New York 1975, no. 183.

Carl Wagner
German, 1796-1867

37. *At the City Wall of Rome,* 1823
Oil on paper, mounted on board
12½ × 17⅛ in. (31.7 × 43.4 cm)
Inscribed l.m.: *Rom d. 12. Febr. 23*
Kunsthalle, Bremen
Illustrated p. 55

After an initial study of forestry, Wagner studied
painting from 1817 to 1820 at the Dresden
Academy. He traveled to Switzerland in 1821 and
spent the following three years in Rome, where
he joined the circle of German artists called the
Nazarenes.

Literature: Bremen 1973, pp. 351-55. Bremen 1977-78,
no. 350, ill. in color, pl. 15.

Ferdinand Georg Waldmüller
Austrian, 1793-1865

38. *The Ziemitzberg, near Ischl,* 1831
Oil on panel
12⅜ × 10¼ in. (31.5 × 26 cm)
Inscribed, l.r.: *Waldmüller 1831*
The Federal Republic of Germany, on loan to the
Wallraf-Richartz-Museum, Cologne
Illustrated p. 62

Waldmüller was the master of Austrian Biedermeier
painting. His portraits and still lifes, genre pictures
and landscapes, display an untroubled confidence
in the tangible pleasures of a modest, comfortable
life.

In the early 1830s, Waldmüller developed a
distinctive notation for the brittle appearance of
wood, foliage, and rock under sharp sunlight. The
technique admirably served the abrupt, frozen,
refractory quality of his landscapes. It is this qual-
ity, more than superficial precision of detail, which
makes Waldmüller's mountain views of the 1830s
seem photographic.

Before about 1850, this style may be found only
in the landscapes, but in the late 1840s Waldmüller
began to apply it also to figural pictures. He aban-
doned the bland illumination of his earlier genre
scenes, arresting figures in mid-gesture and scatter-
ing over them a crystaline pattern of shadow and
light. This development has been attributed to the
influence of the daguerreotype, but it has a more
obvious source in Waldmüller's own landscapes of
the 1830s.

Literature: Heinrich Schwarz, *Salzburg und das
Salzkammergut: Die künstlerische Entdeckung der Stadt
und der Landschaft im 19. Jahrhundert,* 3d ed. (Vienna:
Anton Schroll, 1957). Bruno Grimschitz, *Ferdinand
Georg Waldmüller* (Salzburg: Galerie Welz, 1957). Maria
Buchsbaum, *Ferdinand Georg Waldmüller 1793-1865*
(Salzburg: Residenz, 1976).

Friedrich Wasmann
German, 1805-1886

39. *Castle in the Tyrol,* c. 1831
Oil on paper
8½ × 10¼ in. (21.5 × 26 cm)
Kunsthalle, Hamburg
Illustrated p. 72

40. *View from a Window,* c. 1833
Oil on paper
9½ × 7⁹/₁₆ in. (24.1 × 19.2 cm)
Kunsthalle, Hamburg
Illustrated p. 44

41. *Study of a Grapevine,* c. 1830-35
Oil on paper
6⅜ × 3⁹/₁₆ in. (16.3 × 9 cm)
Kunsthalle, Hamburg
Illustrated in color p. 36

Many landscape painters made oil sketches
throughout their lives, but the sketch — the *étude* —
was always associated closely with students. The
notion that the painter learned as he sketched
encouraged the already considerable freedom that
sketching had by virtue of its independence from
the constraints of exhibition. It is significant that
many of the works shown here were made by young
painters.

Less talented and consistent than John Constable
or J.-B.-C. Corot, Wasmann was for several years in
his youth as inventive. After studying in Hamburg,
Dresden, and Munich, he lived in Merano in the Ita-

Figure 32. Friedrich Wasmann. *Open Window*, 1830-35. Oil on paper, 7⅞ × 9⅛ in. Kunsthalle, Hamburg

Figure 33. Piet Mondrian. *Painting, I*, 1926. Oil on canvas, 44¾ × 44 in. The Museum of Modern Art, New York, Katherine S. Dreier Bequest

lian Tyrol in 1830-31 and among the Nazarene circle in Rome in 1832-35. In these years he did his most original work.

A few of Wasmann's sketches (such as no. 39) are for their date surprisingly casual in form and feel-

ing. Next to these are many others (such as nos. 40, 41 and fig. 32) whose considerable formal boldness bears comparison with much later art. Relevant to these works is Meyer Schapiro's observation, in an essay on Mondrian, that the formal strategies of twentieth-century art are in important respects continuous with the nineteenth-century conception of the picture as a fragment of a broader visual field: "The new abstract elements of [Mondrian's] art are disposed on the canvas in asymmetric and open relationships that had been discovered by earlier painters in the course of a progressive searching of their perceptions of encountered objects in the ordinary world and had been selected for more than aesthetic reasons. In that art of representation, the asymmetry and openness of the whole, which distinguished a new aesthetic, also embodied allusively a way of experiencing directly and pointedly the everyday variable scene — a way significant of a changing outlook in norms of knowledge, freedom, and selfhood." (Schapiro, "Mondrian: Order and Randomness in Abstract Painting," in *Modern Art, 19th and 20th Centuries: Selected Papers*, New York: Braziller, 1978, p. 242.)

Literature: Peter Nathan, *Friedrich Wasmann, sein Leben und seine Werke: Ein Beitrag zur Geschichte der Malerei des neunzehnten Jahrhunderts* (Munich: Bruckmann, 1954). Hamburg 1976, p. 265. Paris 1976-77, pp. 219-22.

Photographer unknown
American (?)

42. *New York* (?), 1850s (?)
Salt print from a paper negative
9⅜ × 6⅞ in. (23.8 × 17.5 cm)
Collection Paul F. Walter, New York
Illustrated p. 112

Photographer unknown
French (?)

43. *Church of Saint Martin, Candes*, 1851-55
Salt print from a paper negative
8¹⁄₁₆ × 10¹⁄₁₆ in. (20.5 × 25.5 cm)
International Museum of Photography at
George Eastman House, Rochester
Illustrated p. 113

This photograph is one of a large group of paper negatives and positive prints acquired by the International Museum of Photography from the establishment of Louis-Désiré Blanquart-Evrard in Lille. Some of the pictures are by Hippolyte Bayard; the authorship of the others remains unknown. Blanquart-Evrard's Imprimerie Photographique, in operation 1851-55, was the first thoroughgoing establishment for printing albums of photographs in multiple editions. No practical process had yet been devised to adapt photography to the traditional print media, so that Blanquart's albums contained original photographic prints. In its brief heyday, the firm printed the great albums of Maxime Du Camp (no. 54), Auguste Salzmann (no. 71), and others, as well as a series of collections of prints by various photographers.

The photographs and negatives in Rochester represent mainly medieval religious architecture. As Robert A. Sobieszek suggested when he exhibited some of the works at Eastman House in 1973, they

may have been part of an unfinished collective publication. In any case, the pictures certainly represent the enthusiastic participation of early French photographers in the movement to document and preserve their nation's medieval heritage. From an aesthetic point of view, the cathedrals served the photographers much as Rome had served the landscape sketchers: the indisputable importance of the monuments lent authority to pictorial experiment.

Literature: Isabelle Jammes, *Albums photographiques édités par Blanquart-Evrard 1851-55* (exh. cat., Chalon-sur-Saône: Musée Nicéphore Niépce, 1978).

Photographer unknown
British

44. *The Silver Hook,* 1860s (?)
Albumen-silver print from a glass negative
2¹⁵/₁₆ × 2¹⁵/₁₆ in. (7.4 × 7.4 cm)
Inscribed on the mount: *The Dog Cart. Harper Rigg/"The Silver Hook"*
The Museum of Modern Art, New York
Purchased as the Gift of Mrs. John D. Rockefeller 3rd
Illustrated p. 89

45. *Through the Window,* 1860s (?)
Albumen-silver print from a glass negative
2⁵/₈ × 2¹³/₁₆ in. (6.7 × 7.1 cm)
Inscribed on the mount: *A slightly exaggerated foreground/"Through the Window"*
The Museum of Modern Art, New York
Purchased as the Gift of Mrs. John D. Rockefeller 3rd
Illustrated p. 116

The automatic character of photography is a prodigious force. The modern eye has welcomed the medium's ability to make whole pictures on a minimum of deliberate choices, and has often found aesthetic merit in pictures made without aesthetic intent. Of the large number of photographs that fall

Figure 34. Photographer unknown. *Great Pyramid at Ghizeh, Egypt,* 1860s (?). Albumen-silver print from a glass negative, 2¹¹/₁₆ × 2¹⁵/₁₆ in. The Museum of Modern Art, New York, Purchased as the Gift of Mrs. John D. Rockefeller 3rd

into this category, most influential have been those made in the service of scientific investigation, and the casual records of amateurs.

These two works are from an album of fifty-three pictures, nearly identical in size, which on the basis of technique and the costume of the subjects may be assigned provisionally to the 1860s. The first thirty-five pictures record a journey to the Middle East, showing the noted landscapes and monuments (e.g., fig. 34) and the author's companions and servants. The return home is marked by several views of Gorwood House, Institution for Imbecile Children, Larbert, Stirlingshire, Scotland—presumably the author's place of work. The remainder of the pictures record a fishing expedition, the author's family and friends, and the house and garden of his home at 11 Church Hill, Morningside, Edinburgh. The front cover of the album bears the words "From the East," the back cover simply "Etc."

Like many of today's snapshooters, the director of Gorwood House (as I suspect the author was) may well have wished to reproduce the orderly compositions of professional topographers and portraitists. It is doubtful that he thought of the pictures as much more than the best records he could make of people and places he cared for. Still, some

of the inscriptions (such as the one for no. 45) suggest that the photographer enjoyed the unconventional effects of some of his pictures. Thus it does not seem unfair that more self-conscious painters and photographers have come to identify the spontaneous, elliptical character of such pictures with the spirit of private enthusiasms.

Photographer unknown
Italian

46. *Study of the Sky,* c. 1865
Albumen-silver print from a glass negative
8⅛ × 6¾ in. (20.6 × 17.1 cm)
Inscribed in the negative: *170*
Collection André and Marie-Thérèse Jammes, Paris
Illustrated p. 87

Clouds posed a problem for early photographers. The paper or glass negatives were sensitive only to blue light, so that the sky was usually overexposed, a blank white area in the positive print. Many photographers solved the problem by making separate negatives for sky and earth and surreptitiously printing them together. This practice contributed to the tradition, established by painters, of pure sky studies; but it also meant that most cloud photographs were broad, distant views, suitable for a match with a landscape. This picture is an exception, a truly independent, close study of clouds.

Literature: Chicago: The Art Institute of Chicago, *Niépce to Atget: The First Century of Photography from the Collection of André Jammes* (exh. cat., 1978), no. 53.

Photographer unknown
German (?)

47. *Triumphal Entry of the Bavarian Army into Munich,* 1871
Albumen-silver print from a glass negative
8½ × 7³/₁₆ in. (21.6 × 18.3 cm)
Inscribed on the mount: *Triumphal Entry/of the Bavarian Army into Munich*
Lunn Gallery, Washington, D.C.
Illustrated p. 114

The Franco-Prussian War of 1870-71 and the ensuing events challenged photography's growing but still imperfect capacity as a tool of reportage. Hampered as they were by their inability to capture action, the photographers nevertheless compiled an extensive and (as Kirk Varnedoe has shown in an unpublished lecture) often tendentious record of the highly charged events, personalities, symbols, and ruins of the war.

The theme of number 47 is among the oldest represented in this exhibition. As the viewer may ascertain upon close inspection of the photograph or, more easily, by reading the caption below, it is a triumphal entry. Whether the photographer knew in advance that the billowing awning would so perfectly express the spirit of the theme, or whether he was allowed no closer by the security forces, is open to question.

George N. Barnard
American, 1819-1902

48. *The Battleground of Resaca,* 1864-65
Albumen-silver print from a glass negative
10¼ × 14³/₁₆ in. (25.7 × 36 cm)
Printed on the mount: *Photo from nature By G. N. Barnard/BATTLE GROUND OF RESACCA, GA. No. 2*
The Museum of Modern Art, New York
Acquired by Exchange with the Library of Congress
Illustrated p. 84

This picture is from *Photographic Views of Sherman's Campaign,* an album of sixty-one photographs published by Barnard in New York in 1866. As Barnard himself explained in the pamphlet he wrote to accompany the album, Sherman's march from Tennessee through Georgia to the sea was so rapid that the photographer had to return to many of the sites after the close of the war. Unlike some of the Civil War photographers, Barnard made no effort in this series of pictures to suggest the fray of battle close at hand. John Szarkowski has pointed out that the pictures "are composed carefully and deliberately, by a photographer who did not fear for his life. The spirit of the pictures is retrospective and contemplative." (In *Looking at Photographs,* New York: The Museum of Modern Art, 1973, p. 28.)

Literature: George N. Barnard, *Photographic Views of Sherman's Campaign,* reprint, preface by Beaumont Newhall (New York: Dover, 1977). Keith F. Davis, "'The Chattanooga Album' and George N. Barnard," *Image,* vol. 23, no. 2 (Dec. 1980), pp. 20-27.

Felice Beato
British, born in Italy. Before 1830 – after 1904

49. *Panorama at Tangku,* 1860
Albumen-silver prints from glass negatives
Eight sheets, overall 8⅝ × 88⅞ in. (21.1 × 223.8 cm)
Inscribed on the mount: *Panorama at Tangkoo, August 10, 1860*
The Museum of Modern Art, New York
Purchased as the Gift of Shirley C. Burden and the Estate of Vera Louise Fraser
Illustrated pp. 75-78

50. *Charge of the Dragoon's Guard at Palichian,* 1860
Albumen-silver print from a glass negative
9¹/₁₆ × 11⅞ in. (23.1 × 30.2 cm)
Inscribed on the mount: *Charge of the Dragoon's Guard at Palichian*
The Museum of Modern Art, New York
Purchased as the Gift of Shirley C. Burden and the Estate of Vera Louise Fraser
Illustrated p. 85

Beato appears to have been one of the most talented, as well as one of the most ubiquitous, early photographers of the Near and Far East. He began his career in the Mediterranean in partnership with James Robertson, whom he met in 1850. Robertson and Beato worked together in Constantinople in the early 1850s and in Sevastopol at the end of the Crimean War in 1855. They next worked in Malta and Palestine and then traveled to India in 1857 to photograph the sites of the Indian Mutiny. Little is known of Robertson's later career, but Beato is known to have traveled next to China, where he documented the Anglo-French campaign of 1860, which successfully forced trade on the Chinese. Beato went to Japan in 1862, was again in

China in 1870, and documented the Mahdist rebellion against the British at Khartoum in the Sudan in 1884-85. In the late 1880s Beato opened shops in Rangoon and Mandalay for mail-order export of Burmese arts and crafts. Felice (or Felix) Beato should be distinguished from Antonio Beato (d. 1903), a topographical photographer based at Luxor from 1862.

These two works are drawn from an album of ninety-two photographs by Felice Beato at The Museum of Modern Art, New York. The album traces the conquests of the Anglo-French North China Expeditionary Force in 1860, beginning with the assembly of the fleet at Hong Kong in the spring of that year. The force traveled north in June and July, taking the Tangku and Taku forts on the coast near Peking on August 14 and 21. Peking itself fell on October 21. The album concludes with portraits of the British leaders of the expedition and a series of photographs that Beato had made in Canton in April.

Beato and an artist named Charles Wirgman (who later traveled with Beato to Japan) worked in China at the invitation of the British military. Wirgman was employed by the *Illustrated London News*, which published engravings based on his sketches. Some of Beato's photographs of the campaign also appeared in engraved form in the *News* (Oct. 6,

1860, p. 314; Oct. 27, 1860, p. 390), as had some of Robertson's Crimean pictures, but Beato's arrangement with the journal is not known.

The Beato album is exemplary of the fine work of early photographers charged to record faraway events and places in difficult circumstances. The photographer's appetite for work apparently was large. D. F. Rennie, a surgeon attached to the North China Expedition, reported thus Beato's reaction to a group of corpses: "Signor Beato was here in great excitement, characterising the group as 'beautiful,' and begging that it might not be interfered with until perpetuated by his photographic apparatus, which was done in a few minutes afterwards." (Quoted by Henisch, p. 9.)

This zeal for the task is also evident in seventeen of the album's photographs, which are composed of two or more prints, pasted together to form panoramas. The *Panorama at Tangku* (no. 49), composed of eight prints, is the largest of these. Like Timothy O'Sullivan in the American West (nos. 68, 69), Beato clearly often felt that he could not accommodate his vast subject to a single plate. Unlike O'Sullivan, who made series of pictures from different points of view, Beato solved the problem by making panoramas, which require nearly as much attention as the subject itself.

Literature: Henry Knollys, *Incidents in the China War of 1860 Compiled from the Private Journals of General Sir Hope Grant, Commander of the English Expedition* (Edinburgh: Blackwood, 1875). Nobuo Ina, "Beato in Japan," *Image*, vol. 15, no. 3 (Sept. 1972), pp. 9-11. B. A. and H. K. Henisch, "Robertson of Constantinople," *Image*, vol. 17, no. 3 (Sept. 1974), pp. 1-9. John Lowry, "Victorian Burma by Post: Felice Beato's Mail-Order Business," *Country Life*, March 13, 1975, pp. 659-60. Jammes, *Egypte*, nos. 19 and 51. Clark Worswick, ed., *Imperial China: Photographs 1850-1912* (New York: Pennwick, 1978), pp. 136-39.

Louis-Auguste Bisson
French, 1814-1876

Auguste-Rosalie Bisson
French, 1826-1900

51. *Cathedral of Notre Dame, Paris, the Saint Marcel Portal, Called the Sainte Anne Portal*, c. 1853
Albumen-silver print from a glass negative
14⁵/₁₆ × 9⁹/₁₆ in. (36.4 × 24.4 cm)
Printed on the mount: *à Paris, A. Morel, éditeur, rue Ste. Anne, 18. Bisson Frères Photog – Imp Lemercier, Paris/VANTAIL DE LA PORTE SAINT MARCEL/dite porte Sainte Anne*
Collection Phyllis Lambert, on loan to the Canadian Centre for Architecture, Montreal
Illustrated p. 95

The Bisson Frères, first established as daguerreotypists in the 1840s, were among the leading professional architectural photographers in France in the 1850s and 1860s. This photograph is plate number 17 from the *Monographie de Notre Dame de Paris et de la nouvelle sacristie de MM. Lassus et Viollet-le-Duc contenant 63 planches, gravés par MM. Hibon, Ribault, Normand, etc., 12 planches photographiques de MM. Bisson Frères, 5 planches chromolithographiques, de M. Lemercier, précédé d'une notice historique et archéologique par M. Celtibère, architecte-archéologue* (Paris: A. Morel, [c. 1853]).

Literature: Philadelphia 1978, pp. 405-06.

Samuel Bourne
British, 1834-1912

52. *A Road Lined with Poplars, Kashmir,* 1863-70
Albumen-silver print from a glass negative
8^{15}/$_{16}$ × 11 in. (22.8 × 27.9 cm)
Inscribed in the negative: *Bourne 801A* (partially
trimmed); inscribed, verso: *801A/A Grove of
Poplars, Kashmir*
Collection Paul F. Walter, New York
Illustrated p. 93

Literature: Clark Worswick, ed., *The Last Empire:
Photography in British India, 1855-1911* (Millerton, New
York: Aperture, 1976). Sean Sprague, "Samuel Bourne:
Photographer of India in the 1860s," *The British Journal
of Photography,* Jan. 14, 1977. G. Thomas, "The First
Four Decades of Photography in India," *History of
Photography,* vol. 3, no. 3 (July 1979), pp. 215-26.

A. Collard
French, before 1840– after 1887

53. *Bridge,* 1860s (?)
Albumen-silver print from a glass negative
9^{15}/$_{16}$ × 13^7/$_8$ in. (25.2 × 35.3 cm)
Blindstamp on the mount: *ATELIER CENTRAL
DE PHOTOGRAPHIE/COLLARD/
PHOTOGRAPHE/DES PONTS ET
CHAUSSEES/Bould. de Strasbourg, 39;* printed on
the mount: *XV*
Collection Samuel J. Wagstaff, Jr., New York
Illustrated p. 101

Collard was an official photographer for the French
Service of Bridges and Roads. He worked in this
capacity through much of the Second Empire
(1852-70), which is to say he had a great deal to do.

His work is not yet fully known, but it appears that
he rarely showed the whole of a given monument.
Instead, he concentrated the spirit of the grand
designs in close details, boldly conceived on large
plates.

Literature: New York 1980, no. 44.

Maxime Du Camp
French, 1822-1894

54. *Profile of the Great Sphinx, from the South,*
1849-51
Salt print from a paper negative
6^1/$_4$ × 8^9/$_{16}$ in. (15.5 × 21.8 cm)
Inscribed on the mount: *Egypte. Profil du grand
sphinx, pris du sud. No. 21*
Gilman Paper Company Collection
Illustrated p. 109

In 1849 budding journalist and man of letters
Maxime Du Camp set off on a second journey to
the far side of the Mediterranean. Even if he had
not persuaded his friend Gustave Flaubert to join
him, the trip would still be a famous one. For it
resulted in one of the earliest and most impressive
photographically illustrated books of the
nineteenth century. Du Camp returned to Paris in
1851 with more than two hundred photographic
negatives on paper.
 In 1852 he published an album of 125 photo-
graphs, printed from his negatives by Blanquart-
Evrard (see no. 43): *Egypte, Nubie, Palestine et
Syrie: Dessins photographiques recueillis pendant
les années 1849, 1850 et 1851.* The picture repro-
duced here, not included in the published album, is
from a portfolio of 175 of Du Camp's photographs
of the Near East, once owned by Viollet-le-Duc and
now in the Gilman Paper Company Collection. The
photograph is one of a series that Du Camp made
of the Sphinx and the Great Pyramids.

Literature: Francis Steegmuller, ed., *Flaubert in Egypt: A
Sensibility on Tour. A Narrative Drawn from Gustave
Flaubert's Travel Notes & Letters* (Boston: Atlantic-Little,
Brown, 1972). Jammes, *Egypte,* nos. 34 ff.

Roger Fenton
British, 1819-1869

55. *Dead Stag,* 1852
Albumen-coated salt print from a paper negative
6^7/$_8$ × 8^1/$_2$ in. (17.7 × 21.5 cm)
Inscribed in the negative: *June 1852/R. Fenton*
Daniel Wolf, Inc., New York
Illustrated p. 83

56. *Lichfield Cathedral, Porch of the South
Transept,* c. 1855
Albumen-silver print from a glass negative
13^7/$_{16}$ × 16^1/$_4$ in. (34.2 × 41.3 cm)
The Museum of Modern Art, New York
John Parkinson III Fund
Illustrated p. 105

Fenton was trained as a painter and as a lawyer. He
took up photography in the mid-1840s, and helped
to found the Calotype Club in 1847 and the Royal
Photographic Society in 1852. Little is known of his
photographic work of this early period, apart from
some views made in Russia. The *Dead Stag* (1852,
no. 55) suggests that the work may have been, like
that of many of the early English amateur photog-
raphers, humble in spirit and modest in subject.
 Fenton's later work is very different. From the
mid-1850s until he abandoned photography at the
end of the decade, he was one of the leading profes-
sional photographers in England—perhaps the
best. He photographed the royal family, the Cri-
mean War, the sculptures of the British Museum,

and the cathedrals and landscape of England and Wales. His commercial work, in other words, dealt with subjects of intrinsic importance.

Literature: John Hannavy, *Roger Fenton of Crimble Hall* (Boston: Godine, 1975).

John Bulkley Greene
American, c. 1832-1856

57. *River Bank, North Africa*, 1855-56
Salt print from a paper negative
9¼ × 11¾ in. (23.5 × 29.8 cm)
Lunn Gallery, Washington, D.C.
Illustrated p. 86

Beaumont Newhall recently established that Greene, long thought to have been British, was American. The son of an American banker living in Paris, the young Greene evidently was closely associated with the formidable group of French photographers of the 1850s that included Henri Le Secq (nos. 62, 63), Gustave Le Gray (no. 61), and Charles Marville (nos. 65, 66). He was a founding member of the Société Française de Photographie in 1855.

In 1854, L.-D. Blanquart-Evrard (see no. 43) printed an album of ninety-four photographs by Greene, entitled *Le Nil, monuments, paysages, explorations photographiques*. Greene's work in Egypt clearly was conceived in part as an archaeological study, but like his slightly later work in Algeria, it includes a number of beautiful pictures of little obvious archaeological value. This photograph belongs to the Algerian series, which (as William F. Stapp of the National Portrait Gallery, Washington, D.C., has established) was made in 1855-56.

Literature: Jammes, *Egypte*, nos. 13-15. New York 1980, no. 73.

Alfred A. Hart
American, active 1864-1875

58. *Rounding Cape Horn*, c. 1869
Stereograph, albumen-silver prints from glass negatives
Two prints, overall 3 × 6⅛ in. (7.6 × 15.6 cm)
Inscribed on the mount: *CENTRAL PACIFIC RAILROAD./CALIFORNIA./56. Rounding Cape Horn./Road to Iowa Hill from the river, in the distance.*
The Museum of Modern Art, New York
Purchase
Illustrated p. 115

The stereograph—a pair of pictures made to simulate binocular vision—was invented in the late 1830s, just before the invention of photography was announced. Soon, virtually all stereographs were stereophotographs, made with a camera whose two lenses were about as far apart as the human eyes. The pictures were viewed through a simple, hand-held device, which visually collapsed the two pictures into one, yielding an astonishing illusion of depth. From the 1850s until the early twentieth century, collecting stereophotographs was a parlor pastime of great popularity.

Photographers met the popular demand with stereo views of nearly everything that was important and a good deal that, by traditional standards, was not. The market for variety and novelty goaded photographers to seek new subjects and new aspects of old subjects. In their search they were aided by the small size of the stereo pictures, which allowed more rapid exposures than those required for larger plates. And the depth illusion invited photographers to compose differently, to look for striking juxtapositions of near and far. Commercially and technically, the stereo format encouraged pictorial invention.

In terms of aesthetic intent, the stereophotographs were as trivial as they were numerous. But like the popular panoramic paintings of the early nineteenth century (see no. 1), the stereos were not unrelated to serious art. Their marginal subjects, unexpected points of view, and casual pictorial order frequently parallel the strategies of advanced painters of the second half of the nineteenth century.

Literature: Oliver Wendell Holmes, "The Stereoscope and the Stereograph" (1859), reprinted in Beaumont Newhall, ed., *Photography: Essays and Images* (New York: The Museum of Modern Art, 1980), pp. 53-61. William C. Darrah, *The World of Stereographs* (Gettysburg, Pennsylvania: the author, [1977]). Edward W. Earle, ed., *Points of View: The Stereograph in America—A Cultural History* (Rochester: Visual Studies Workshop, 1979). New York: Grey Art Gallery and Study Center, *American Stereographs* (exh. cat., 1980).

Humphrey Lloyd Hime
Canadian, born in Ireland. 1833-1903

59. *The Prairie on the Bank of the Red River, Looking South*, 1858
Albumen-silver print from a glass negative
5¼ × 6¾ in. (13.4 × 17.2 cm)
Inscribed, l.l.: *Hime*
The Notman Photographic Archives,
McCord Museum, Montreal
Illustrated p. 92

Hime came to Canada from Ireland in 1854 and found work as a surveyor. In 1857 he joined the firm of the Toronto surveyors Armstrong and Beere, from whom he learned the craft of photography. In 1858 the Canadian Government hired Hime as a photographer and surveyor for the Assiniboine and Saskatchewan Exploring Expedition. Hime made this view in the autumn of 1858, when the expedition reached the Red River.

Professor Henry Youle Hind, the geologist who led the expedition, was not pleased with his photographer's work. Hime returned briefly to Armstrong and Beere but soon left surveying and photography altogether to found his own stock-brokerage firm. In 1867-69 he served the first of two terms as President of the recently founded Toronto Stock Exchange.

Radical formal simplicity is such an important element of modern art that one almost instinctively views Hime's photograph as a bold, adventurous work. The picture, however, is probably best understood as a competent description of an intractably empty landscape.

Literature: Ralph Greenhill, "Early Canadian Photographer, Humphrey Lloyd Hime," *Image*, vol. 2, no. 3 (1962), pp. 9-11. Richard J. Huyda, *Camera in the Interior, 1858: H. L. Hime, Photographer, The Assiniboine and Saskatchewan Exploring Expedition* (Toronto: The Coach House Press, 1975), no. 32.

Jean-Charles Langlois
French, 1789-1870

60. *Detail of the Fortification at Malakhov*, 1855
Albumen-silver print from a paper negative
10⁷/₁₆ × 12⁹/₁₆ in. (26.6 × 31.9 cm)
Collection Texbraun, Paris
Illustrated p. 97

In 1807 Langlois graduated from the Ecole Polytechnique in Paris. He immediately joined Napoleon's army and eventually earned the rank of Colonel. After the battle of Waterloo, Langlois retired to Bourges and began to study painting. In 1817, under the patronage of the War Ministry, he returned to Paris to continue his studies under Antoine-Louis Girodet and Horace Vernet. He first exhibited at the Salon in 1822.

Impressed by the full-circle panoramas of Pierre Prévost (which were of the type invented by Robert Barker; see no. 1), Langlois began to paint his own, exhibiting the first, *The Battle of Navarin*, in 1830. For the next forty years, battle panoramas were his specialty.

Late in 1855, Langlois traveled to Sevastopol, where combined French, British, and Turkish forces had recently defeated the Russians, ending the Crimean War. In order to make photographic studies for his panorama *The Taking of Sevastopol*, which opened in Paris in 1860, Langlois enlisted the aid of Léon-Eugène Méhédin and Frédéric Martens. Pre-sumably under Langlois's direction, the two photographers made a number of individual studies, such as number 60, and a series of fourteen contiguous pictures that form an uninterrupted panorama of 360 degrees (Collection Texbraun, Paris). The photographs were made not at Sevastopol but at Malakhov, a crucial fortified point just east of the city. Twenty-nine photographs from the campaign are preserved at the Bibliothèque Nationale, Paris, in an album entitled *Souvenirs de la guerre de Crimée, Hommage à S. M. L'Empereur Napoléon III par le Colonel C. Langlois.*

Literature: Germain Bapst, *Essai sur l'histoire des panoramas et des dioramas* (Paris: Imprimerie National, 1889), pp. 22-26. Edinburgh: The Scottish Photography Group, *Mid 19th Century French Photography* (exh. cat., 1979), no. 32. New York 1980, nos. 100, 101.

Gustave Le Gray
French, 1820-1882

61. *Beech Tree*, c. 1855-57
Albumen-silver print from a glass negative
12⁹/₁₆ × 15⁹/₁₆ in. (31.9 × 39.5 cm)
Stamped, l.r.: *Gustave Le Gray*; blindstamp on the mount: *PHOTOGRAPHIE/GUSTAVE LE GRAY & C/PARIS*
Private collection
Illustrated p. 81

Several of the best and most original early photographers were trained as painters. Gustave Le Gray, Charles Nègre (no. 67), Henri Le Secq (nos. 62, 63), and Roger Fenton (nos. 55, 56) all studied in the 1840s in the Paris studio of Paul Delaroche. This is not to say that they followed Delaroche's style, but only that they worked in the large and diverse

studio of one of the most popular and successful painters of the day.

The photographers who had been trained as painters naturally were well acquainted with the tradition of landscape sketching in oil that is represented in the first half of this exhibition. In general, the relationship between the paintings and photographs shown here is one of shared artistic outlook, not direct influence; but it is certain that some of the painter-photographers drew on the sketching tradition. Exemplary of this development are Le Gray's photographs of the forest of Fontainebleau, especially number 61. The forest—a domain of wild nature easily reached from Paris—had been a haunt of painters since the 1820s. Initially it had been above all a place to sketch, but in the 1840s and 1850s the painters of Barbizon, near Fontainebleau, increasingly favored more elaborate compositions. In this period, the photographers helped to preserve the tradition of the *étude d'après nature*—the small, direct study after nature.

Literature: Paris 1976-77, p. 27. Philadelphia 1978, pp. 411-16. Philippe Néagu et al., eds., *La Mission héliographique: Photographies de 1851* (exh. cat., Paris: Direction des Musées de France, 1980), pp. 69-91. New York 1980, nos. 79-84.

Henri Le Secq
French, 1818-1882

62. *Chartres Cathedral, South Transept Porch, Central Portal,* 1851-52
Photolithograph
13 1/8 × 9 5/16 in. (33.4 × 23.7 cm)
Inscribed in the plate: *h. Le secq./chartres*
Collection Phyllis Lambert, on loan to the Canadian Centre for Architecture, Montreal
Illustrated p. 99

Figure 35. Henri Le Secq. *The Quarry at Saint-Leu,* c. 1852. Cyanotype from a paper negative, 8 5/8 × 12 3/4 in. International Museum of Photography at George Eastman House, Rochester

63. *Garden Scene,* c. 1852
Salt print from a paper negative
12 13/16 × 9 11/16 in. (32.6 × 24.7 cm)
Inscribed in the negative: *h. Le Secq*
International Museum of Photography at George Eastman House, Rochester
Illustrated p. 98

Number 62 is drawn from a portfolio of twenty-five lithographs by Le Secq: *Fragments d'architecture et sculpture de la cathédrale de Chartres d'après les clichés de Mr. le Secq, artiste peintre, et imprimés à l'encre grasse par Mrs. Thiel aîné et cie* (Paris, [1852]). Like many other early French photographers, Le Secq spent a good deal of his brief photographic career documenting medieval cathedrals. He photographed extensively in Alsace, Lorraine, and Champagne, and at Chartres, Amiens, Rheims, and Strasbourg. This aspect of his work would be valuable even if it were not beautiful.

The subjects of many of Le Secq's most original photographs, however, are anything but important. There is an extraordinary series of views of the quarries at Saint-Leu (fig. 35) and a large number of landscapes. The latter are rarely general views of idyllic or conventionally interesting spots. Nor do most of them have the stately grandeur of Le Gray's

equally original work (no. 61). The pictures are, rather, personal and even eccentric. Le Secq's landscapes, if indeed works like the *Garden Scene* (no. 63) may be classified as landscapes, are perhaps the first extended group of pictures to make the case that nearly anything may be the subject of a beautiful photograph.

Literature: Eugenia Parry Janis, "Man on the Tower of Notre Dame: New Light on Henri Le Secq," *Image*, vol. 19, no. 4 (Dec. 1976), pp. 13-25. Philadelphia 1978, pp. 416-17. Janet E. Buerger, "Le Secq's 'Monuments' and the Chartres Cathedral Portfolio," *Image*, vol. 23, no. 1 (June 1980), pp. 1-5. Philippe Néagu et al., eds., *La Mission héliographique: Photographies de 1851* (exh. cat., Paris: Direction des Musées de France, 1980), pp. 51-68.

Robert MacPherson
British, 1811-1872

64. *The Theater of Marcellus, from the Piazza Montanara, Rome,* c. 1855
Albumen-silver print from a glass negative
16 1/16 × 11 1/4 in. (40.9 × 28.6 cm)
Collection Samuel J. Wagstaff, Jr., New York
Illustrated p. 103

A surgeon from Edinburgh, MacPherson moved to Rome for his health in the 1840s. In 1851 he took up photography. The 1858 edition of John Murray's *Handbook of Rome* (London; p. xix) speaks of MacPherson as one of the first to have practiced photography in Rome. By 1863, when he published a broadsheet listing 305 subjects (*MacPherson's Photographs, Rome*), he was well established as one of the city's leading photographers.

MacPherson's photographs were for sale; the broadsheet mentions a price of five shillings. But his work, like that of the Bisson Frères (no. 51), Roger Fenton (nos. 55, 56), and other contemporary commercial photographers, is different from the

slightly later productions of the Alinari Brothers and similar firms. Most obviously, the earlier pictures are larger in scale and fewer in number. They are also in general more thoughtfully composed. It is as if the early architectural photographers could not rid themselves of the notion that picture-making was a labor of time, intelligence, and love.

The Theater of Marcellus is also the subject of Ernst Meyer's painting (no. 32), which MacPherson almost certainly did not know.

Literature: Helmut and Alison Gernsheim, "Robert Mac-Pherson," *Ferrania*, vol. 8, no. 10 (Oct. 1954), pp. 2-4. Copenhagen: The Thorvaldsen Museum, *Rome in Early Photographs: The Age of Pius IX* (exh. cat., 1977). Piero Becchetti, *Fotografi e fotografia in Italia 1839-1880* (Rome: Quasar, 1978).

Charles Marville
French, active 1851-1879

65. *Spire of the Chapel of the Collège Saint Dizier (Haute Marne)*, 1860s (?)
Albumen-silver print from a glass negative
14¼ × 9⅞ in. (36.2 × 25.1 cm)
Printed on the mount: *CHAPEL DU COLLÈGE ST. DIZIER (HTE. MARNE)/PAR MR. FISBACQ ARCHITECTE/CH. MARVILLE PHOT/ FLÊCHE EN PLOMB MARTELÉ/EXÉCUTÉ PAR MONDUIT BÉCHET;* blindstamp on the mount: *CH. MARVILLE/PHOTOGRAPHE/DU MUSÉE IMPÉRIAL/DU LOUVRE.*
Gilman Paper Company Collection
Illustrated p. 104

66. *Place de l'Etoile, Paris*, 1860s (?)
Albumen-silver print from a glass negative
8⁹/₁₆ × 14⁷/₁₆ in. (22.8 × 36.7 cm)
Blindstamp on the mount: *CH MARVILLE/ PHOTOGRAPHE/DES MUSÉES NATIONAUX/75, RUE D'ENFER/PARIS;* inscribed on the mount: *No. 43 Place de L'arc de Triomphe/prise de la Place.*
Collection Samuel J. Wagstaff, Jr., New York
Illustrated p. 110

Among the great French architectural photographers of the Second Empire, Marville is most closely associated with the city of Paris. Under official patronage, he methodically documented the old streets of the city that were soon to be destroyed to make way for the new boulevards of Baron Haussmann. He also photographed the new Paris.

Although Marville is best known for his Parisian work, it is only one aspect of his total production. He also contributed to Blanquart-Evrard's portfolios of the early 1850s (see no. 43), and recorded famous monuments throughout France.

Literature: Philadelphia 1978, pp. 419-20. Paris: Galerie Octant, *Charles Marville: Etudes de ciels* (exh. cat., 1978). New York 1980, nos. 98, 99. Paris: Bibliothèque Historique de la Ville de Paris, *Charles Marville: Photographe de Paris de 1851 à 1879* (exh. cat., 1980-81).

Charles Nègre
French, 1820-1880

67. *Miller at Work, Grasse*, 1852-53
Salt print from a paper negative
8¹/₁₆ × 6⁵/₁₆ in. (20.4 × 16 cm)
Collection André and Marie-Thérèse Jammes, Paris
Illustrated p. 117

Trained as a painter, Nègre took up photography about 1844. Like Gustave Le Gray (no. 61), he brought an artist's seriousness and the themes of contemporary painting to his photographic work. This is especially clear in his work for a projected volume of photographs titled *Le Midi de la France*. In late 1852 and early 1853 Nègre made over two hundred negatives in the region of southeast France called the Midi, which includes the town of Grasse, where he was born. In 1854 two fascicles of the publication appeared, comprising ten photographs; the remainder were never published.

Nègre's photographs document the ancient and medieval monuments of the Midi, the landscape, the seaports, and aspects of provincial life: the people's houses, their faces, their work. It is an ambitious series of pictures, based on the notion that the Midi was not merely a collection of famous views and buildings but a coherent geographical and social whole, with a rich history and a contemporary population whose appearance and customs were worthy of study and preservation. This conception of the provinces of France was widely shared by writers and painters of the 1830s through the 1850s. It fostered a number of genre pictures, such as Nègre's *Miller at Work, Grasse* (no. 67), whose subjects are conceived not as unique individuals nor as general representatives of all mankind but as characteristic types of a specific region.

Literature: Ottawa: National Gallery of Canada, *Charles Nègre 1820-1880*, by James Borcoman (exh. cat., 1976), no. 39. Paris: Réunion des Musées Nationaux, *Charles Nègre Photographe*, by Françoise Heilbrun (Dossier d'Orsay no. 2, exh. cat., 1980-81), no. 96.

Timothy H. O'Sullivan
American, c. 1840-1882

68. *Steam Rising from a Fissure near Virginia City, Nevada*, 1867-69
Albumen-silver print from a glass negative
$7^{15}/_{16} \times 10^{13}/_{16}$ in. (20.2 × 27.4 cm)
Gilman Paper Company Collection
Illustrated p. 90

69a-c. *Buttes near Green River City, Wyoming*, 1867-69
Three works, each albumen-silver print from a glass negative
a and b: $7^7/_8 \times 10^1/_2$ in. (20 × 26.7 cm)
c: $10^1/_2 \times 7^7/_8$ in. (26.7 × 20 cm)
The Library of Congress, Washington, D.C.
Illustrated pp. 106-08

O'Sullivan's first subject was the American Civil War. Later he worked in the American West and in Panama as a photographer to the great government geological surveys. In each case he recorded, with astonishing poise, a reality that was vast, complex, difficult of access, important, and known by few at first hand.

O'Sullivan's first campaign as a survey photographer began in 1867, when he joined the first of the surveys, the Geological Exploration of the Fortieth Parallel, directed by Clarence King. The survey party left Sacramento in July 1867, moving eastward, and finished its work by September 1869. O'Sullivan photographed in Nevada, Utah, Colorado, Idaho, and Wyoming.

In his work under King, O'Sullivan frequently made several photographs of a given site. These were not multiple attempts at a single view but series of interdependent pictures. Most often, as in the series of four photographs of buttes near Green River City (three, no. 69a-c), O'Sullivan simply var-

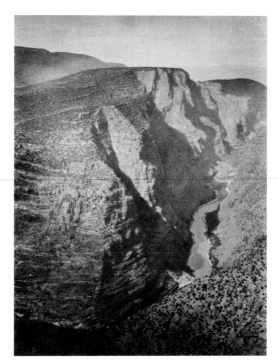

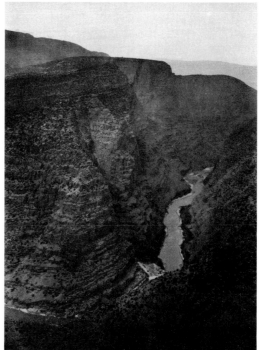

Figures 36 and 37. Timothy H. O'Sullivan. Two of six views of the Green River, Colorado, 1867-69. Albumen-silver prints from glass negatives, each $10^1/_2 \times 7^7/_8$ in. The Library of Congress, Washington, D.C.

ied his point of view. He also made a stunning series of six photographs of the Green River (e.g., figs. 36, 37), in which only the light changes.

O'Sullivan's acute sensitivity to the variety of aspect offered by any site doubtless contributed to the perfect order of his single pictures.

Literature: New York and Buffalo 1975, pp. 125-65. "Photographs from the High Rockies" (1869), reprinted in Beaumont Newhall, ed., *Photography: Essays and Images* (New York: The Museum of Modern Art, 1980), pp. 121-27.

Andrew Joseph Russell
American, 1830-1902

70. *Pontoon Bridge Crossed by General Ord, at Akin's Landing*, 1864
Albumen-silver print from a glass negative
$8 \times 11^{13}/_{16}$ in. (20.4 × 30 cm)
Printed on the mount: *PONTOON BRIDGE CROSSED BY GEN. ORD, AT AKIN'S LANDING/October 1864*
Collection Samuel J. Wagstaff, Jr., New York
Illustrated p. 111

Russell is best known for his photographs documenting the completion of the first American transcontinental railroad, in 1869. Like many of the pioneer photographers of the West, he had also worked earlier recording the sites of the Civil War. He had served as a Captain in the U.S. Military Railroad Construction Corps, photographing bridges and fortifications, the architecture and materials of the war. As Weston J. Naef has pointed out, Russell's pictures present the war not as a conflict but as an accomplishment of logistics and engineering.

Literature: New York and Buffalo 1975, pp. 201-18.

Auguste Salzmann
French, 1824-1872

71. *Jerusalem, the Temple Wall, West Side*, 1853-54
Salt print from a paper negative
9³/₁₆ × 13⅛ in. (23.4 × 33.4 cm)
Printed on the mount: *Aug. Salzmann/ JÉRUSALEM/ENCEINTE DU TEMPLE, CÔTÉ OUEST/Heit-el-Morharby/Gide et J. Baudry, éditeurs, Imp. Photogr. de Blanquart-Evrard, à Lille.*
The Museum of Modern Art, New York
Purchase
Illustrated p. 102

On the basis of an archaeological investigation of Jerusalem in 1850, a French antiquarian named Louis-Félicien Caignart de Saulcy concluded that the oldest architecture of the city was much earlier in date than had been previously thought. He claimed some parts of the city for the era of Solomon (tenth century B.C.). De Saulcy's argument, and the drawings he used to support it, were severely questioned.

In December 1853 Salzmann, a young painter and budding archaeologist, set out for Jerusalem to gather evidence for de Saulcy in the form of photographs. (He took with him an assistant named Durheim. As James Borcoman has pointed out, it is not clear whether Salzmann alone, or Durheim under Salzmann's direction, made the photographs.) Four months later, Salzmann returned to France with some 150 paper negatives. Durheim, who stayed behind, added another fifty. Of the total, 174 pictures were published in an album, printed at the Lille establishment of Blanquart-Evrard (see no. 43), and titled *Jérusalem. Etude et reproduction photographique des monuments de la Ville Sainte depuis l'époque judaïque jusqu'à nos jours* (Paris: Gide et Baudry, 1856). In the preface to the text that Salzmann wrote to accompany the pictures, he stated: "These photographs are no longer tales, but sure facts endowed with a conclusive brute force" (p. 4).

Salzmann had begun his work with the wall shown in number 71, which de Saulcy had recognized as part of the Temple of Solomon, citing the mention of "costly stones, even great stones" in the Old Testament (1 Kings 7:10). In his text (p. 6), but not in the printed caption to the picture, Salzmann identified the subject as the Wailing Wall.

Literature: Vancouver: Vancouver Art Gallery, *The Painter as Photographer: David Octavius Hill, Auguste Salzmann, Charles Nègre*, James Borcoman, intro. (exh. cat., 1978-79). Eyal Onne, *Photographic Heritage of the Holy Land 1839-1914* (Manchester, England: Manchester Polytechnic, 1980). New York 1980, no. 139.

Pierre-Charles Simart (?)
French, 1806-1857

72. *Shrub*, c. 1856
Salt print enlarged from a glass negative
12⅝ × 17¹/₁₆ in. (32.1 × 43.3 cm)
Collection André and Marie-Thérèse Jammes, Paris
Illustrated p. 96

Literature: Chicago: The Art Institute of Chicago, *Niépce to Atget: The First Century of Photography from the Collection of André Jammes* (exh. cat., 1978), no. 83.

Albert Sands Southworth
American, 1811-1894

Josiah Johnson Hawes
American, 1808-1901

73. *Captain Jonathan W. Walker's Branded Hand*, c. 1845
Daguerreotype
2¼ × 2⅝ in. (5.7 × 6.7 cm)
Massachusetts Historical Society, Boston
Illustrated p. 82

74. *Marion Augusta Hawes* or *Alice Mary Hawes*, c. 1855-60
Daguerreotype
4 × 3 in. (10.2 × 7.6 cm)
Stamped, l.l.: *SCOVILL MFG Co/EXTRA*
International Museum of Photography at George Eastman House, Rochester
Illustrated p. 91

Southworth and Hawes formed a partnership in Boston in 1843. Their business in daguerreotype portraits flourished, doubtless because their work was both technically and artistically fine. They often triumphed over the long exposures their medium required, producing portraits that seem to capture a momentary expression.

These two works are not representative of Southworth and Hawes's public commercial work. The first (no. 73) shows the branded hand of a Florida sea captain who, in 1844, attempted to sail seven slaves to freedom, earned the brand "SS" ("slave stealer") for his trouble, and later became an ardent abolitionist. (The hand, like the subject of every daguerreotype, is laterally reversed.) The second daguerreotype (no. 74), perhaps made by Hawes alone, is a portrait of one of his daughters: Marion Augusta (1855-1941) or Alice Mary (1850-1938).

Literature: Robert A. Sobieszek and Odette M. Appel, *The Spirit of Fact: The Daguerreotypes of Southworth & Hawes, 1843-1862* (Boston: Godine, 1976), nos. 18 and 51.

William James Stillman
American, 1828-1901

75. *The Parthenon, Athens, Profile of the Eastern Facade,* 1868-69
Carbon print from a glass negative
$7^3/_8 \times 9^3/_8$ in. (18.7 × 23.8 cm)
Inscribed in the negative: *17*
The Museum of Modern Art, New York
Gift of Miss Frances Stillman
Illustrated p. 100

Stillman was an accomplished journalist, a historian, a diplomat, an artist, and not least, a photographer. In 1855 he founded the first substantial journal of American art, *The Crayon.* In 1857, while recovering in Florida from an attack of pneumonia, he took up photography. Later, Stillman continued to photograph on Crete, where he was appointed U.S. consul in 1865. His support of the Cretan insurrection angered the ruling Turkish pasha, and in 1868 he left Crete for Athens. There Stillman "set about photographing the

ruins, [which he] found had never been treated intelligently by the local photographers" *(Autobiography,* vol. 2, p. 455). The result was an album of twenty-five photographs: *The Acropolis of Athens Illustrated Picturesquely and Architecturally in Photography* (London: F. S. Ellis, 1870).

Stillman's photographs for the album are both beautiful pictures and intelligent representations of the architectural logic of the Acropolis. The rationale for this bold detail, plate number 17 in the album, is explained in Stillman's caption: "Profile of the eastern facade, showing the curvature of the stylobate. The system of curvatures of the Greek temples (which will also be seen in No. 12) with regard to which so much discussion has taken place, seems, taken in connection with the diminution of the extreme intercolumniations of the facade (seen in No. 16), to indicate, as its purpose, the exaggeration of the perspective, and, consequently, of the apparent size of the building. It is common to the Greek temples of the best epoch." (This note is based in part on research by Richard Bullock.)

Literature: W. J. Stillman, *The Autobiography of a Journalist,* 2 vols. (Boston: Houghton Mifflin, 1901). Nelson F. Adkins, *Dictionary of American Biography,* rev. ed. (New York: Scribner's, 1963-64), vol. 9, part 2, pp. 29-30. Elizabeth Lindquist-Cock, "Stillman, Ruskin & Rosetti: The Struggle between Nature and Art," *History of Photography,* vol. 3, no. 1 (Jan. 1979), pp. 1-14.

William Henry Fox Talbot
British, 1800-1877

76. *The Open Door,* 1843
Salt print from a paper negative
$5^7/_{16} \times 7^3/_8$ in. (13.9 × 18.7 cm)
Arnold H. Crane Collection, Chicago
Illustrated p. 88

Of the inventors of photography, the most interesting as photographers are Hippolyte Bayard and Fox Talbot. The two are closest in the quiet, contemplative pictures that each made of his own immediate environment. *The Open Door* (no. 76), made in the courtyard of Talbot's estate at Lacock Abbey, is one of these. Talbot published the picture in *The Pencil of Nature* (1844-46), a thoughtful and prescient survey of photography's potential scientific and aesthetic applications. He illustrated the book with his own photographs, each accompanied by a brief commentary. In reference to *The Open Door,* Talbot wrote that "we have sufficient authority in the Dutch school of art, for taking as subjects of representation scenes of daily and familiar occurrence. A painter's eye will often be arrested where ordinary people see nothing remarkable." The passage speaks for the great role of seventeenth-century Dutch art in the nineteenth century: The earlier art gave painters (and photographers) the authority to base their work on personal observation instead of academic rules — and, in doing so, to choose subjects even more humble than those of the Dutch.

Literature: Talbot, *The Pencil of Nature,* (1844-46), reprint, Beaumont Newhall, intro. (New York: Da Capo, 1969), pl. 6. Gail Buckland, *Fox Talbot and the Invention of Photography* (Boston: Godine, 1980), with extensive bibliography.

Linnaeus Tripe
British, 1822-1902

77. Ava, Upper Burma, 1855-56
Salt print from a paper negative
10⅝ × 13½ in. (27 × 34.4 cm)
Collection Phyllis Lambert, on loan to the
Canadian Centre for Architecture, Montreal
Illustrated p. 94

For many years the army officers of the British East
India Company had documented the architecture of
the Indian subcontinent in drawings and paintings.
In 1855 the Company adopted photography for this
purpose, noting the medium's usefulness "as a
means by which representations may be obtained of
scenes and buildings, with the advantages of perfect
accuracy, small expenditure of time, and moderate
cash." (Quoted by Desmond, p. 316.) Linnaeus
Tripe, already in India, was among the first to
photograph for the Company.

Born and educated in England, Tripe enlisted in
1839 as an ensign in the Twelfth Madras Native
Infantry. In 1851, he earned the rank of Captain.
Four years later he became an official photographer
to the British Mission at the Court of Ava in Burma
and, in 1856, Government Photographer to the
Madras Presidency. In 1857-58 he published a
series of ten albums containing over three hundred
of his splendid photographs of the architecture of
India and Burma. After 1861, when Tripe became a
Major, he seems to have made no more photo-
graphs.

Literature: London: Royal Photographic Society, *Captain
Linnaeus Tripe – 1822 to 1902: Photographs in India and
Burma in the 1850s,* Usha Desai, intro. (typescript exh.
cat., 1977). R. Desmond, "19th Century Indian Photog-
raphers in India," *History of Photography,* vol. 1, no. 4
(Oct. 1977), pp. 313-17.

BIBLIOGRAPHY

The effort to disencumber the introduction (pp. 11-29) of lengthy notes has necessitated a bibliographical essay of this sort. It follows the plan of the introduction as closely as possible. Studies of individual artists, cited in the catalogue entries, are not repeated here.

On the relationship between painting and photography and especially on the role of artistic tradition in the invention of photography, the most perceptive essay I have found is J. A. Schmoll gen. Eisenwerth's "Vom Sinn der Fotografie," in Otto Steinert, ed., *Subjective Fotografie 2* (Munich: Brüder Auer, 1955), pp. 25-40. It includes many stimulating propositions that are absent from Schmoll's later essay, "Zur Vor- und Frühgeschichte der Photographie in ihrem Verhältnis zur Malerei," pp. 8-13, in the Zurich catalogue, edited by Erika Billeter, cited below. Also original and provocative, with an extensive bibliography, is Ursula Peters's *Stilgeschichte der Fotografie in Deutschland 1839-1900* (Cologne: DuMont, 1979). See also Peters, "Die beginnende Photographie und ihr Verhältnis zur Malerei," in Cologne: Josef-Haubrich-Kunsthalle, *"In unnachahmlicher Treue": Photographie im 19. Jahrhundert —ihre Geschichte in den deutschsprachigen Ländern* (exh. cat., 1979), pp. 59-82.

Parallel to my argument here is that of Kirk Varnedoe in "The Artifice of Candor: Impressionism and Photography Reconsidered," *Art in America*, vol. 68, no. 1 (Jan. 1980), pp. 66-78.

I am above all indebted to the work of John Szarkowski, especially *The Photographer's Eye* (New York: The Museum of Modern Art, 1966) and *Looking at Photographs* (New York: The Museum of Modern Art, 1973). I also owe a great deal to the extraordinary book of William M. Ivins, Jr., *Prints and Visual Communication* (Cambridge, Massachusetts: Harvard University Press, 1953).

The most thorough exposition of the notion that the invention of photography satisfied a longing for realism is to be found in Heinz Buddemeier, *Panorama Diorama Photographie: Entstehung und Wirkung neuer Medien im 19. Jahrhundert* (Munich: Wilhelm Fink, 1970).

The suggestion that photography adopted the representational function of painting is present in Heinrich Schwarz, "Art and Photography," *Magazine of Art*, vol. 42, no. 7 (Nov. 1949), p. 252: "Through the technique of photography the principles initiated in the days of the renaissance reached their climax and limits and were, so to speak, led into absurdities, thus preparing the ground for the new approach and turning point at the beginning of the twentieth century, which may be typified by the proclamation of the German expressionists in 1907: 'Today photography takes over exact representation. Thus painting, relieved from this task, gains its former freedom of action.'" Schwarz does not cite the source of the quotation.

An analogous, although more complex, argument is to be found in Pierre Francastel, *Peinture et société: Naissance et destruction d'un espace plastique, de la Renaissance au Cubisme* (Paris: Gallimard, 1965), pp. 129 ff. See also Mario Praz, *Mnemosyne: The Parallel between Literature and the Visual Arts* (Princeton, New Jersey: Princeton University Press, 1970), pp. 233-34, n. 16, where Francastel is cited and discussed, and E. H. Gombrich, *The Story of Art* (London: Phaidon, 1966), p. 397.

The authoritative technical history and prehistory of photography remains Josef Maria Eder's *History of Photography* (4th ed., 1932; translated by Edward Epstean, 1945; reprint, New York: Dover, 1978).

The basis of any critical discussion of the history of photography is Beaumont Newhall's *The History*

of Photography from 1839 to the Present Day (4th ed. rev., New York: The Museum of Modern Art, 1964). The other standard histories are: Helmut and Alison Gernsheim, *The History of Photography from the Camera Obscura to the Beginning of the Modern Era* (New York: McGraw-Hill, 1969) and Raymond Lécuyer, *Histoire de la photographie* (Paris: Baschet, 1945).

On the invention of photography see:

Arnold, H. J. P. *William Fox Talbot: Pioneer of Photography and Man of Science*. London: Hutchinson Benaham Ltd., 1977.

Buckland, Gail. *Fox Talbot and the Invention of Photography*. Boston: Godine, 1980.

Coe, Brian. *The Birth of Photography*. New York: Taplinger Publishing Co., 1977.

Essen: Museum Folkwang. *Hippolyte Bayard, ein Erfinder der Photographie*. Exh. cat., 1959-60.

Gernsheim, Helmut and Alison. *L. J. M. Daguerre: The History of the Diorama and the Daguerreotype*. 1956. Reprint. New York: Dover, 1968.

Jammes, André. *Hippolyte Bayard: Ein verkannter Erfinder und Meister der Photographie*. Lucerne: C. J. Bucher, 1975.

_____. *William H. Fox Talbot: Inventor of the Negative-Positive Process*. New York: Macmillan, 1973.

Kossoy, Boris. "Hercules Florence, Pioneer of Photography in Brazil." *Image*, vol. 20, no. 1 (March 1977), pp. 12-21.

Litchfield, R. B. *Tom Wedgwood: The First Photographer*. London, 1903.

London: The Arts Council of Great Britain. *'From Today Painting Is Dead': The Beginnings of Photography*. Exh. cat., 1972.

Naef, Weston. "Hercules Florence 'Inventor do Photographia.'" *Artforum*, vol. 14, no. 6 (Feb. 1976), pp. 57-59.

Newhall, Beaumont. *Latent Image: The Discovery of Photography*. New York: Doubleday & Co., 1967.

Paris: Musée des Arts Décoratifs. *Un Siècle de photographie de Niépce à Man Ray*. Exh. cat., 1965. Extensive bibliography.

Potoniée, Georges. *The History of the Discovery of Photography*. Translated by Edward Epstean, 1936. Reprint, New York: Arno Press, 1978.

Stenger, Erich. "Aus Frühgeschichte der Photographie: Aus welchen Berufen kamen die ersten Lichtbilder?" *Das Atelier des Photographen*, vol. 38 (1931).

_____. *Die beginnende Photographie im Spiegel von Tageszeitungen und Tagebüchern, nach hauptsächlich in der Schweiz durchgeführten Forschungen*. 2d ed. Würzburg, 1943.

Thomas, D. B. *The First Negatives: An Account of the Discovery and Early Use of the Negative-Positive Process*. London: Her Majesty's Stationery Office (HMSO), 1964.

_____. *The Science Museum Photography Collection*. London: HMSO, 1969.

The most important and influential work on painting and photography is Aaron Scharf, *Art and Photography* (London: Penguin, 1968). See also:

Chiarenza, Carl. "Notes toward an Integrated History of Picturemaking." *Afterimage*, vol. 7, nos. 1 and 2 (Summer 1979), pp. 35-41.

Coke, Van Deren. *The Painter and the Photograph: From Delacroix to Warhol*. Albuquerque: University of New Mexico Press, 1964.

Heilbrun, Françoise. "Photographie et peinture." In Michel Laclotte, ed., *Petit Larousse de la peinture*, vol. 2, pp. 1428-34. Paris: Larousse, 1979.

Mayor, A. Hyatt. "The Photographic Eye." *Bulletin of the Metropolitan Museum of Art* (Summer 1946), pp. 15-26.

Stelzer, Otto. *Kunst und Photographie: Kontakte, Einflüsse, Wirkungen*. 2d ed. Munich: R. Piper & Co., 1978.

Turin: Museo Civico. *Combattimento per un'immagine: Fotografi e pittorie*. Exh. cat., 1973.

Vigneau, André. *Une Brève Histoire de l'art de Niépce à nos jours*. Paris: Robert Laffont, 1963.

Zurich: Kunsthaus. *Malerei und Photographie im Dialog von 1840 bis heute*. Edited by Erika Billeter. Exh. cat., 1977.

The most valuable works concerned with the invention of photography in a social context are:

Benjamin, Walter. "A Short History of Photography" (1931). Translated by Phil Patton, *Artforum*, vol. 15, no. 6 (Feb. 1977), pp. 46-51.

_____. "The Work of Art in the Age of Mechanical Reproduction." In Hannah Arendt, ed., *Illuminations*, pp. 217-51. New York: Schocken Books, 1969.

Braive, Michel F. *The Era of the Photograph: A Social History*. London: Thames & Hudson, 1965.

Freund, Gisèle. *La Photographie en France au dix-neuvième siècle: Essai de sociologie et d'esthétique*. Paris, 1936.

_____. *Photography and Society*. Boston: Godine, 1980.

Rudisill, Richard. *Mirror Image: The Influence of the Daguerreotype on American Society*. Albuquerque: University of New Mexico Press, 1971.

The authoritative study of the functions of linear perspective is M. H. Pirenne's *Optics, Painting & Photography* (Cambridge, England: Cambridge University Press, 1970), with extensive bibliography. Of the many works concerned with the history

and meaning of perspective, I have profited most from the following, especially the essays by Panofsky and Ivins:

Bunim, Miriam Schild. *Space in Medieval Painting and the Forerunners of Perspective.* New York: Columbia University Press, 1940.

Carter, B. A. R. "Perspective." In H. Osborne, ed., *Oxford Companion to Art.* Oxford, England: Clarendon Press, 1970.

Gombrich, E. H. "Mirror and Map: Theories of Pictorial Representation." In *Philosophical Transactions of the Royal Society of London,* vol. 270, no. 903 (1975), pp. 119-49.

Ivins, William M., Jr. *On the Rationalization of Sight.* 1938. Reprint, New York: Da Capo, 1973.

_____. *Art & Geometry: A Study in Space Intuitions.* 1946. Reprint, New York: Dover, 1964.

Jantzen, Hans. "Die Raumdarstellung bei kleiner Augendistanz." *Zeitschrift für Aesthetik und allgemeine Kunstwissenschaft,* vol. 6 (1911), pp. 119-23.

Panofsky, Erwin. "Die Perspektive als 'Symbolische Form.'" In *Vorträge der Bibliothek Warburg* (1924-25), pp. 258-330.

Snyder, Joel. "Picturing Vision." *Critical Inquiry,* vol. 6, no. 3 (Spring 1980), pp. 499-526.

Some of the most interesting recent investigations of the aesthetic history of perspective have focused on seventeenth-century Dutch painting. A good introduction to this work is the text and bibliography of Arthur K. Wheelock, Jr., *Perspective, Optics, and Delft Artists around 1650* (New York: Garland Publishing, 1977). See also Walter A. Liedtke's excellent review of Wheelock in *The Art Bulletin,* vol. 61 (1979), pp. 490-96.

Before Photography would have been impossible without the considerable scholarly attention that has been given in the last decade to landscape painting around 1800. Much of the new work has appeared in exhibition catalogues, of which the following are the most useful:

Bremen: Kunsthalle. *Zurück zur Natur: Die Künstlerkolonie von Barbizon: Ihre Vorgeschichte und ihre Auswirkung.* 1977-78.

Detroit: Institute of Arts. *Romantic Art in Britain: Paintings and Drawings 1760-1860.* 1968.

Hamburg: Kunsthalle. *William Turner und die Landschaft seiner Zeit.* 1976.

London: British Museum. *French Landscape Drawings and Sketches of the Eighteenth Century.* 1977.

London: The Tate Gallery. *Landscape in Britain c. 1750-1850.* 1973.

Munich: Städtische Galerie im Lenbachhaus. *Münchner Landschaftsmalerei 1800-1850.* 1979.

New York: The Metropolitan Museum of Art. *French Painting 1774-1850: The Age of Revolution.* 1975.

Paris: Orangerie des Tuileries. *La Peinture allemande à l'époque du Romantisme.* 1976-77.

I have also depended greatly upon four fine studies of the landscape sketch in oil:

Boston: Museum of Fine Arts. *Close Observation: Selected Oil Sketches by Frederic E. Church.* Edited and introduction by Theodore E. Stebbins, Jr. Exh. cat., 1978.

Philip Conisbee. "Pre-Romantic *Plein-Air* Paintings." *Art History,* vol. 2, no. 4 (Dec. 1979), pp. 413-28.

London: The Arts Council of Great Britain. *Painting from Nature: The Tradition of Open-Air Oil Sketching from the 17th to 19th Centuries.* Introduction by Lawrence Gowing, catalogue by Philip Conisbee. Exh. cat., 1980-81. (Gowing's introduction is based on a lecture, which I heard at Columbia University, New York, on Dec. 6, 1978.)

Norwich: Norwich Castle Museum. *A Decade of English Naturalism, 1810-1820.* Edited and introduction by John Gage. Exh. cat., 1969-70.

These studies in turn form part of a growing interest in all kinds of oil sketch, which first found major expression in *Masters of the Loaded Brush: Oil Sketches from Rubens to Tiepolo* (exh. cat., New York: Columbia University, 1967). The most important work in the present context is Albert Boime's *The Academy and French Painting in the Nineteenth Century* (London: Phaidon, 1971), particularly for its insistence on the continuity of early and late nineteenth-century painting, on the progressive aspects of so-called academic art, and on the importance of preparatory works as a domain of innovation. However, Boime's failure to apply the fundamental distinction between the nature study *(étude)* and the compositional sketch *(ébauche)* led him to focus on the spurious issue of loose brushwork. Boime's approach, which suggests that the salient feature of Impressionism and advanced pre-Impressionist art lay in technique rather than in a new response to the visual world, is also present in *French Nineteenth Century Oil Sketches: David to Degas* (exh. cat., Chapel Hill, North Carolina: The William Hayes Ackland Memorial Art Center, 1978).

My argument that the syntax and values of modern art first appear in recognizable form around 1800 is not original. Perhaps the most persuasive apologist for this widely held position is Robert Rosenblum. See especially his *Modern Painting and the Northern Romantic Tradition: Friedrich to*

Rothko (New York: Harper & Row, 1975).

Of the many other works to which I am indebted, I am most conscious of my obligation to the following:

Antal, Frederick. "Reflections on Classicism and Romanticism." In *Classicism and Romanticism and with other Studies in Art History,* pp. 1-45. New York: Harper & Row, 1966.

Badt, Kurt. *John Constable's Clouds.* London: Routledge & Kegan Paul, 1950.

Bialostocki, Jan. *Stil und Ikonographie.* Dresden, 1966.

Eitner, Lorenz. "The Open Window and the Storm-Tossed Boat: An Essay in the Iconography of Romanticism." *The Art Bulletin,* vol. 37 (1955), pp. 281-90.

Friedländer, Max J. *Landscape, Portrait, Still-Life: Their Origin and Development.* New York: Schocken Books, 1963.

Gombrich, E. H. "The Renaissance Theory of Art and the Rise of Landscape." In *Norm and Form: Studies in the Art of the Renaissance,* pp. 107-21. London: Phaidon, 1966.

Hofmann, Werner. *The Earthly Paradise: Art in the Nineteenth Century.* New York: Braziller, 1961.

———. "Zu Friedrichs geschichtlicher Stellung." In Hamburg: Kunsthalle. *Caspar David Friedrich,* pp. 69-78. Exh. cat., 1974.

Honour, Hugh. *Neo-classicism.* Harmondsworth, England: Penguin, 1968.

———. *Romanticism.* New York: Harper & Row, 1979.

Houston: The Museum of Fine Arts. *Gustave Caillebotte: A Retrospective Exhibition.* Exh. cat., 1976-77.

London: Hazlitt, Gooden & Fox. *The Lure of Rome: Some Northern Artists in Italy in the Nineteenth Century.* Exh. cat., 1979.

Miquel, Pierre. *Le Paysage français au XIXe siècle 1824-1874: L'École de la nature.* 3 vols. Maurs-la-Jolie: Editions de la Martinelle, 1975.

Nochlin, Linda. *Realism.* Harmondsworth, England: Penguin, 1971,

Panofsky, Erwin. *Idea: A Concept in Art Theory.* New York: Harper & Row, 1968.

Pool, Phoebe. *Impressionism.* New York: Praeger, 1967.

Rosenblum, Robert. *Transformations in Late Eighteenth Century Art.* Princeton, New Jersey: Princeton University Press, 1967.

San Francisco: California Palace of the Legion of Honor. *Barbizon Revisited.* By Robert L. Herbert. Exh. cat., 1962.

Schapiro, Meyer. "On Some Problems in the Semiotics of Visual Art: Field and Vehicle in Image-Signs." *Semiotica,* vol. 1 (1969), pp. 223-42.

Schmoll gen. Eisenwerth, J. A. "Fensterbilder: Motivketten in der europäischen Malerei." In *Beiträge zur Motivkunde des 19. Jahrhunderts.* Studien zur Kunst des 19. Jahrhunderts, vol. 6, pp. 13-166. Munich: Prestel, 1970.

Zeitler, Rudolf. *Die Kunst des 19. Jahrhunderts.* Propyläen Kunstgeschichte, n.s., vol. 11. Berlin, 1966.

PHOTOGRAPH CREDITS

INDEX TO THE ARTISTS IN THE EXHIBITION

Page numbers for plates are in italics. Page numbers for catalogue entries are in roman.